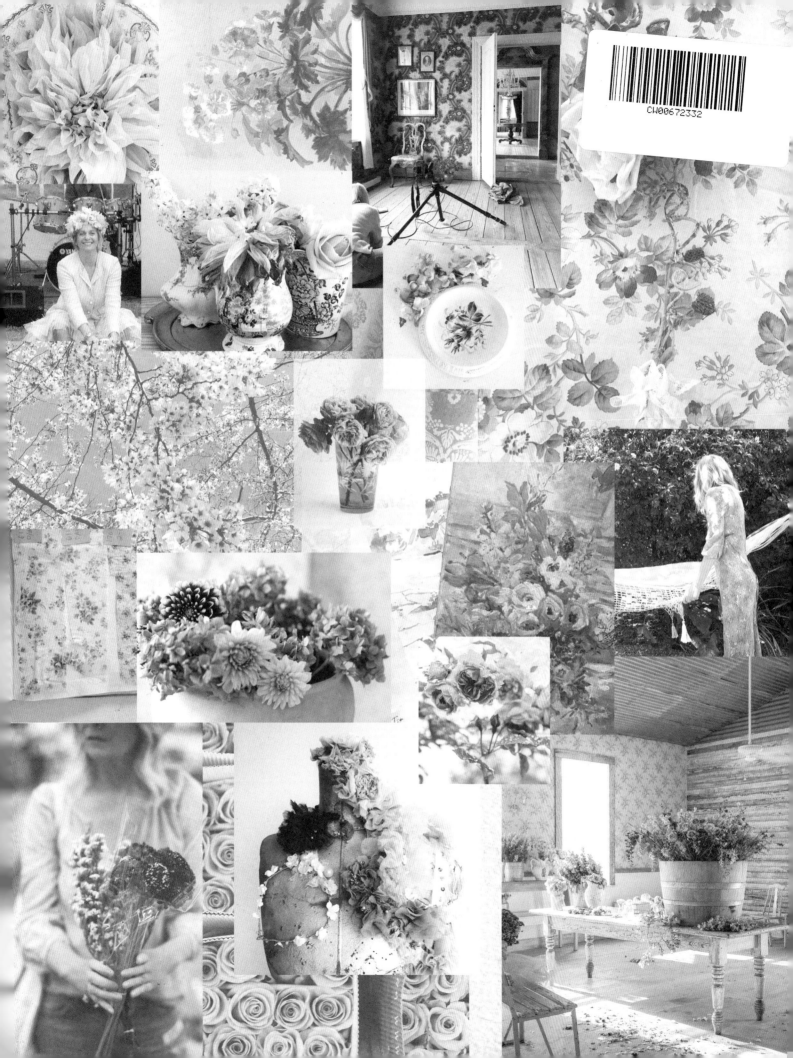

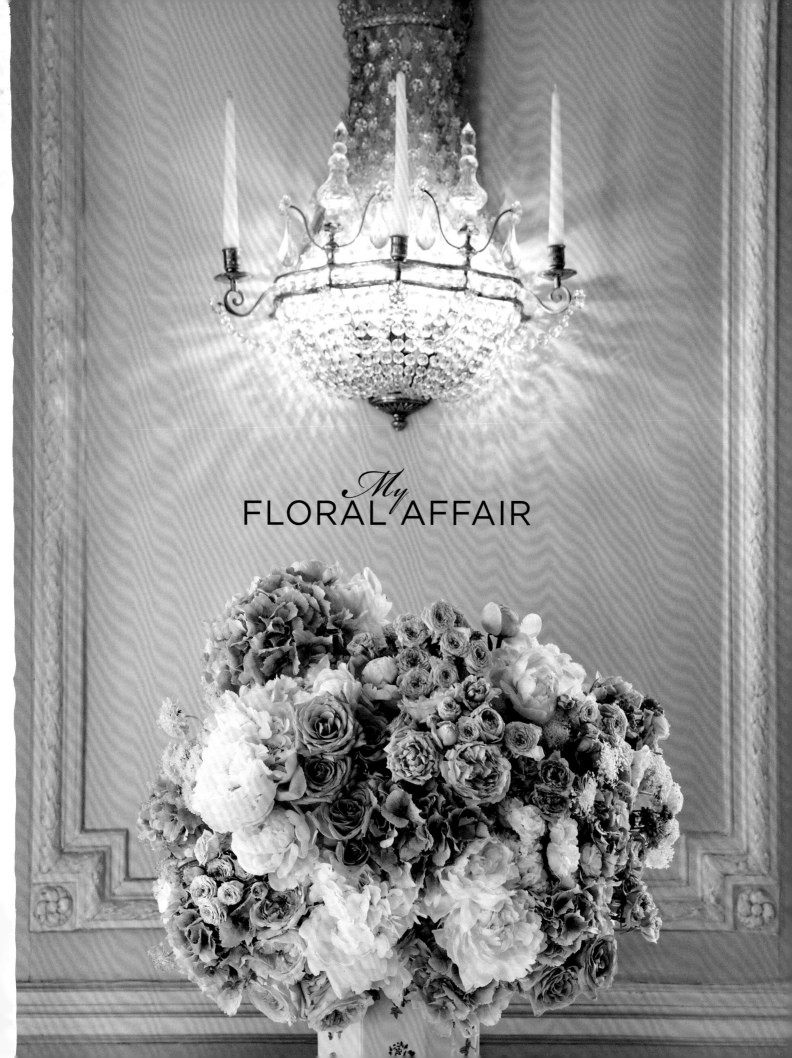

My
FLORAL AFFAIR

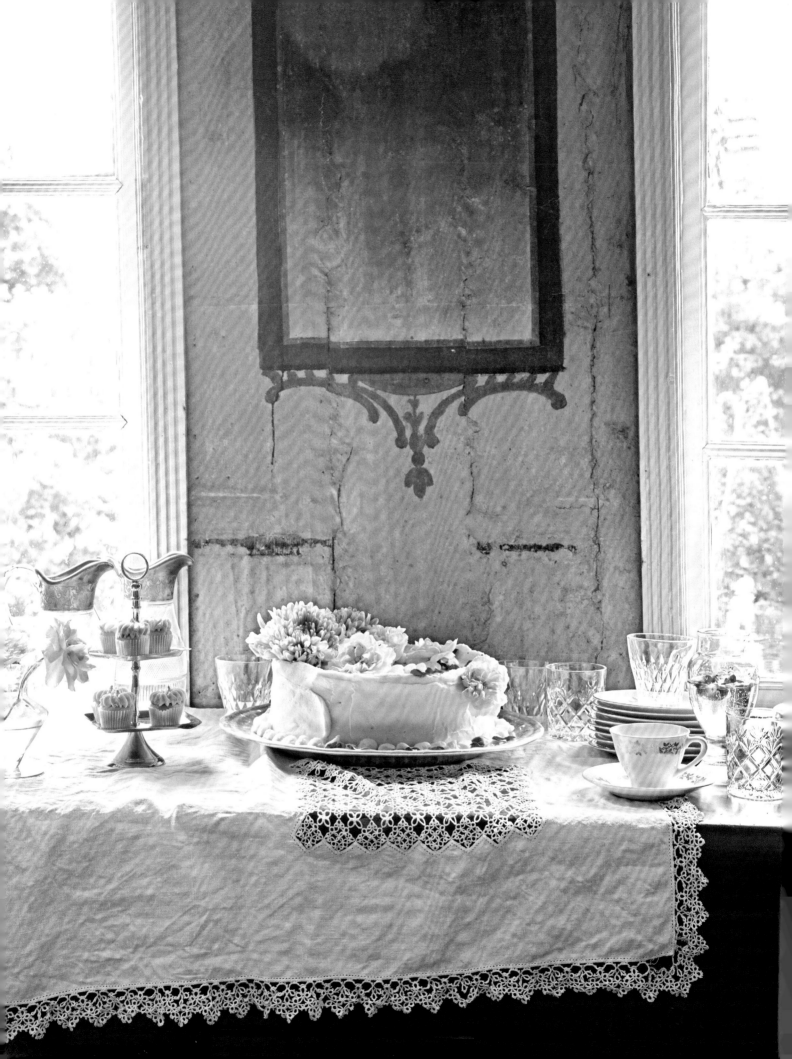

RACHEL ASHWELL

My FLORAL AFFAIR

Whimsical Spaces and Beautiful Florals

Photography by Amy Neunsinger

CICO BOOKS
LONDON NEW YORK

Published in 2018 by CICO Books
An imprint of Ryland Peters & Small Ltd
20–21 Jockey's Fields 341 E 116th St
London WC1R 4BW New York, NY 10029

www.rylandpeters.com

10 9 8 7 6 5 4 3 2 1

A CIP catalog record for this book is
available from the Library of Congress
and the British Library.

ISBN: 978 1 78249 547 5

Printed in China

Text: Alexandra Parsons
Editor: Gillian Haslam
Designer: Geoff Borin
Photographers: Amy Neunsinger; © Michael
Paul (pages 11, 87, 93); © Belle Daughtry
(pages 34, 64, 78, 120, 121); © Adriana
Anzolia (page 123); Gisela Torres (pages
206, 207, 210, 213, 216, 218); and © Sarah
Pankow (pages 211, 212, 214, 217)
Bouquet illustrations: Hilary Dempsey
Endpaper collage: Sarah Pankow, with
images by Rachel Ashwell, Belle Daughtry,
Gisela Torres, and Sarah Pankow

In-house editor: Anna Galkina
Art director: Sally Powell
Head of production: Patricia Harrington
Publishing manager: Penny Craig
Publisher: Cindy Richards

CONTENTS

Introduction 6

ENGLISH COUNTRYSIDE
& A LITTLE BIT OF WALES 12

Beautiful Babington 14
Storybook cottage 30
Roses, roses & roses 52
Gorgeous garden flowers 72
A Welsh treasure 86

FRENCH FLEURS 94

Whimsical beauties 96
Forever flowers 114
Trés jolie 122
Sweet petite Paris 134

NORWAY FLORAL DREAMS 142

Faded floral grandeur 144
Poetic portraits 160

BLOSSOMS & BEAUTIES
IN THE USA 168

My floral world 170
Fiore designs 220

Bouquet breakdown 232
Resources 234
Index 235
Dedication & Acknowledgments 238

INTRODUCTION

My affair with flowers began long before the idea for this book came into bloom, as someone once said to me "when I think of you, I think of flowers." I have always identified life with flowers, and flowers are at the core of much of my design work, whether blooming gloriously in the soil, freshly cut, artful make-believe fakes, or decorative, floppy vintage silk. Floral fabrics, wallpapers, painted embellishments, and antique china inspire and give me just as much joy. Rarely in my home are there no fresh flowers on display; even a little bud in a tiny vase here and there brings warmth to my heart. I cannot imagine a world without the sight and fragrance of a flower, and I find there is a powerful emotional healing element to flowers that can often translate to a feeling of overall calmness.

MY FLORAL HEAVEN
In Los Angeles, my rambling English rose garden is quite magical. The front garden is open to the street and as I sit on my balcony, it is not uncommon to see people walking around the flowers and stopping to smell the roses. My garden is not the biggest or the best planned, but there is something whimsical about it. There is an organized chaos, where every little blossom finds its equal footing and not a day goes by that I don't sit in my garden and feel grateful for the beauty and peace it brings me. I appreciate the whole process of nurturing a flower garden—the planting, nourishing, and pruning—and I relish every stage of floral beauty from bud through bloom to the beautiful leftovers, and finally to letting go, trusting that new blossoms will always come.

MY FLORAL AFFAIR
I have written several books prior to this on many subjects, but the common thread to them all is the presence of flowers. So I knew one day I would create a book that would focus on what I consider my love affair with flowers. I knew fresh flowers would be the core of the book, but I also wanted to be sure to include fake make-believe flowers and decorative silk flowers, as I think they are just as beautiful and I love the notion that they last forever. I also wanted to seek out examples of floral decoration on fabrics, in architectural details, painted onto vintage china, and, of course, in art.

Anytime a flower is present, it conjures up the thought of romance, but I am also conscious not to spill over into sugar-sweet frou-frou, and of

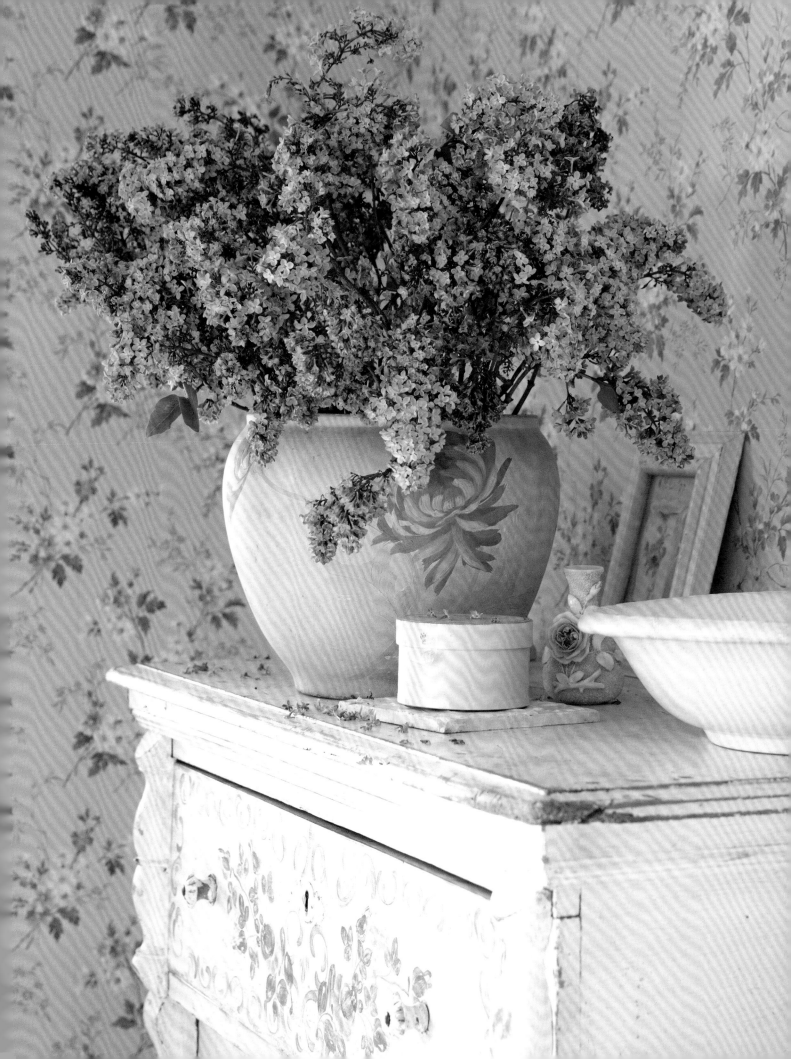

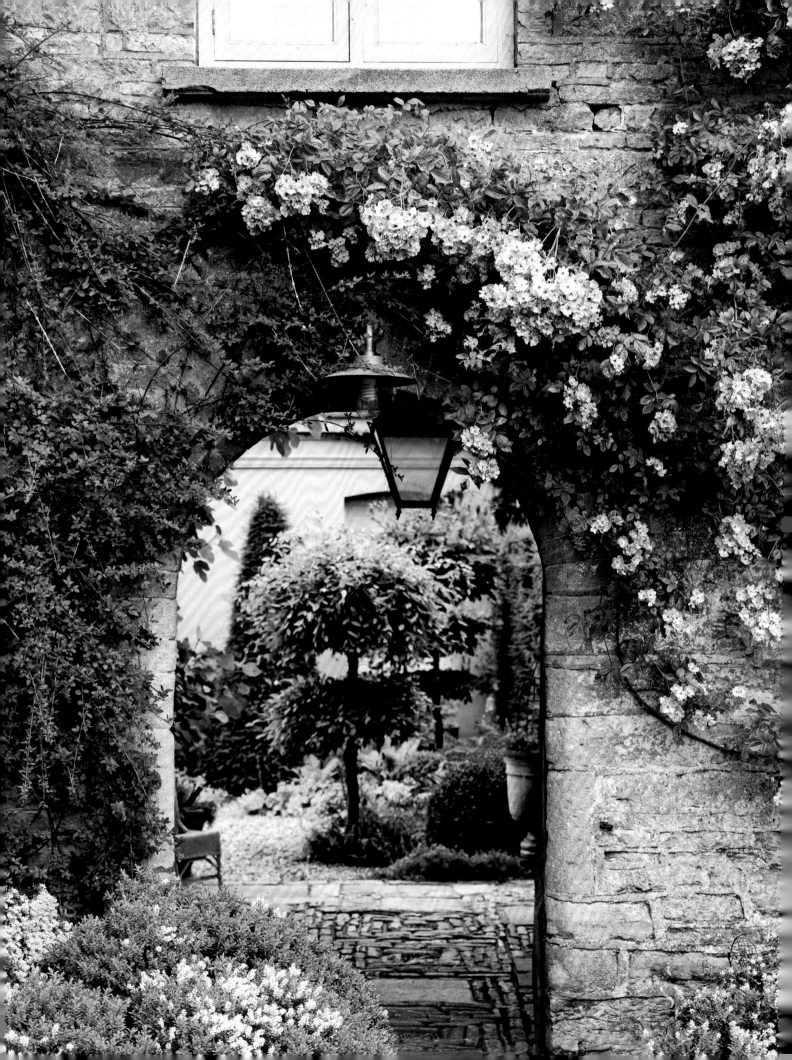

the importance of finding the balance that lets the beauty of flowers complement rather than overwhelm a space. I wanted to capture the world of flowers in whimsical and diverse settings, to give the flowers different opportunities to present their stories. A rose placed in a simple setting sings a different song than when playing the co-star in a fancily decorated space.

So I began the journey by choosing locations: starting in my homeland of England, then exploring the romantic streets of Paris and the surrounding countryside, capturing the elusive magical light of Norway, and finishing in Los Angeles where I live. Belle Daughtry was the anchor of the adventure, handling logistics of travel, people, and flowers, all the while keeping me calmly on my path.

I visited fancy locations, humble homes, and artists' studios, all with the common thread of flowers. The flowers became my guide and compass, and during the time of working on this book they were My Floral Affair. It was a romantic and nourishing experience. Every person I met along the way had their own story of their passion for flowers, which was inspiring and heartwarming and I gained so much knowledge. It was the most extra-ordinary classroom: I learned about the process of choosing the right flowers to plant, the careful maintenance they require, and the diverse ways in which to arrange them—way beyond my plopping-in-a-vase expertise. I tend to lean toward a lighter shade of pale in my palette, but as a reflection of my attraction to the flowers on my journey, I found myself comfortable in colors outside my typical comfort zone. The faded floral grandeur I found in Norway is a good example of this evolution.

I learnt to understand so much about life reflected in the magic created by every floral designer and gardener. Each had their own way to create their world of flowers. Mostly self-taught inspired by their passion, their personalities reflected their process. Some were methodical with an intended vision, others intuitive, having faith what will be will be, always beautiful. Just like life.

A BEAUTIFUL JOURNEY

Over the years I have often stated what a duller and less magical world it would be if there had never been a flower and all that they inspire, but fortunately we have all had a richer and more beautiful life graced with the wonderful world of flowers. I wish I could have captured the fragrances alongside the physical beauty of the flowers. This is a world that is timeless and my journey is shared here. It is certainly an affair to remember.

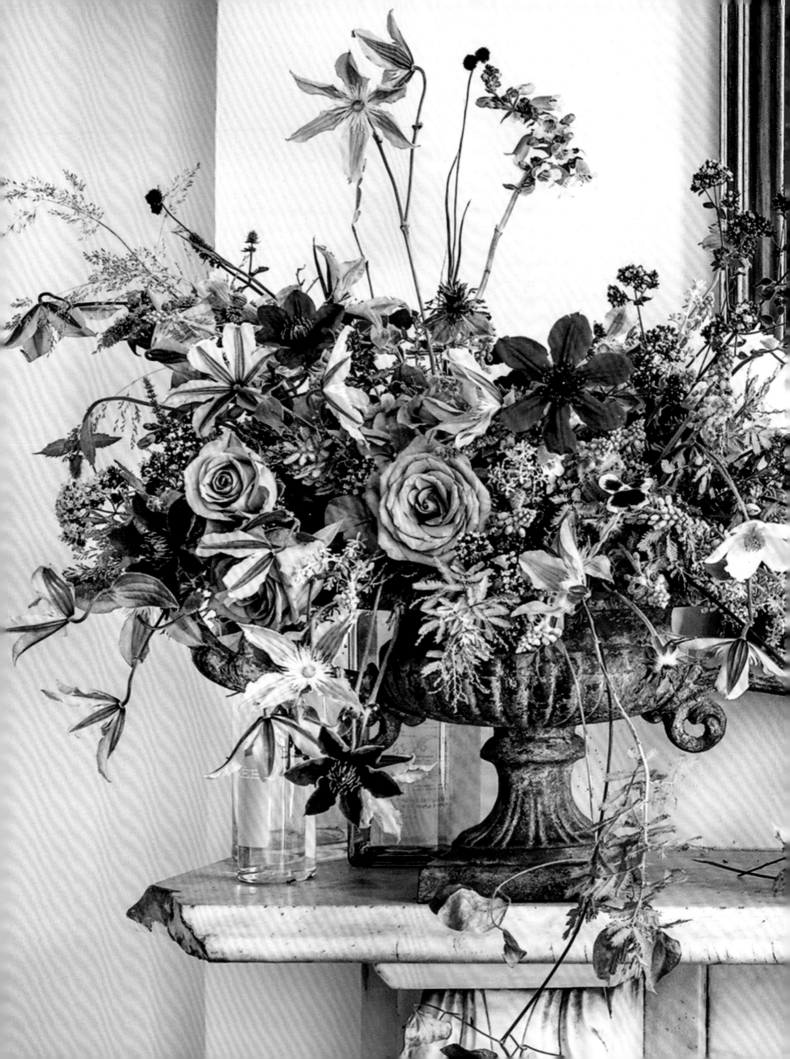

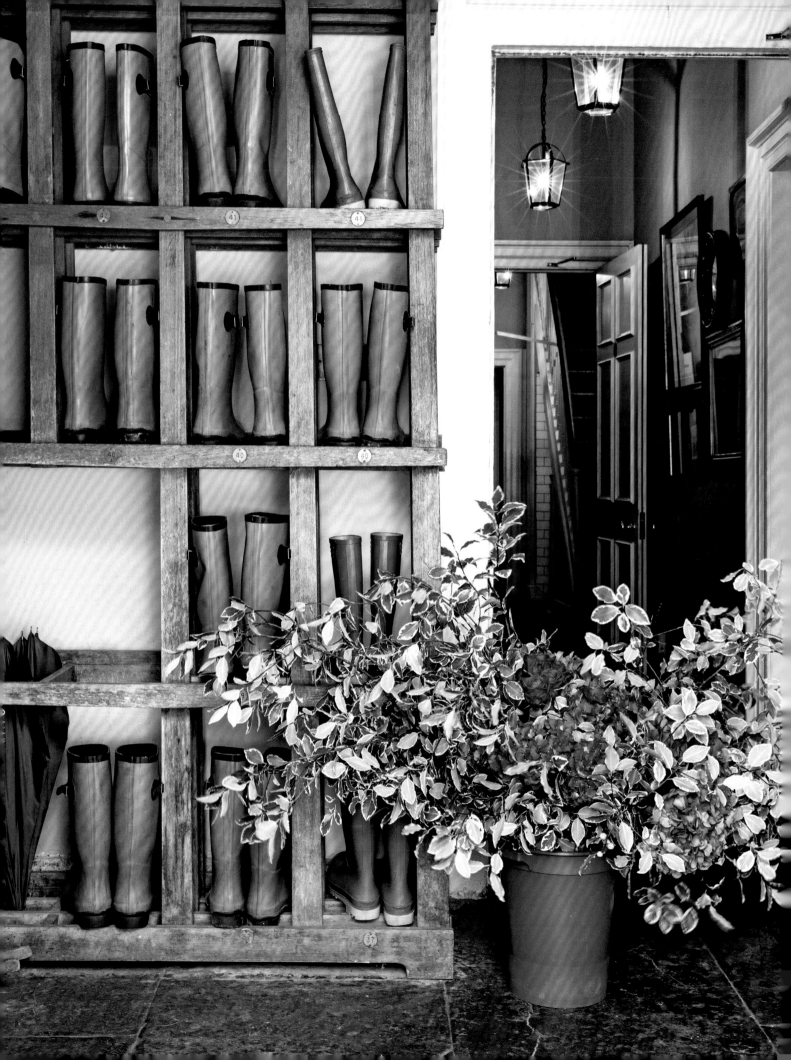

ENGLISH COUNTRYSIDE
& A LITTLE BIT OF WALES

I grew up in London, but it is countryside visits where time stood still that I remember so fondly. Winter days of muddy wellington boots and hot chocolate by the fire, playing the piano, reading aloud from storybooks, and going to bed listening to the rain and wind outside gave me such a sense of home. I loved the playful freedom of long summer days with golden evening skies and meadows of wildflowers and old stone garden walls decorated with dusky-pink climbing roses. I relive those memories in vivid detail, as though they were yesterday, often triggered by a movie, a fragrance, or music. So much of the history of England is rich in romance by ways of decor and fashion, often with a floral tradition at the core.

While California has been my wonderful adopted home, it sometimes leaves me yearning for the changing seasons. I dream of snow, rain, and howling winds, and the beautiful shapes of bare trees, giving way to the promise of spring, the fulfilment of summer, and the sweet decay of autumn. Part of the dream is the romantic country lifestyle, which to me means gatherings of friends and family, timeworn furniture, lovely old faded fabrics, and pottering in the garden. As an artist, I respond to the rhythm of the seasons, with time to reflect and soul-search and time to blossom with creativity. I return to my homeland often to relish and nurture these rhythms and to reconnect with the particularly English beauty of imperfection.

When I decided to make England part of *My Floral Affair*, I wanted to touch on all aspects of country life, mixing humble cottages with luxury mansions. We also met some inspiring floral designers and growers, such as Toria Britten, whose knowledge and loyalty for locally grown, chemical-free flowers were an education for me. At some of the locations we were welcomed as houseguests, at others we spent long days capturing the lifestyles of the homeowners, but in all instances it was magical to hear their stories and share the common thread of their love of flowers.

BEAUTIFUL BABINGTON

Christmas time is when I yearn most for English winter weather and to relive my memories of cozy country life. So over the years, Babington House in Somerset in the west of England has become our Christmas home for my children and I. As the days count down to our yearly visit, I recall the excitement I had as a child of the special treat that was to come. While it is a hotel, it has a feeling of a private country home. The staff feel like long-lost distant relatives. The communal spaces, the library, bar, cinema, and eating areas are intimately designed. Other guests amble through and dogs are welcome, making socializing easy and natural. I was not alone in appreciating the walled gardens and open grassland. There is everything here that you would dream of for a country house party organized by relaxed but very efficient angels.

Babington is part of the Soho House group that was founded well over ten years ago with originally just the one place in London as a home from home for people working in the creative industries. The design ethos is impeccable. It's a beautiful mix of the effortlessly comfortable and grand—buttoned leather chesterfields, velvet armchairs, crystal chandeliers, four-poster beds—and the edgy. The result is an environment that is forward-thinking, a bit boho and witty, while remaining true to the country house style. Home away from home.

The main house is a bit of a Downton Abbey, in that it is quite grand. It was built around 1705, and has inevitably been much remodeled, but it's a proper Georgian gem, and the restorations have been sympathetic. The eighteenth-century stable block and coach house have been sensitively turned into self-contained suites for guests. I love to see historic properties that have been really well-maintained without being overly slicked-up and polished, and here that care and consideration are much in evidence. The exteriors are pretty and mellow against a backdrop of worn pale stone paving, box hedges, and pink roses, the interiors welcoming, meandering, and homey.

The house style for floral arrangements is quite laid back and minimal —quite lovely—but I was thrilled with the opportunity to bring some of my floral affair ideas and see them live in this magical setting.

PREVIOUS PAGES The side entrance houses wellington boots for guests to borrow. I plopped this bucket down on my way to the main entrance. I'm not a big lover of green "fill," but I love Pittosporum leaves because of their white trim. Raspberry and violet hydrangeas await their moment.

RIGHT The mellow stone stable block approached via beds of roses. I love the mossy roof tiles and the wonky window header beams. Imperfection is always perfect in my eyes.

OVERLEAF I navigated my crew on the opposite side of the road through the winding lanes of the English countryside to our photo shoot. At each location I wanted to be sure to use local flowers so in this case, I reached out to local artisan florist and flower grower, Toria Britten. Having communicated my feelings on arrangements and scale, she arrived with her SUV packed to capacity with an abundance of choice. The amazing cascade of bellflowers, hydrangeas, and Peruvian lilies was a collaborative vision created by her to my direction. She used two vases, one tall one on the console table and a squat one on the floor beneath, visually joined together. The effect is quite glorious. This is the main reception of the house—the grand and twinkly chandelier hung in the center of elegant but chunky floral molding adds romantic drama, while the raspberry velvet tufted Victorian conversation sofa supplies the practical element and contributes to the overall whimsy.

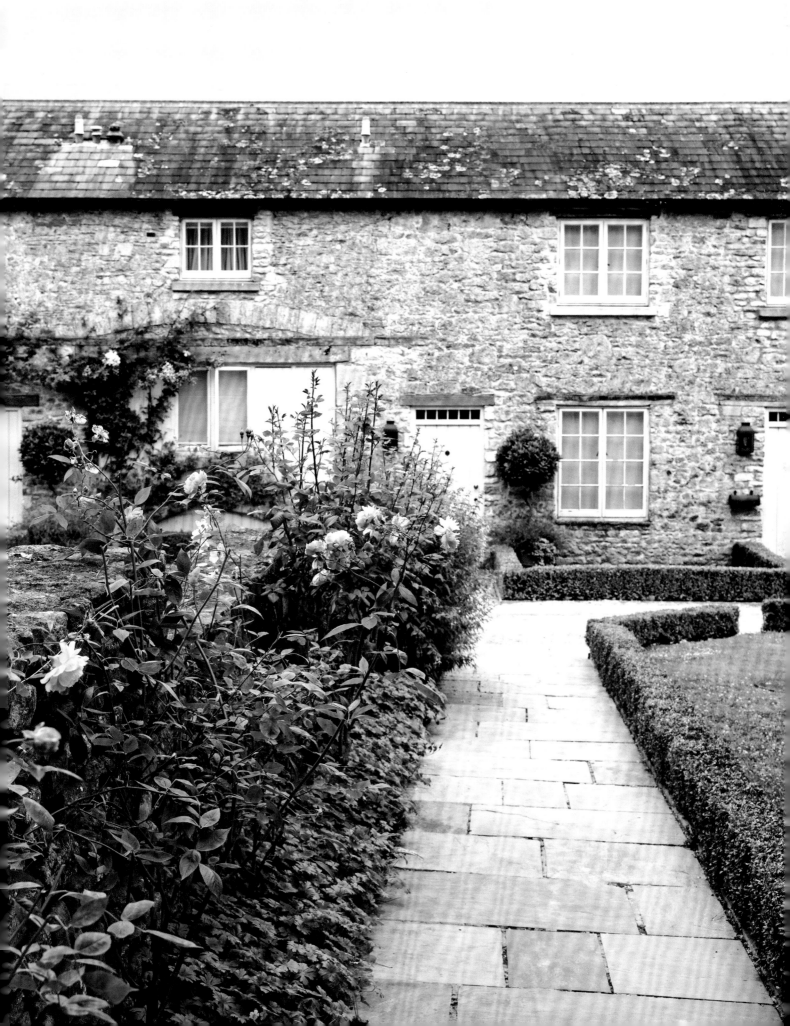

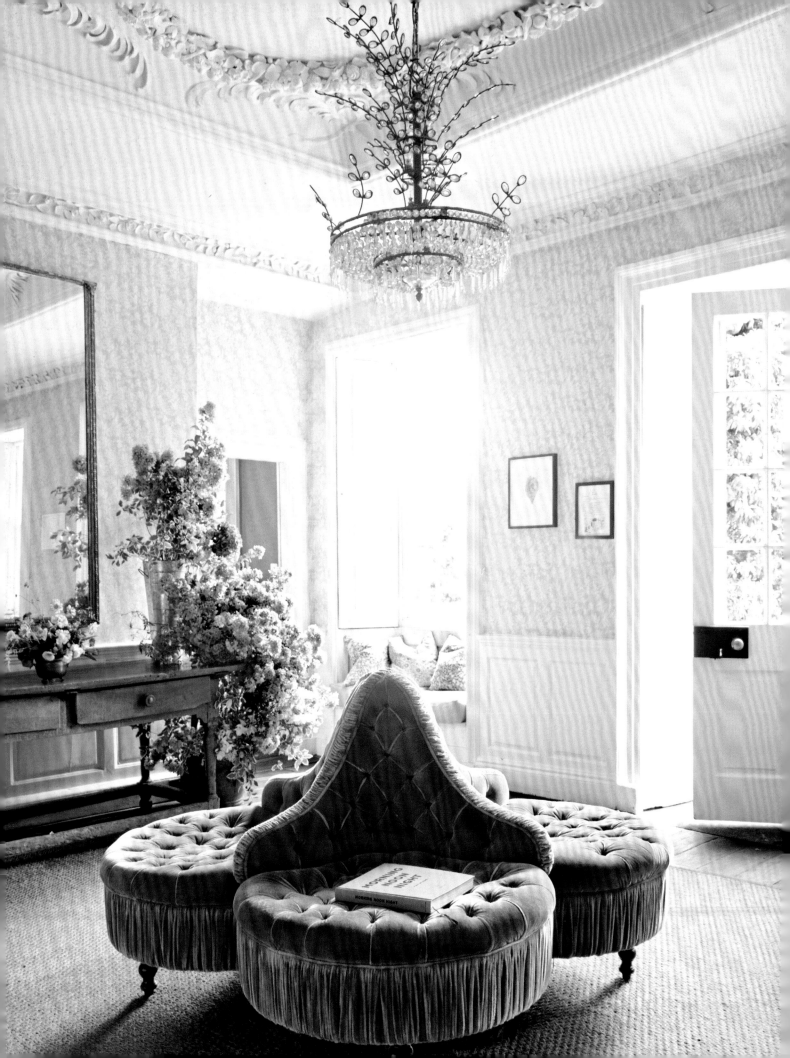

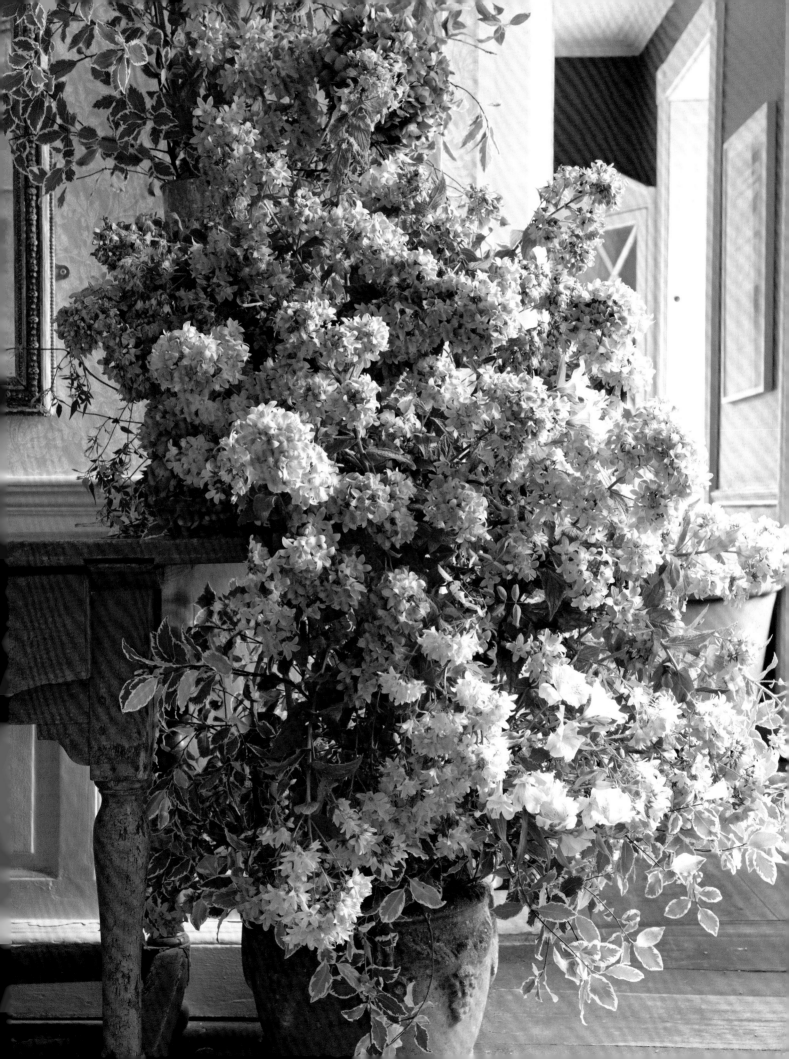

ABOVE I loved the discovery of the little floral crystal nestled in the sconce on the busy wall wallpaper. **RIGHT** The log room, which owes its name to the massive fireplace and log storage, is used for private dining and large gatherings. The sturdy, timeworn oak table can seat over twenty. In this room of substance, it's lovely to see the juxtaposition of silky, frilly lampshades and assorted garden flowers in a mish-mash of mercury and metal vases. A special callout to some lovely honey-colored carnations—so often an unsung hero. **OVERLEAF** The bar area is a study in orderly chaos —a lot for the eyes to see from the busy wallpaper to the mix of velvet and linen upholstery and cushions with an array of trims. Eclectic prints, photographs, and mixed media pieces cancel out any sweetness. The flatteringly smoked vintage mirror panels are a signature touch. This floral arrangement is a nice balance of formal tradition with garden perennials. See page 232 for bouquet breakdown.

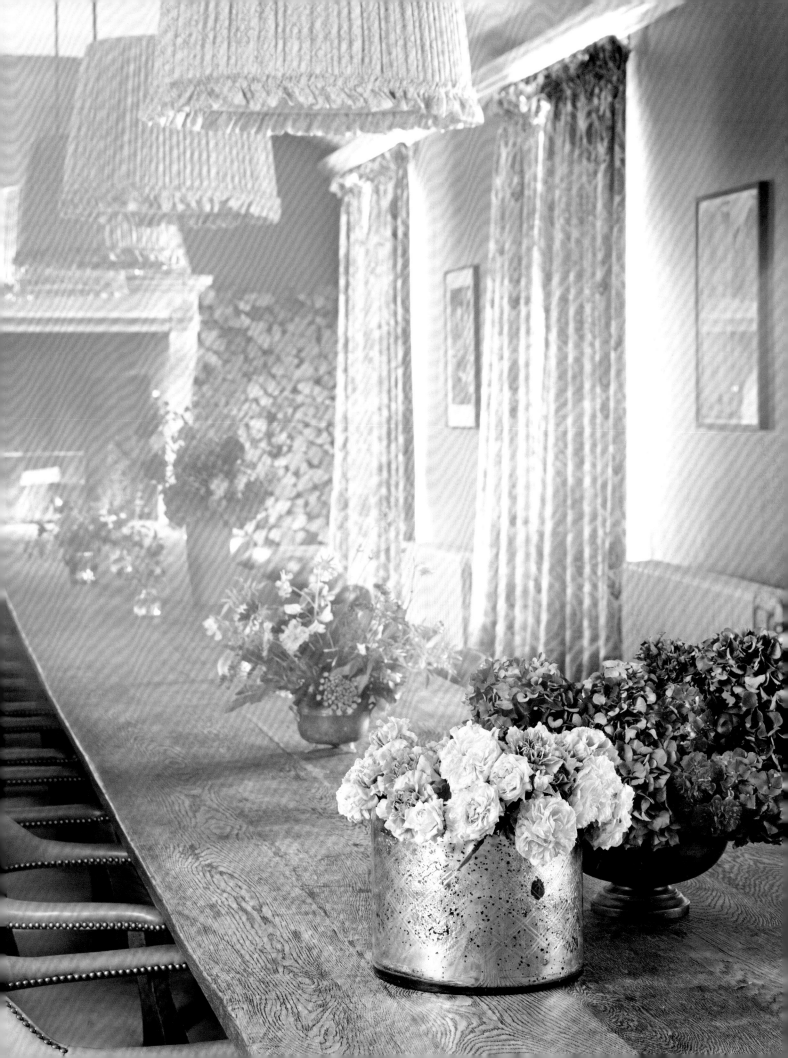

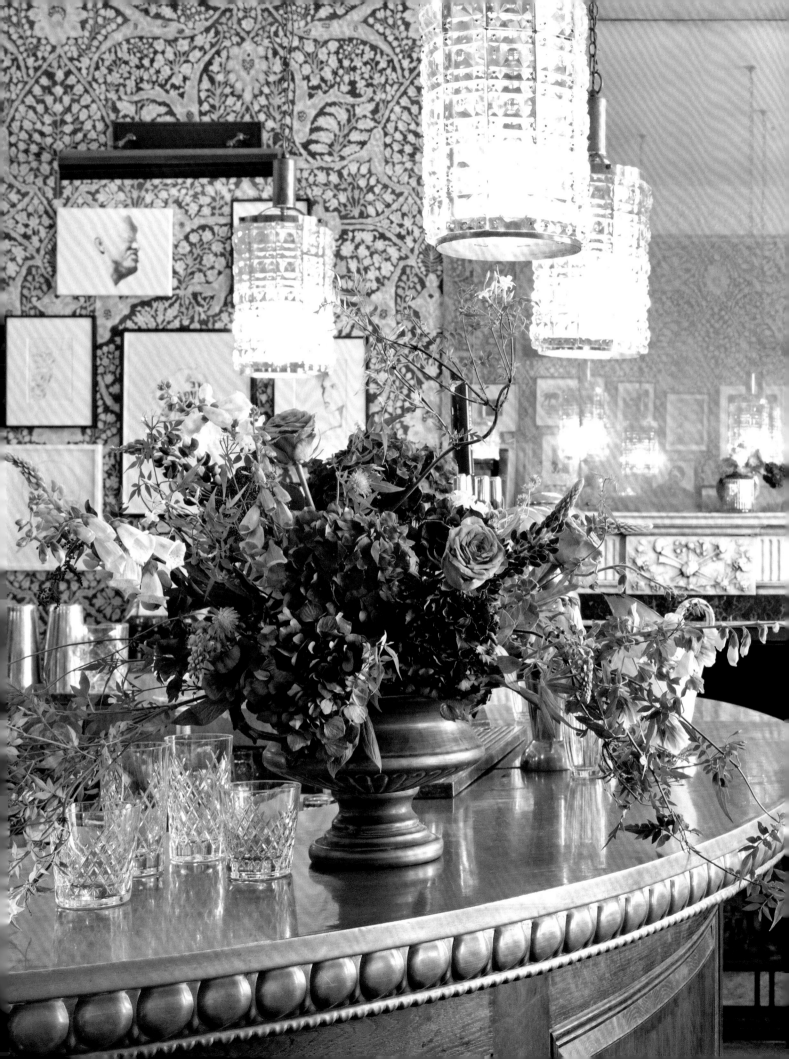

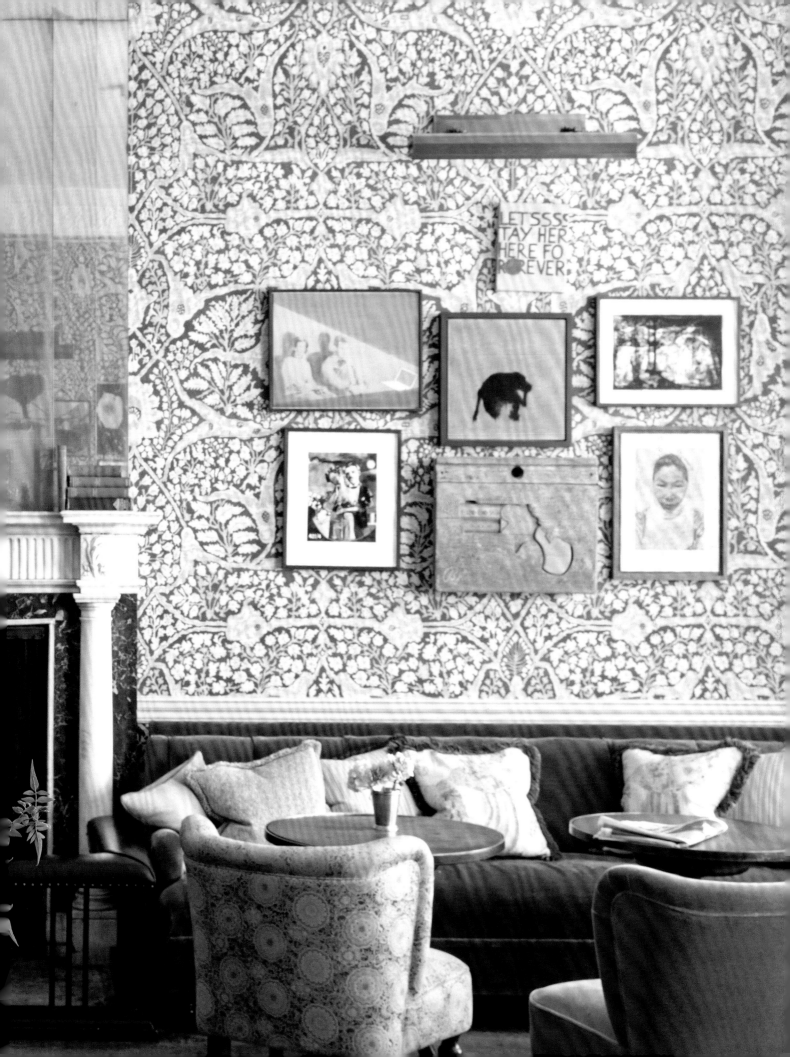

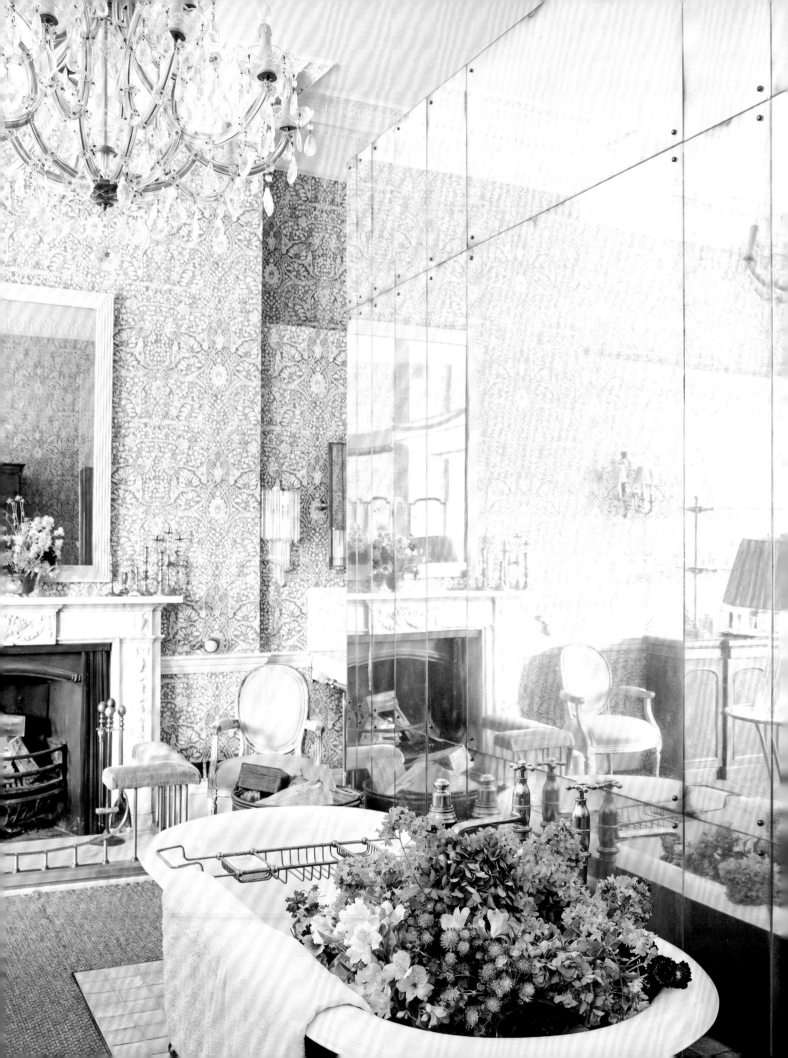

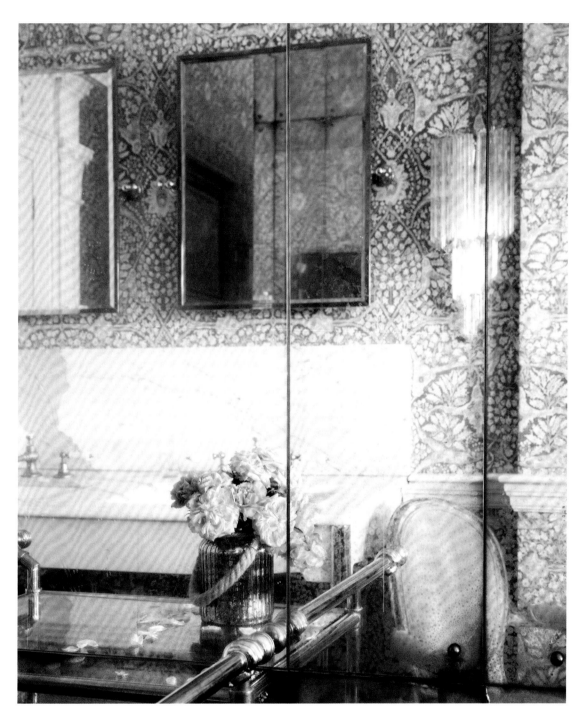

LEFT AND ABOVE The joys of a Babington House bathroom: opulent and comfortable with a wall of smoky mirrors that is kind and flattering, subtle floral wallpaper, honed marble sinks and backsplash, a grand crystal chandelier, and a velvet side chair. Flowers on the marble washstand are as gloriously pretty as the room, by way of honey carnations and some floppy pink Joie de Vivre roses. **OVERLEAF** Known as the Playroom, this bedroom often serves as the bridal suite. A perfect balance of subtle opulence,

it was our moment of luxury on our travels. The palette and the patina give the room a real feeling of individuality. I like the mix of Marie Antoinette-style decadence with a touch of 1940s pieces. The sofa is a delicious faded teal velvet with a perfect amount of mush in the eclectic cushions. The quiet but significant floral arrangement is one of my favorites by Toria, a feeling of handpicked from the garden but given some structure by her gentle use of wire and foam. See page 232 for bouquet breakdown.

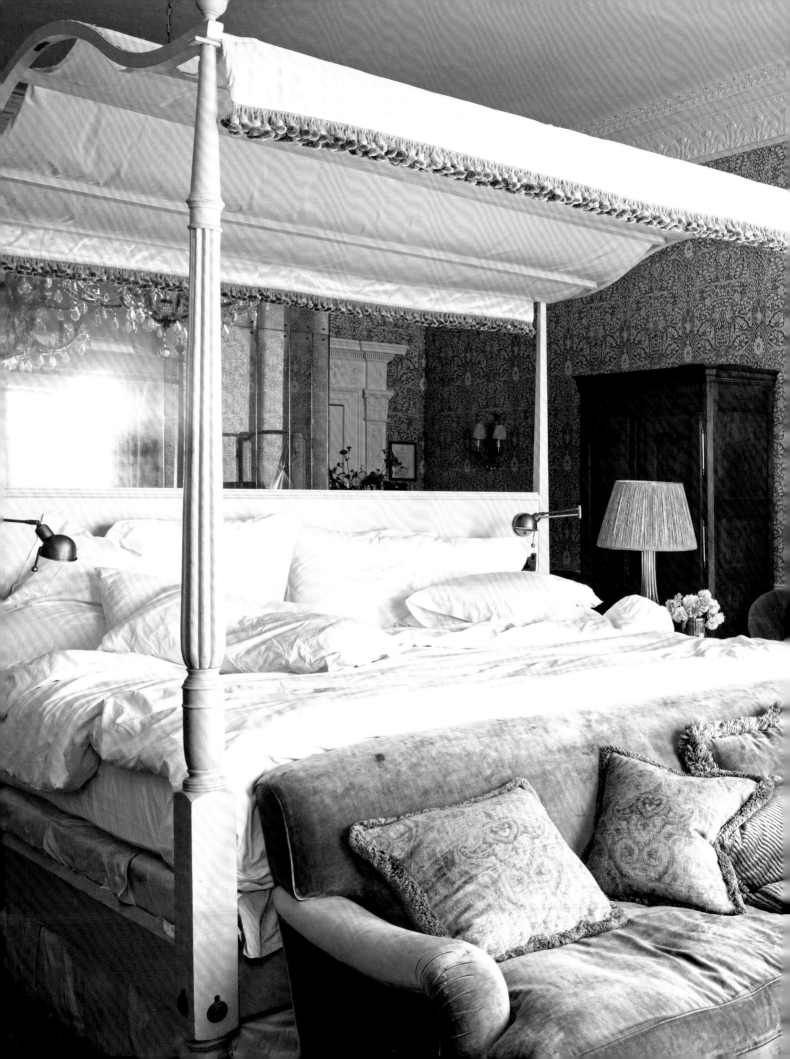

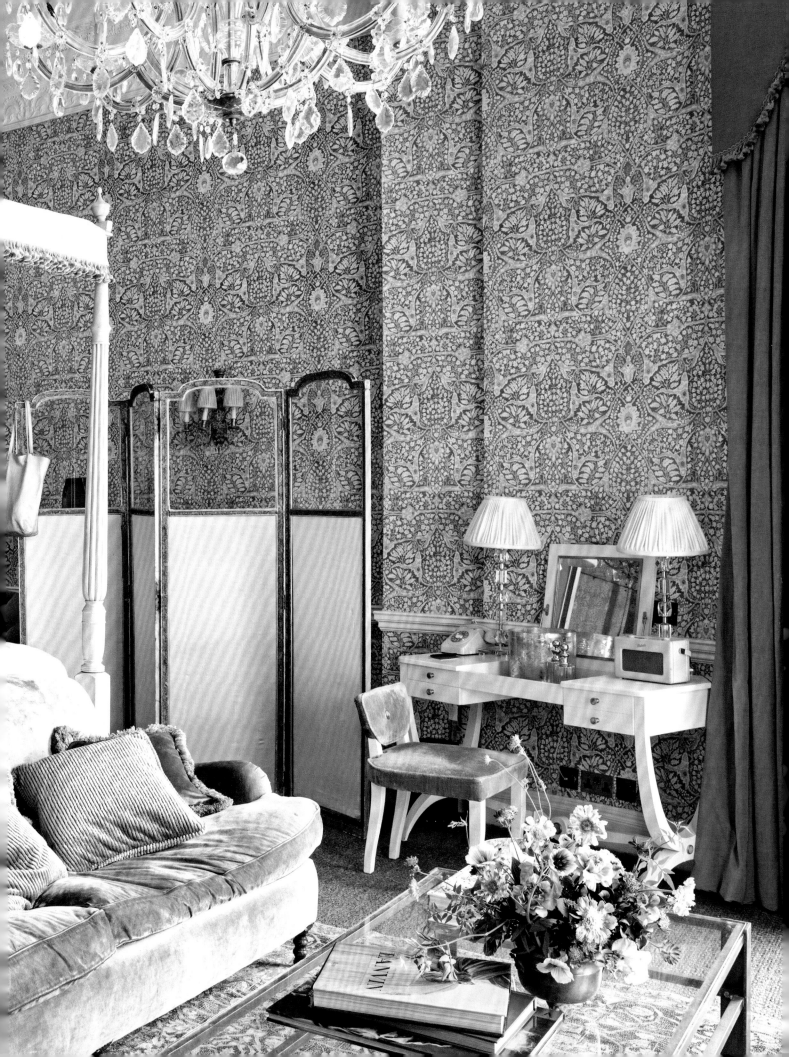

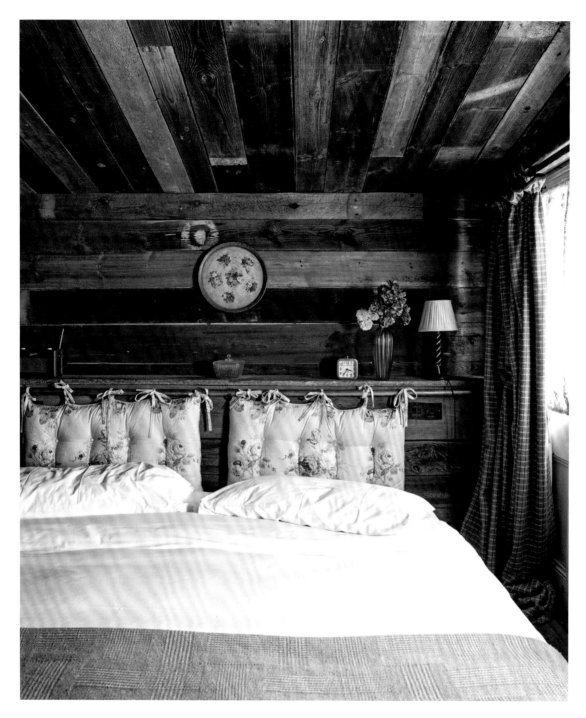

ABOVE A self-contained suite, referred to as the Cabin by the Lake, is a cozy luxury, but as comfortable and curated as rooms in the main house. Garden roses in the bedroom give a pop of color. I love the idea of the cushions-with-ties headboards, easily removed for cleaning. **RIGHT** In the sitting area of the cabin, the sofa is upholstered in a vintage dhurry and the mushy cushions in a comfy velvet. The floral display on the table is grand in size and the classical vase is formal in intent, but the airy arrangement of blue scabious, mallow flowers, spiked speedwell, and Iranian wood sage is delightfully whimsical. Due to the imminent arrival of a guest, Toria brilliantly put this display together in just five minutes. See page 232 for bouquet breakdown. **OVERLEAF** A magical carpet of cornflowers in Babington's walled garden.

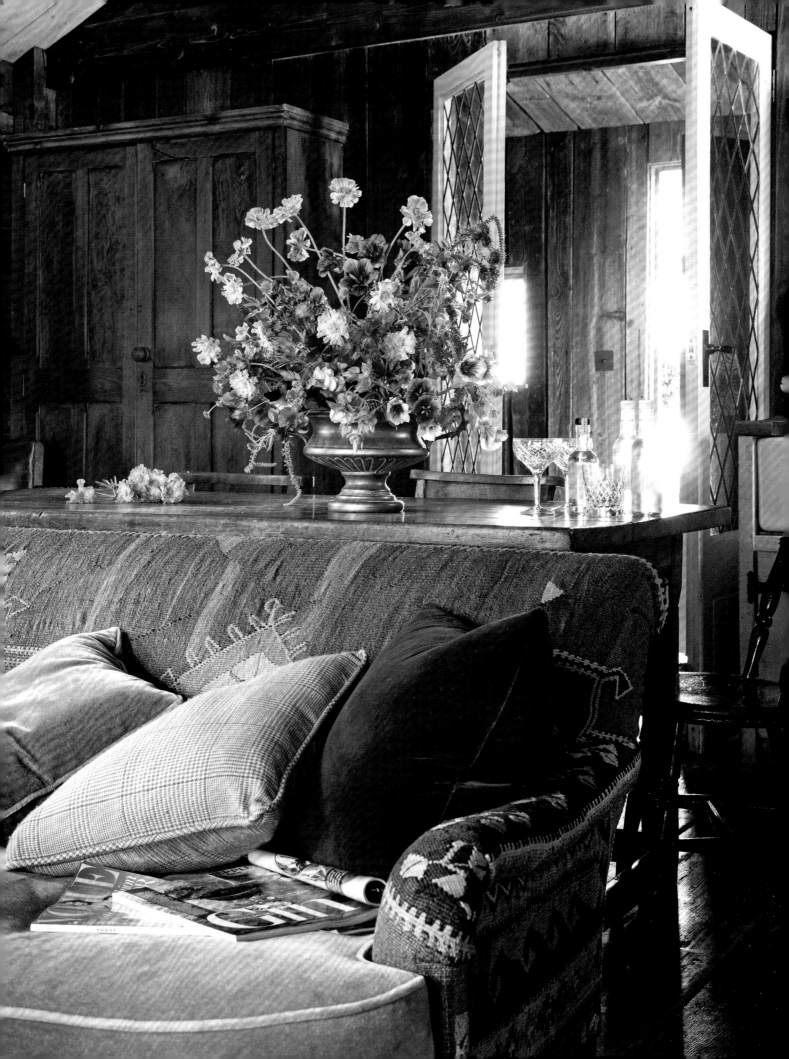

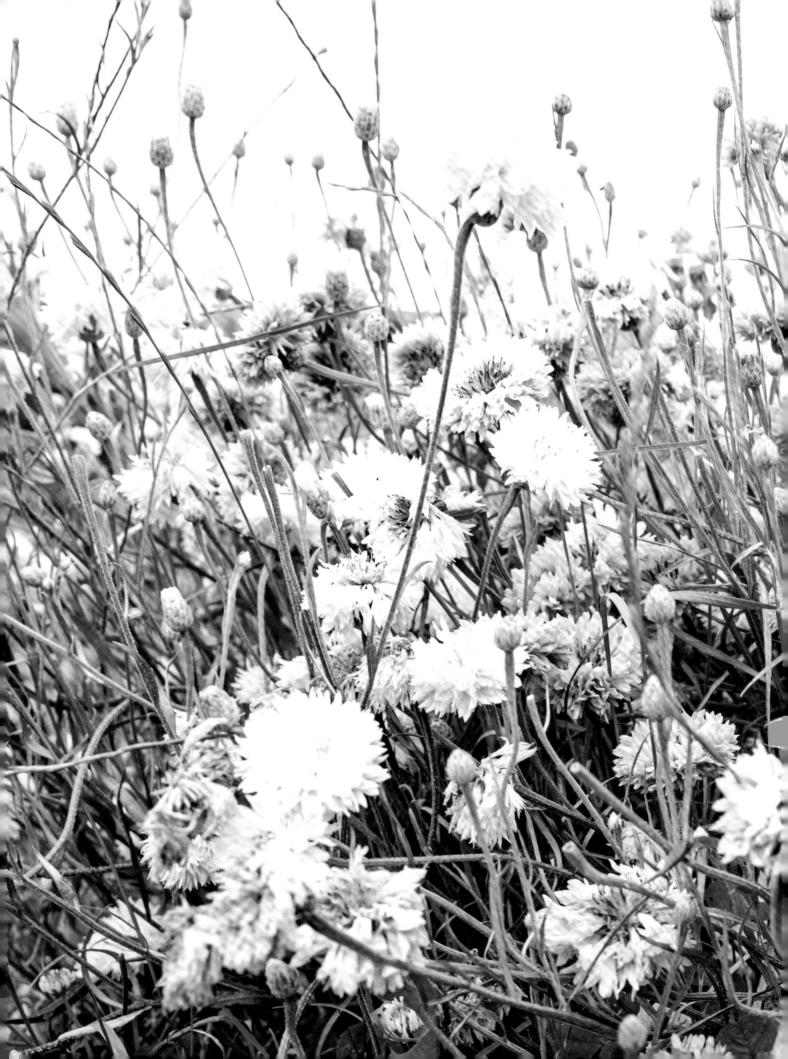

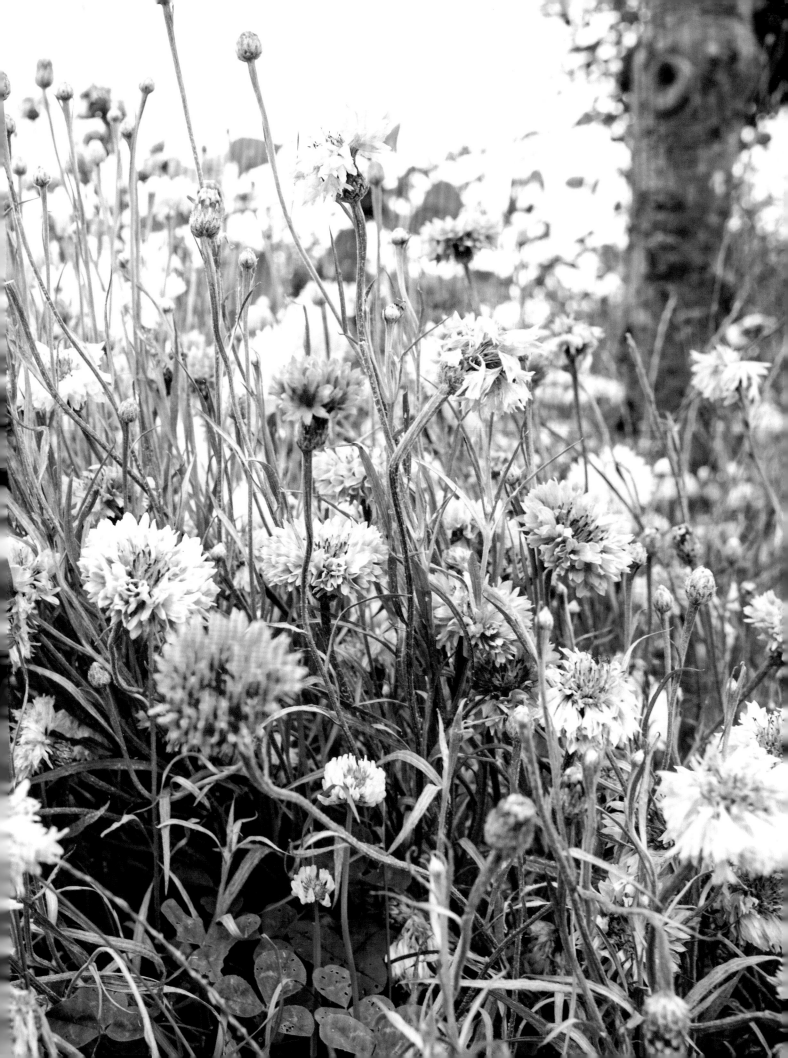

STORYBOOK COTTAGE

A WHITER SHADE OF PALE

The wonderful world of Instagram is where I discovered this delightful cottage, whose owner enjoys an enthusiastic following of fans for her uncompromisingly pale palette of white to the very core, the simple, achievable beauty of her uncluttered spaces, and her inventive way with garden flowers and natural materials. Samantha is a master of the art of curating things: everything she puts together seems effortless but just right. Her style resonates with me on every level, and I was delighted to visit her and her husband Richard in their chalky-white cottage, plonked in the middle of a field with no neighbors in sight, deep in the Devon countryside, and to meet the little flock of chickens, the ducks, and the dogs, George and Harvey, that have free run of the house and garden.

The thatched cottage has quite some age to it, and was most likely a cattle shed before it was made into a domestic dwelling. The thick walls are traditionally plastered cob (a mix of mud, horsehair, and stones from the fields that surround the house). The cottage was a tiny two-up-two-down when the couple bought it twelve years ago. Samantha and Richard wisely and patiently lived in the cottage for six years, getting to know it and its various seasonal moods before taking the plunge and extending it. Patience is a true virtue.

Working alongside a sympathetic builder, doing much of the plastering and decorating work herself, the cottage was transformed, slowly, thoughtfully, and by hand. For instance, the kitchen units were made by a rural carpenter in his garden shed from a picture given to him by Samantha and delivered one by one over about six months for her to paint. It's that level of attention to detail that makes this such a personal and charming space.

It's not just the house that has been created practically with bare hands, but also the garden. A garden stocked to bursting with every imaginable English country flower. It's a magical mix of scented stocks, sweet peas, roses, and hydrangeas, many of which feature in this particular moment in my floral affair with the English countryside.

RIGHT Deep windowsills are a feature of this 400-year-old cottage, and the sunlight dapples playfully on the uneven walls. White cosmos, David Austin Fragrant Memories roses, campanula, and purple scabious from the garden are a lovely, simple joy. Fallen petals always add to the story.

OVERLEAF The flavor of the garden captured in a single snapshot. It's a controlled chaos of abundant flowers. In the background are the sweet-pea poles, and storybook fence, and somewhere amongst the mass of David Austin Ballerina roses wander a happy flock of chickens and a couple of ducks.

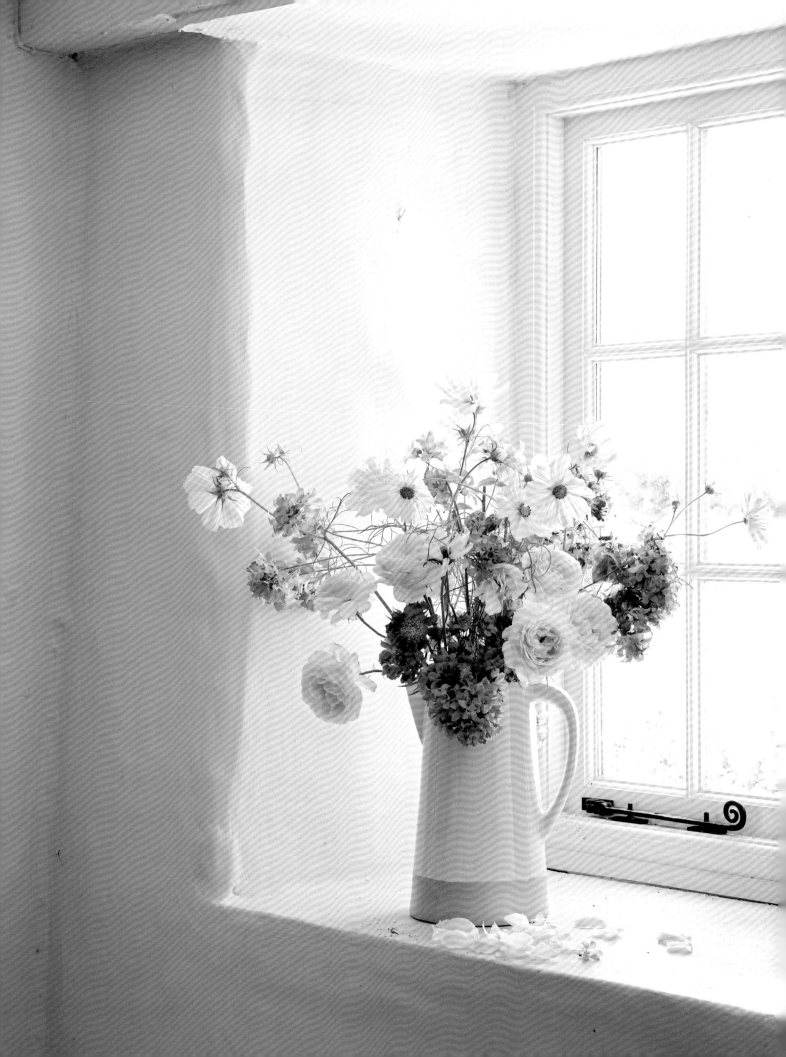

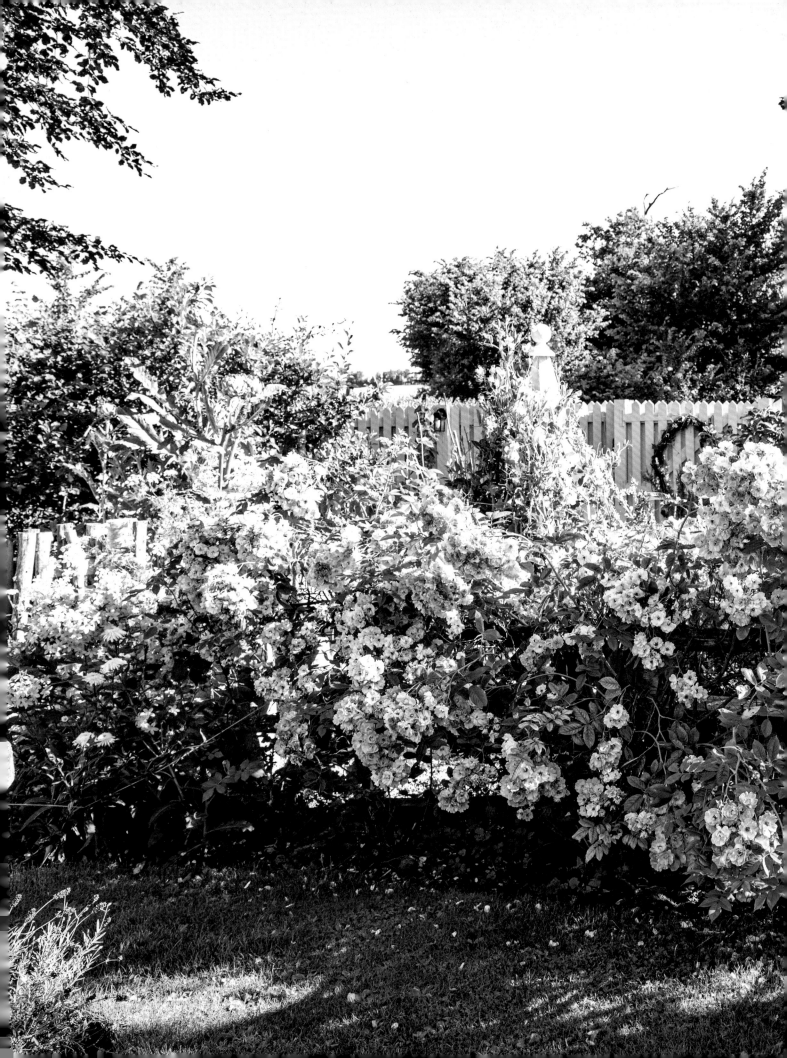

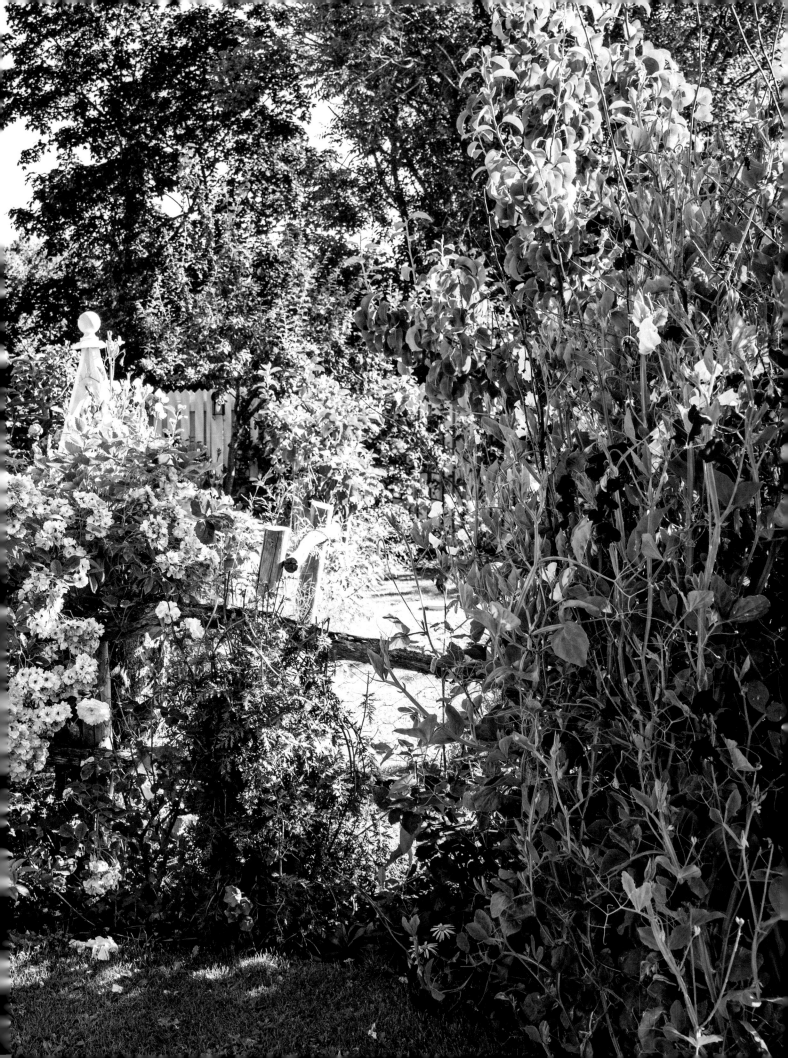

ABOVE Wisteria, albeit out of bloom, wraps around the back door. RIGHT A plain linen slipcover, made by Samantha, no piping, no frills, and just slightly wonky—to me that's perfection. My way with flowers is a cascade of unstructured abundance —these are mainly the Ballerina roses from the garden. I haven't learned the art of creating bouquets with wire and foam. The floors are made from scaffolding boards, their chunky, gappy feel is perfect here. They are painted in Flake White, a color from Fired Earth. OVERLEAF Dining space and kitchen continue to celebrate the pale palette, here toned in with pale gray complemented with the distressed green of the dresser. I like the home-made sturdy bench softened with faded floral mushy pillows, and the mix-and-match feel of the floral displays: a mix of David Austin roses, sweet peas, clematis, and peonies. FOLLOWING PAGES Cornflowers and sweet peas in the kitchen. The chopping board is a piece of rough plank painted on the sides—a simple but brilliant idea of Samantha's.

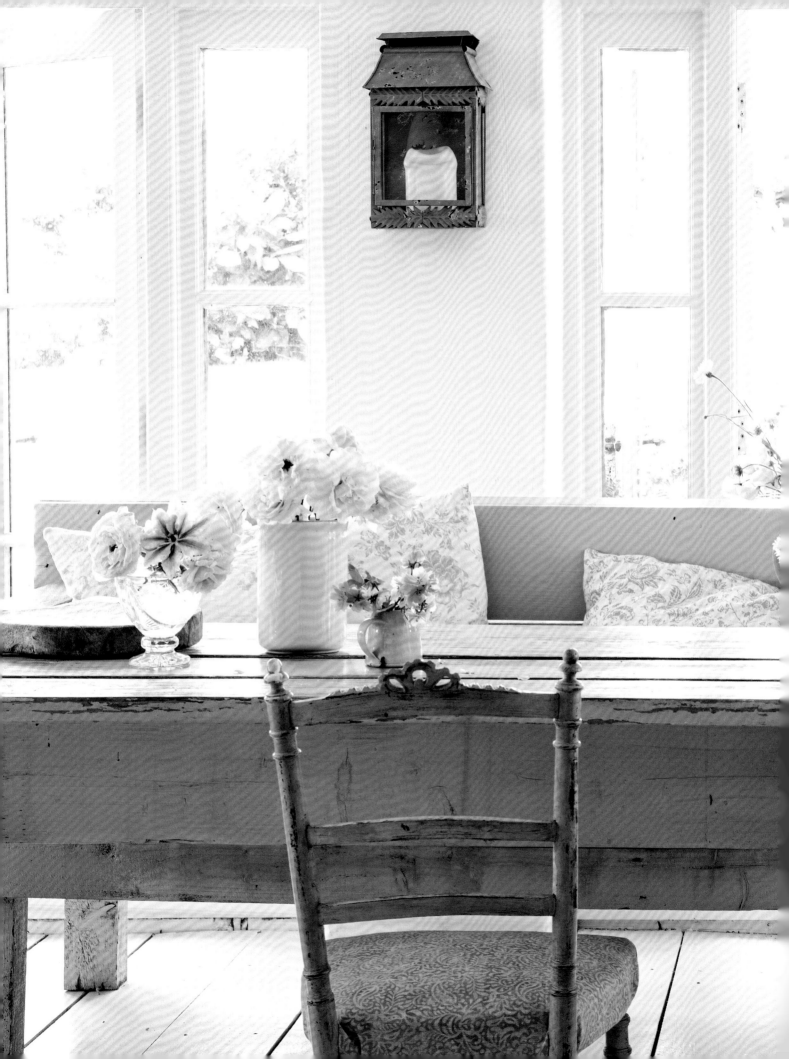

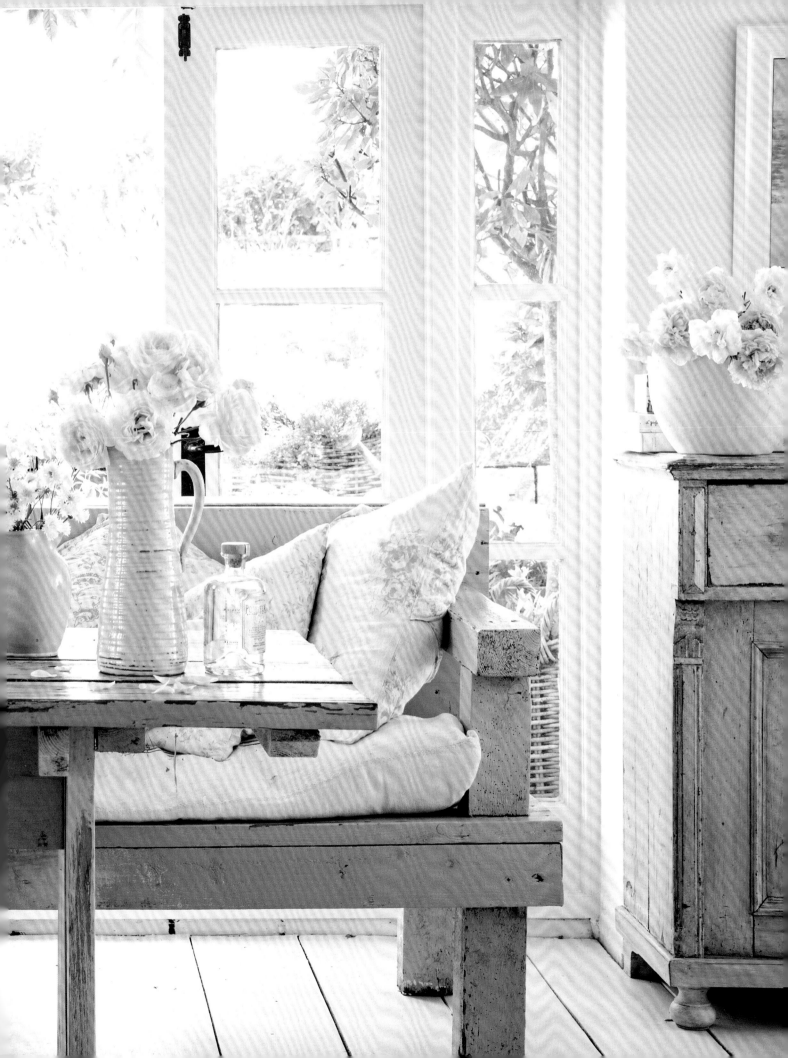

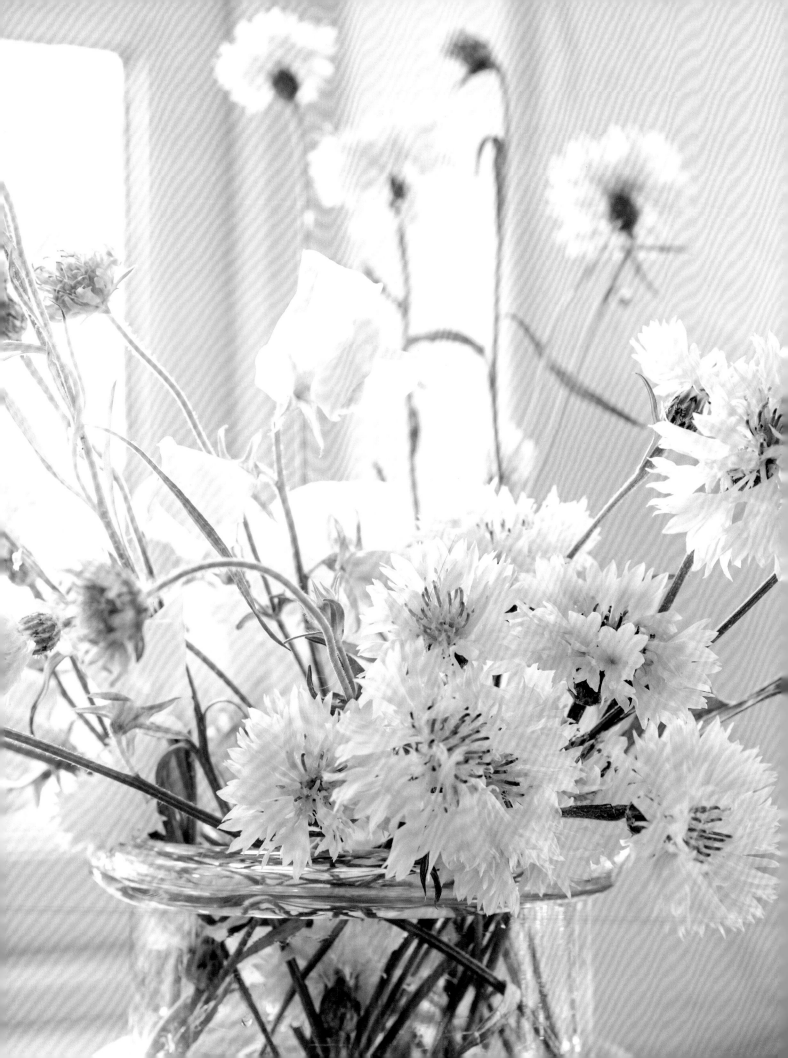

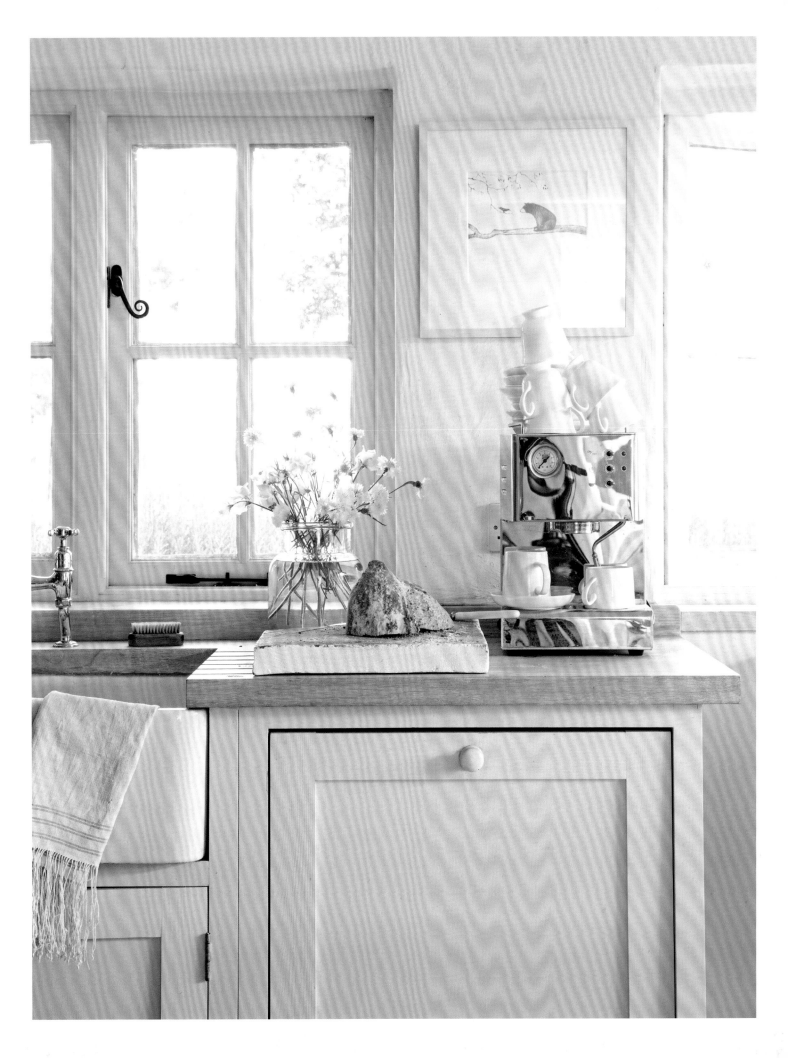

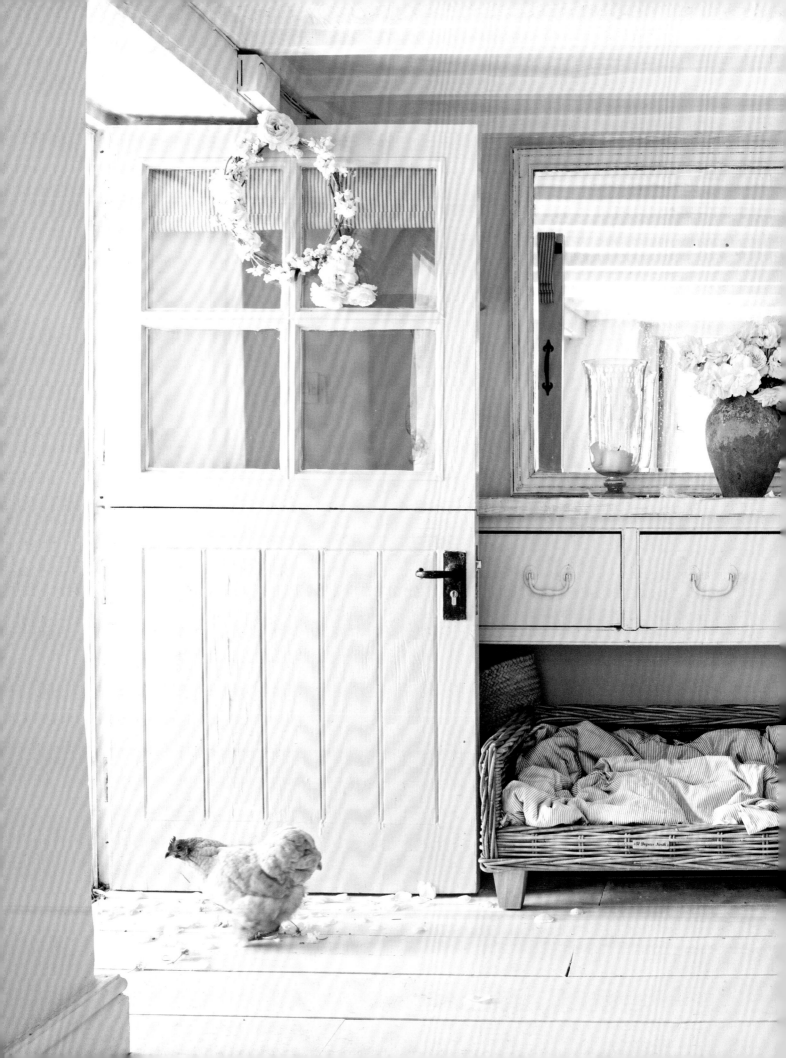

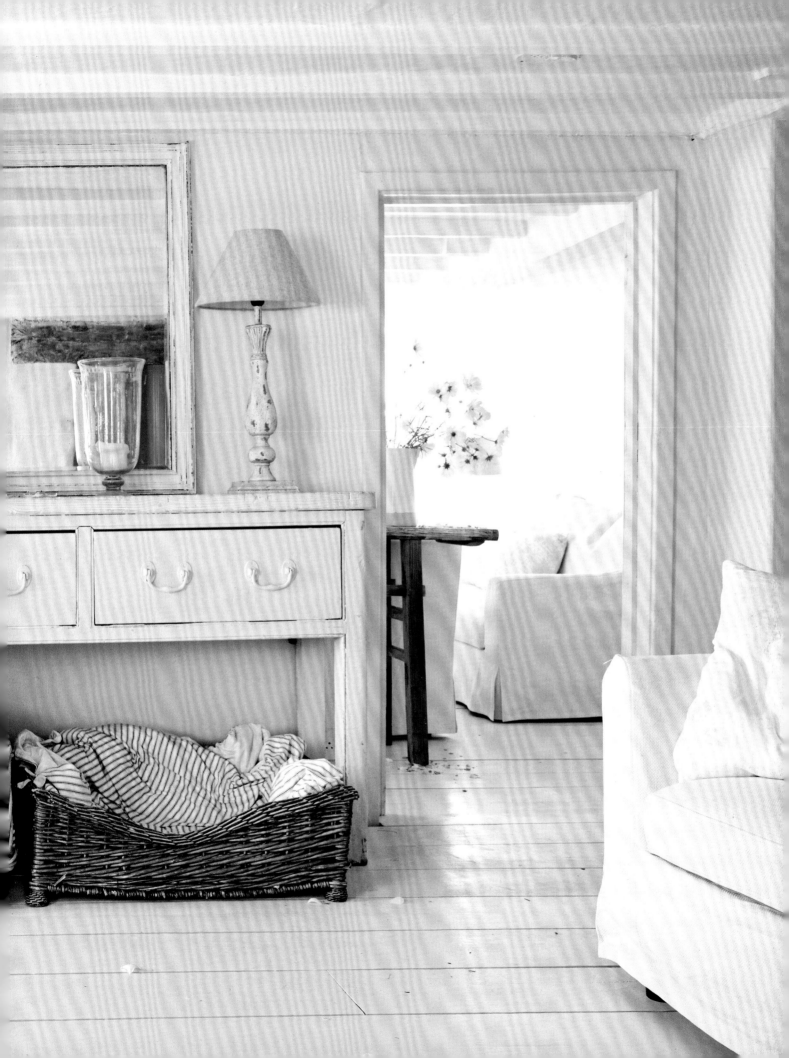

PREVIOUS PAGES I gave a chuckle watching a chicken walking through a scattering of petals on its way out of the front door. Tucked under the dresser are beds for the dogs, George and Harvey. The white-painted surfaces take on different hues as the light moves around, and all-white flowers add texture and beauty. I quickly made the wreath on the door with some wire and fresh flowers— wreaths can be a bit over-the-top romantic, but this one is saved by its imperfections, largely due to my lack of skill. **ABOVE** I love the juxtaposition of the crusty, tough stone with the soft, flaky petals of Fragrant Memories David Austin roses. **RIGHT** A view through to the sitting room. The flowers look structured but sans foam or wire, just a gravity-defying bunch of mixed David Austin garden roses, and Queen Anne's lace. I do like to strip away any intruding green from flowers, giving the blooms the starring role. See page 232 for bouquet breakdown.

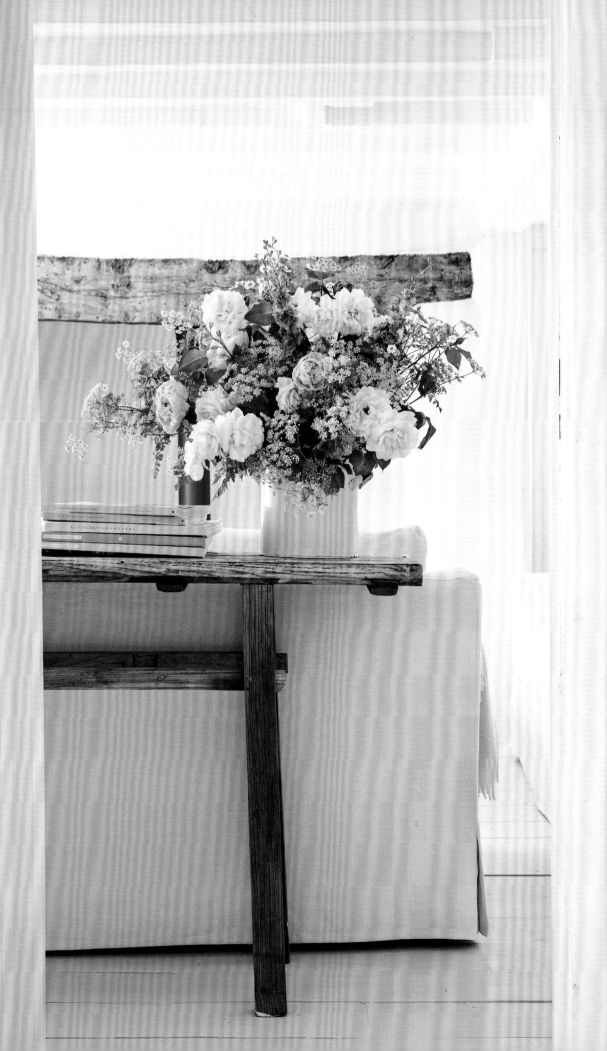

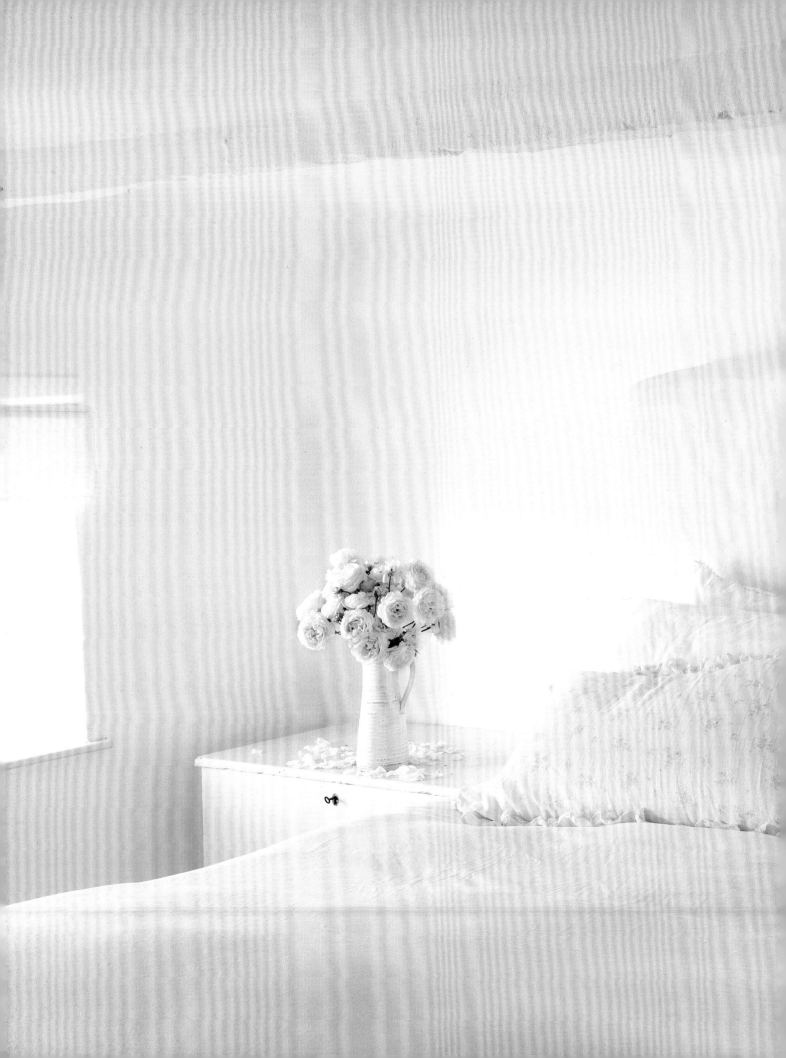

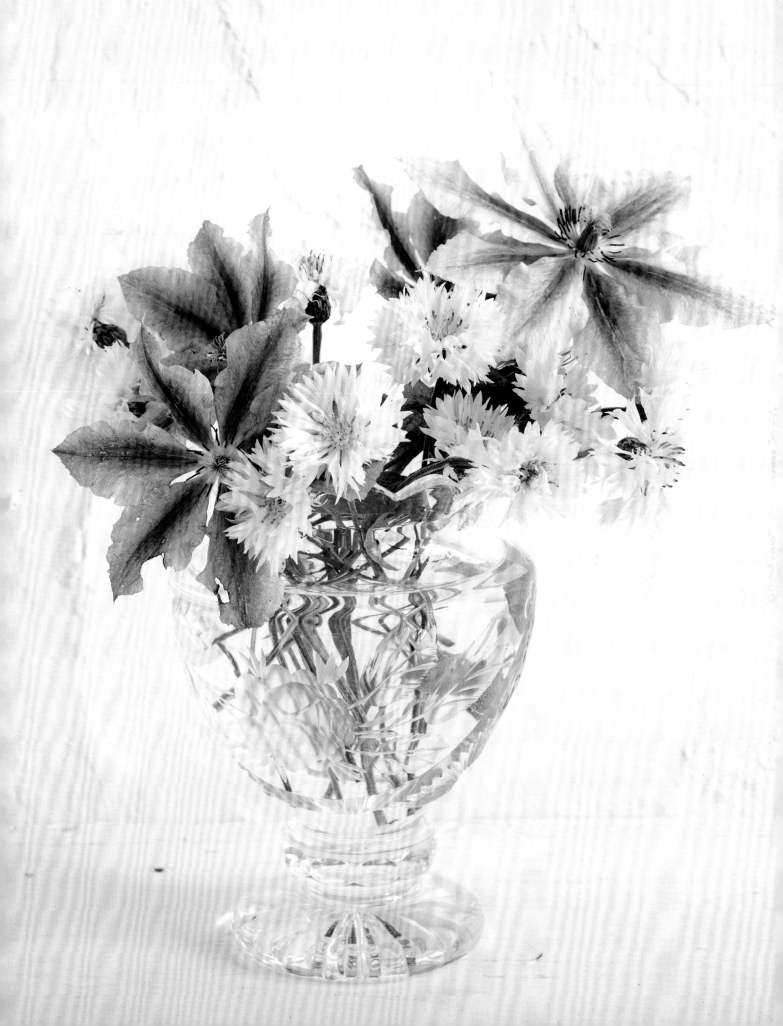

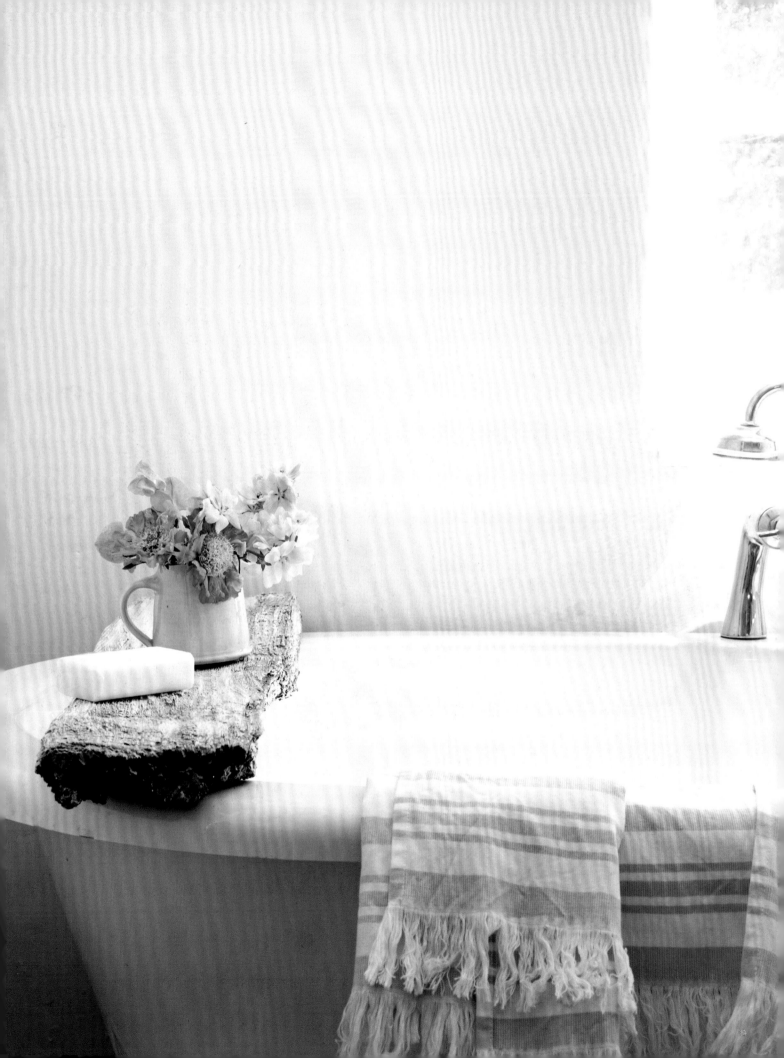

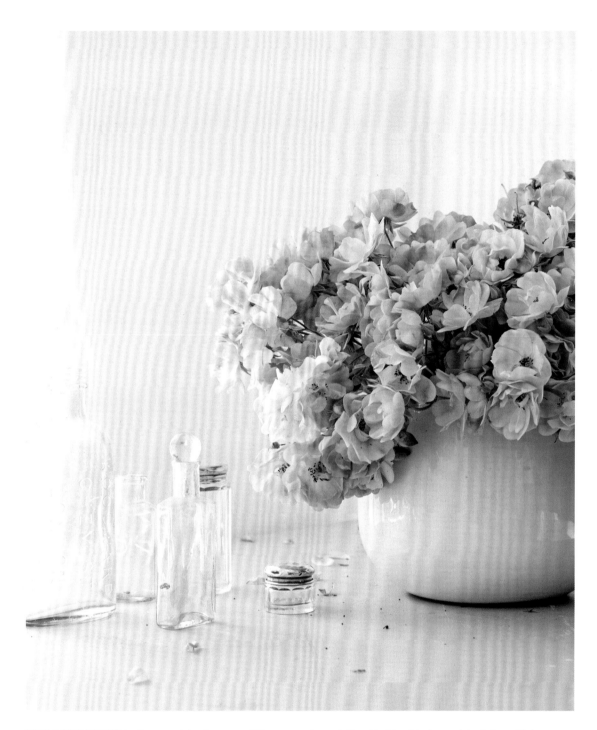

PREVIOUS PAGES In the guest bedroom, a little moment captured: clematis and cornflowers in an elegant crystal vase. The wonky walls are the star attraction. **PRECEDING PAGES** Another lucky guest room is so simple, but so full of character. It is made all the more heavenly by the play of light thanks to the bones of the old rural architecture. The bed is positioned up against the chimney breast, with all its lovely imperfections. Tempting as it might be to hang art on the walls, it's a temptation that had to be resisted. An artful pitcher of roses and a scattering of petals is all that is required, along with my signature *Rosabelle* linen bedding. **LEFT AND ABOVE** In the bathroom, a casual pitcher of wild geraniums and scabious, and a plank of wood found on a country walk. On the washstand little touch of luxe, with silver-topped perfume bottles and Ballerina roses in profusion. **OVERLEAF** Fragrant Memories roses from David Austin.

ROSES, ROSES & ROSES

While shooting at Babington House, I remembered my friend Pearl Lowe lived nearby so I called her up, meaning to go over for a cup of tea. Instead I learnt that she had recently moved, so with flowers in hand we arrived for a spontaneous shoot at her new home. Pearl retreated from the hectic London music scene about twelve years ago, to spend more time with her children and return to her first love, fashion design. She has created a full and committed life in the countryside running her textile and children's fashion business from the home she shares with her musician husband and three children, with welcome visits from her eldest daughter, Daisy Lowe.

Pearl and family moved into this new house—it has eleven bedrooms, just to give you some idea of the size of the project—only eight weeks before these photographs were taken. But then Pearl is a genius when it comes to interiors, and I've visited most of them. Just as she dresses in elegant, feminine, and totally individual floral frocks, her interiors reflect the way she is. There's a definite Pearl palette, bolder and more subdued than mine, that veers sometimes toward dark colors and even black, which somehow in her world still feels romantic to me. Added to the effortless faded elegance she brings to every interior and her make do, mend, and recycle ethos, she creates a fairytale ambiance that is subtly theatrical and never over-dramatic.

Her design credentials began with sourcing and overdying lace curtain panels, which led inevitably to lace dresses and a successful high-street collaboration. Now, she's turned her creativity toward homewares and her unique line of children's clothing—a fantasy of Pierrots, trapeze artists, harlequins, bats, glitter, and magic wands.

In her short tenure of the house, she's stamped her personality on it. All eleven bedrooms have some kind of furnishing and her signature touches of love. Armoires and cupboards overflow with fabrics: napkins, lace, and floral eiderdowns, she's not a crisp white duvet sort of girl. And little moments of floral décor show up over and over, in a non frou-frou way, a perfect match for my floral affair.

RIGHT In an attic bedroom, a romantic carved bedstead with faded floral upholstery and a full-blown eiderdown, to me an eyeful of loveliness.

OVERLEAF In one of the spare bedrooms are things I recognize from Pearl's previous house. The curtains are one of them. Too short for the grander proportions of the new house, they were extended with an altogether different striped fabric. Lace panels, of course, abound, and the pink-and-white, not-too-pretty floral wallpaper that touches the exact chord, is from Nicholas Herbert. Deep red, fully bloomed peonies complement a Victorian pitcher, adding significant touches of color.

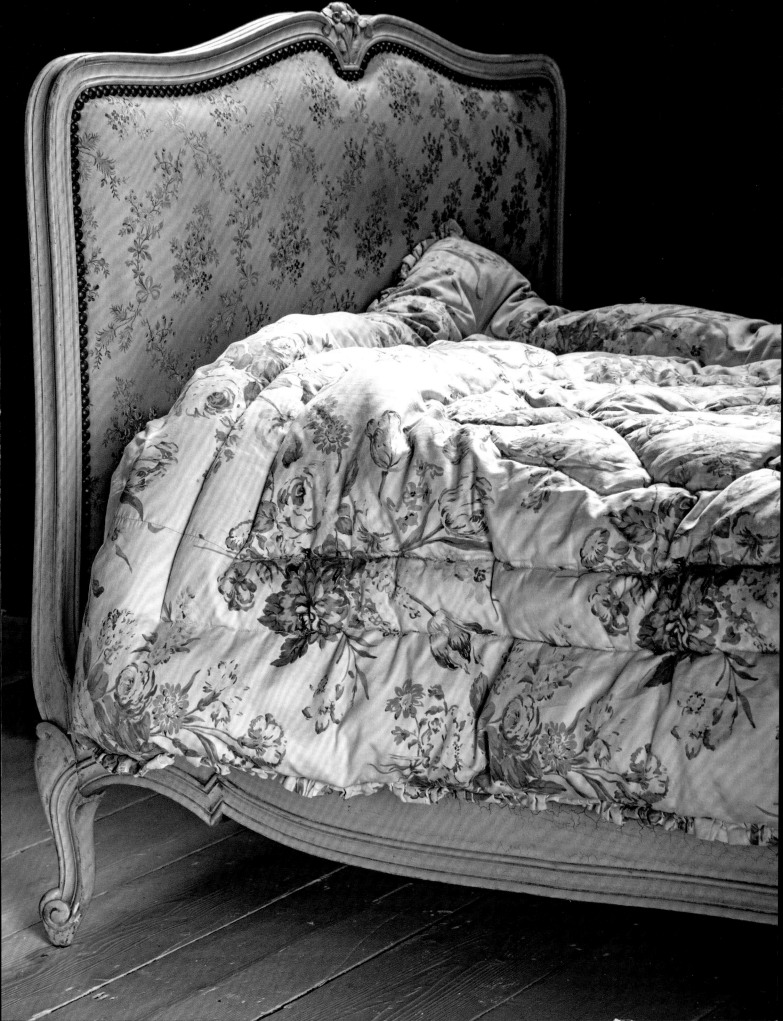

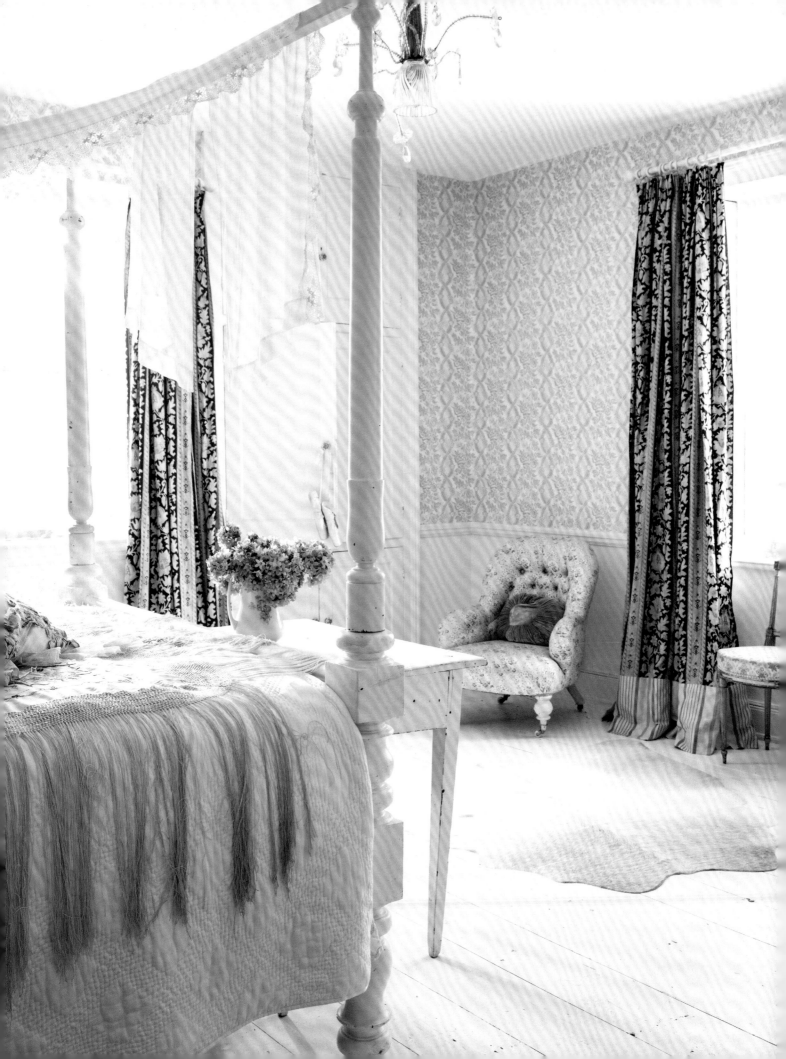

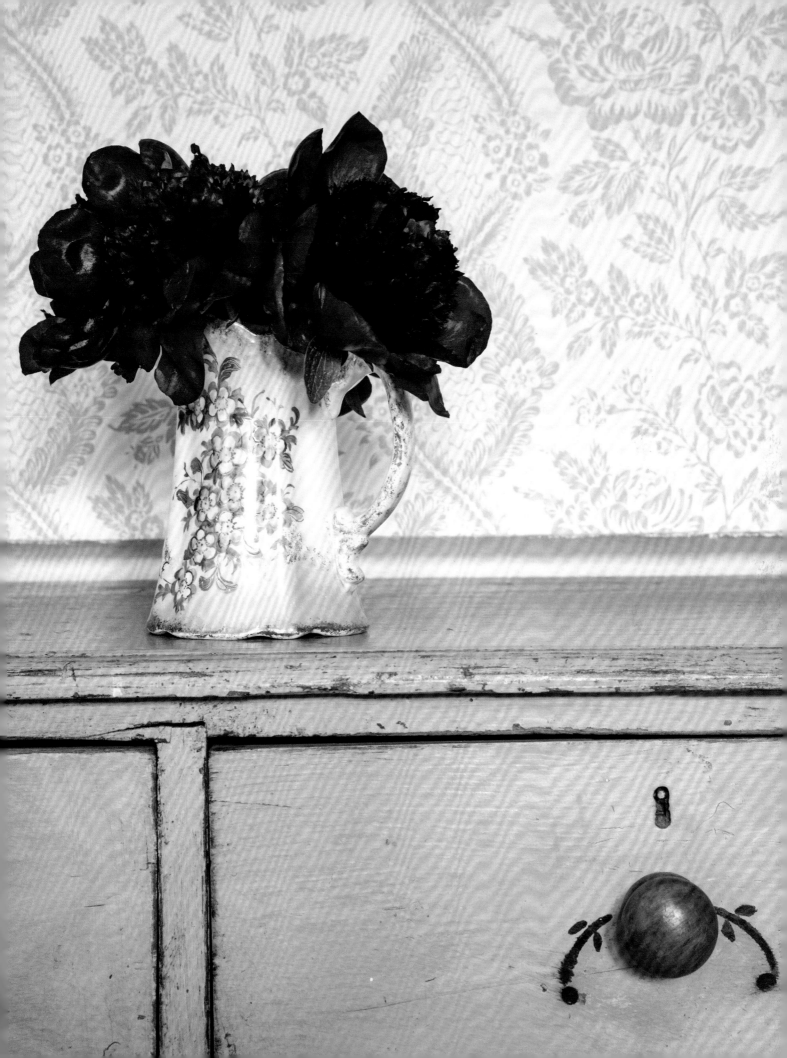

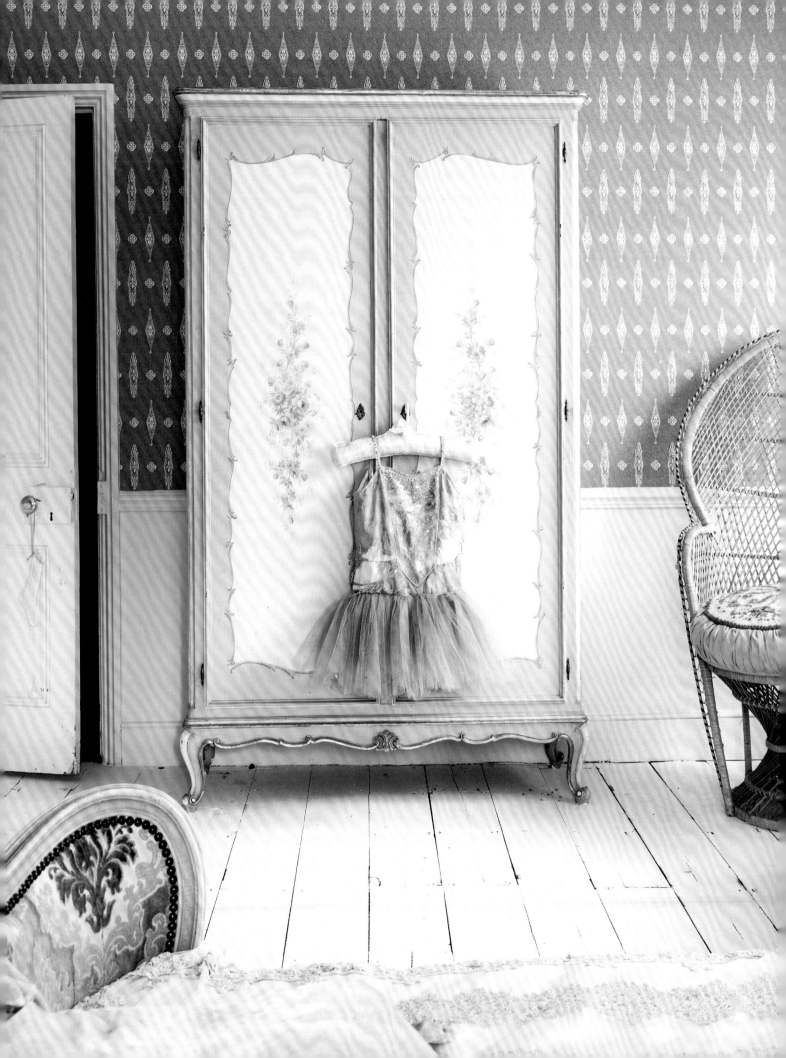

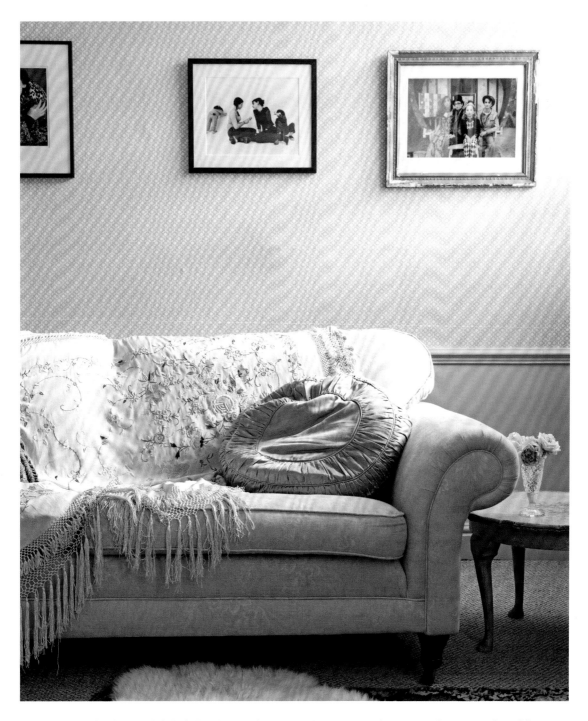

LEFT A child's bedroom, delightfully whimsical. The wallpapers in both these rooms are by Robert Kime. 1940s in their inspiration, busy but restrained, they do a good job of counterbalancing the frills.
ABOVE A dusky pink sofa draped with bohemian silky shawls and a floppy pillow with just the right degree of mush is a nice balance of boho and romance. Family photographs are displayed in an eclectic variety of frames, an interesting way to give photos some status. A quiet bunch of roses complements the embroidered shawls.

OVERLEAF Like me, Pearl is a great fan of flea markets and antique fairs where you can pick up some wonderful scraps of this and that, and with patience, they eventually find a place in your life— like this piece of wonderful silk embroidery and the characterful tattered cushion cover made of net with appliqué flowers cut from pieces of chintz. Pearl takes her treasures with her from house to house; the blinds are made from curtains from her previous home. Fading roses in the candle holder are tucked into a little glass vase.

ABOVE An edgy floral letterholder from her husband Danny's office, against a wall painted in Mizzle from Farrow & Ball. The black cancels the sweetness and is an example of romance in black. **RIGHT** A table for family time. Whenever possible, the family eat together in the evenings, and the children are much involved in setting the table and clearing dishes. The over-the-top crystal candelabra was a flea-market find. Bedecked with flowers, it lost its grandeur to whimsy. **OVERLEAF** In the living room, the sofa is a mush of brown velvet made all the more surprising with improbably pale pink floral seat covers, and a scattering of unrelated cushions. The restrained background of Robert Kime wallpaper and Mizzle paint from Farrow & Ball make this a room for grown-ups. In another context the prism chandelier with little porcelain flowers would be overly sugary, but in this boho setting it takes a back seat.

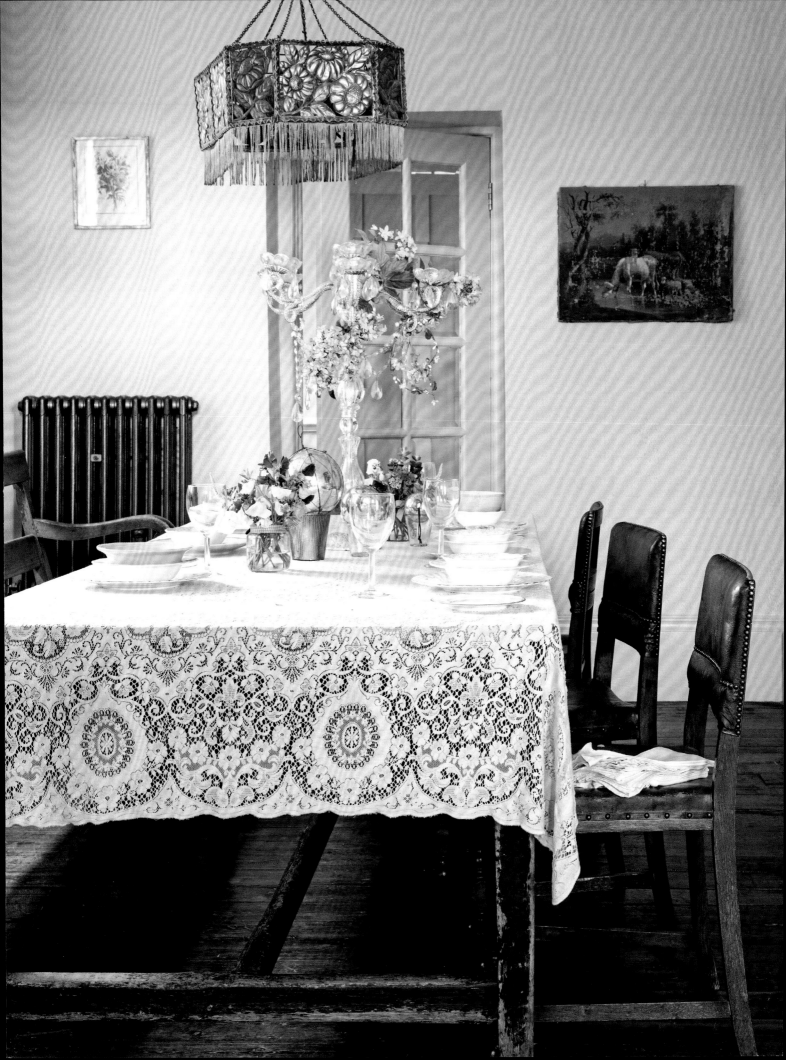

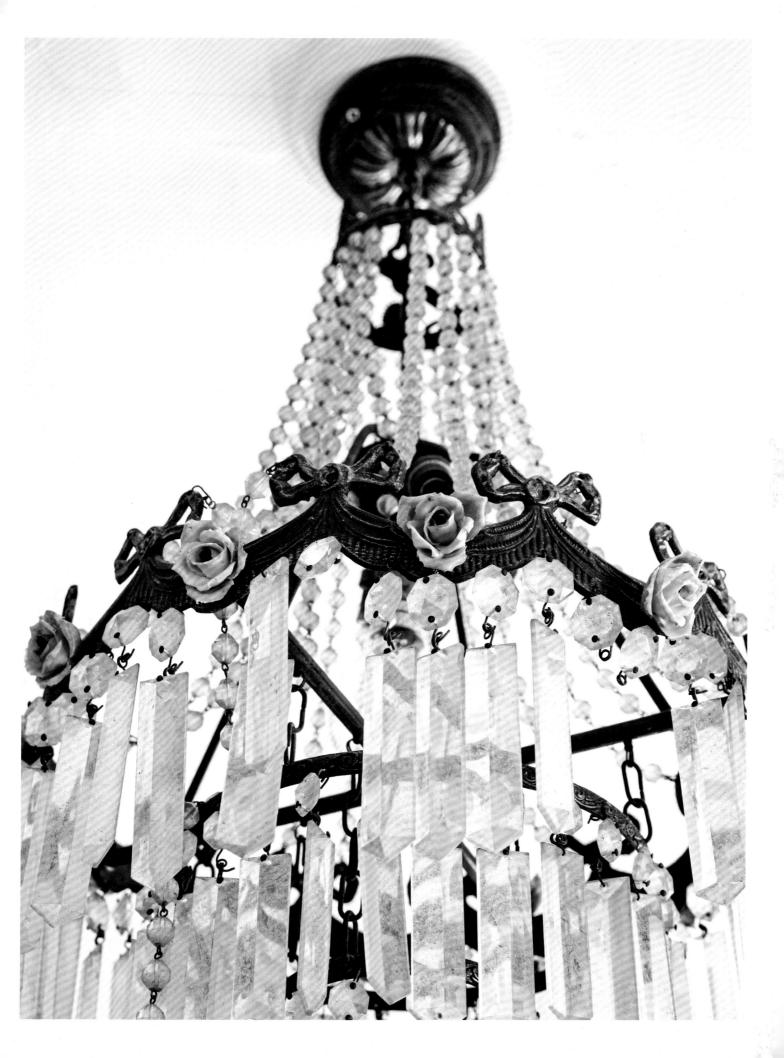

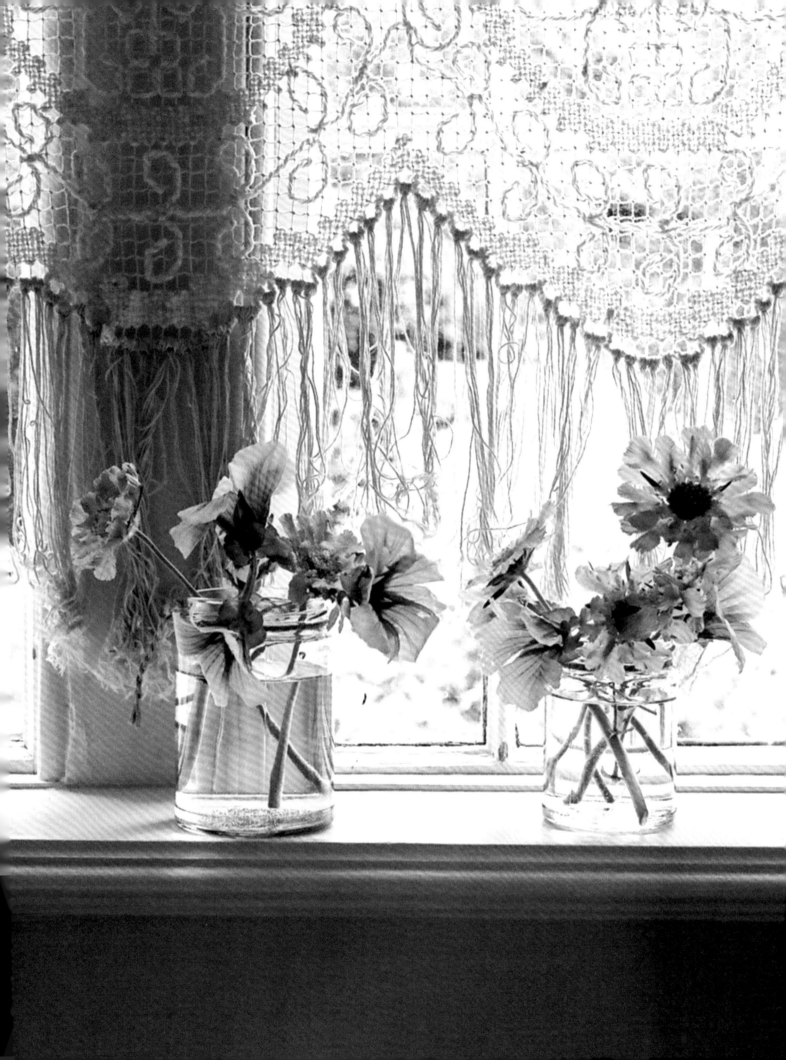

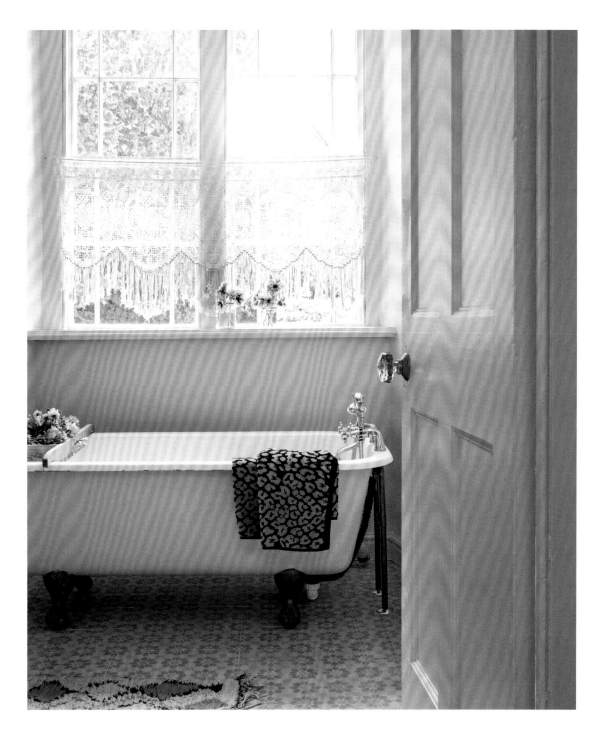

LEFT AND ABOVE There are some wonderful floral touches in this bathroom apart from the faded red hibiscus and scabious flowers in jam jars on the windowsill and bath rack. A quiet wow of a pink glass doorknob and floor tiles from Fired Earth add a restrained stylized touch. All eyes, of course, are drawn to the amazing crochet café curtain from Pearl's own textile collection. The walls are painted in Green Ground by Farrow & Ball.
OVERLEAF Another attic bedroom. This one is ready to receive guests: generous pillows all plumped and frilled and a lovely antique patchwork quilt, made from an eclectic mix of floral fabric scraps. A little rag rug adds a touch of comfort to the bare white floorboards, while the walls are painted in Farrow & Ball's French Gray.

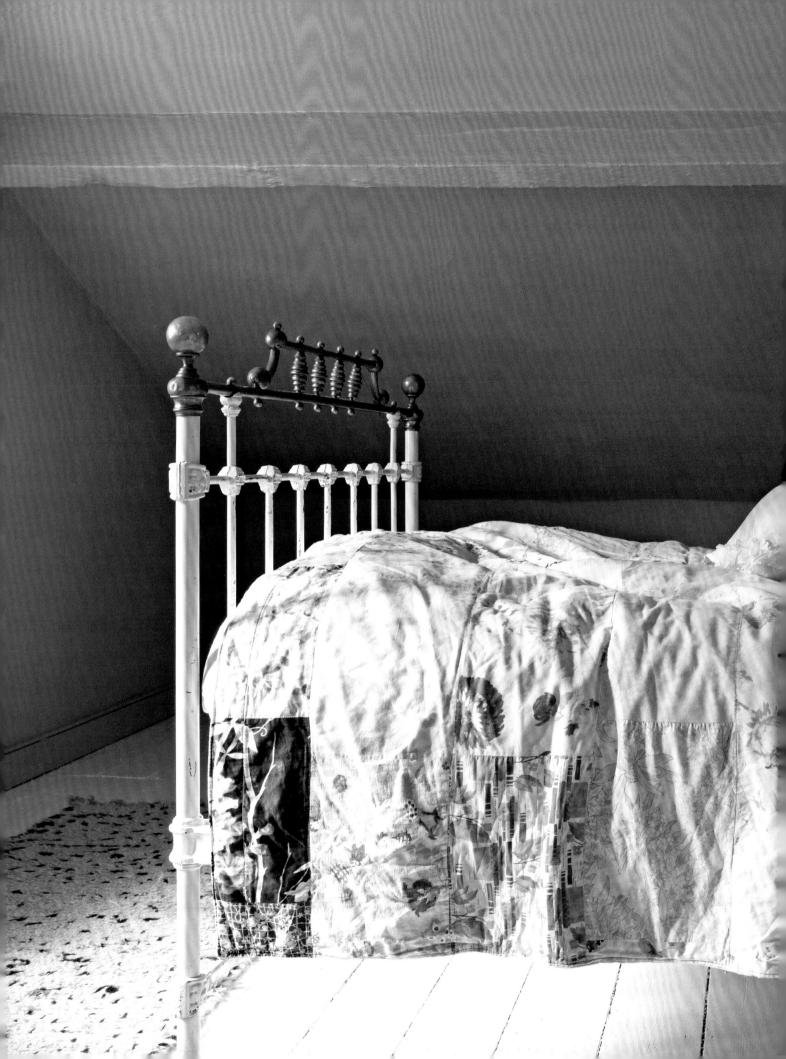

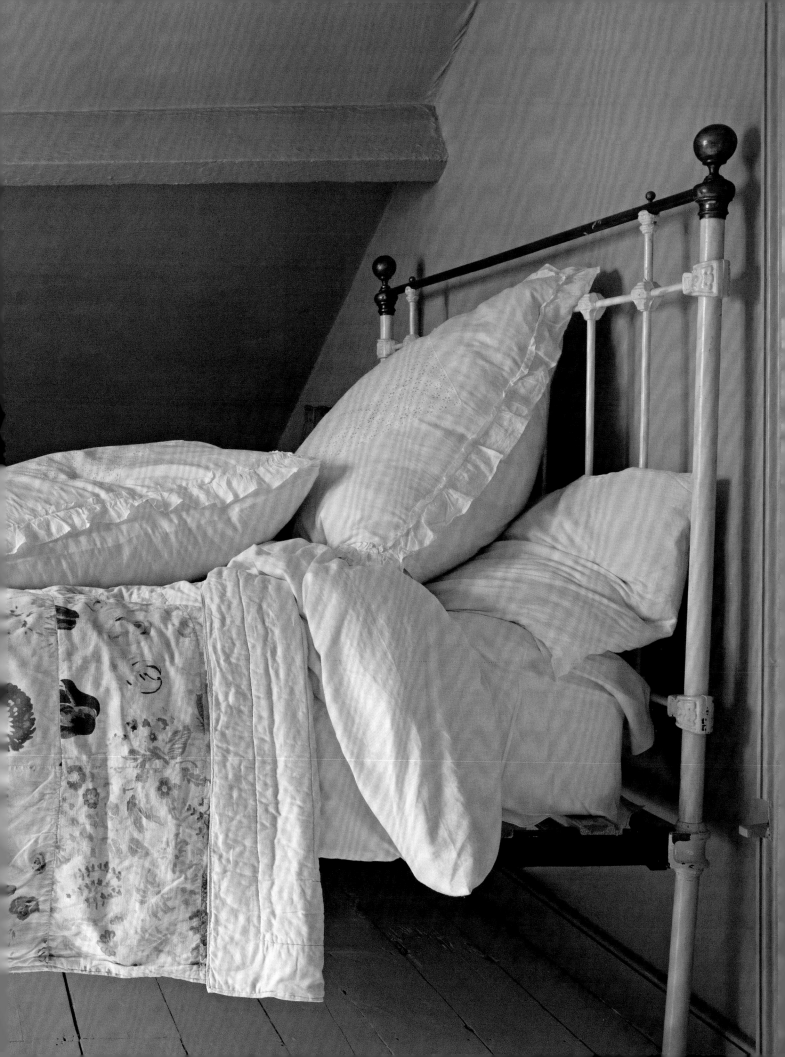

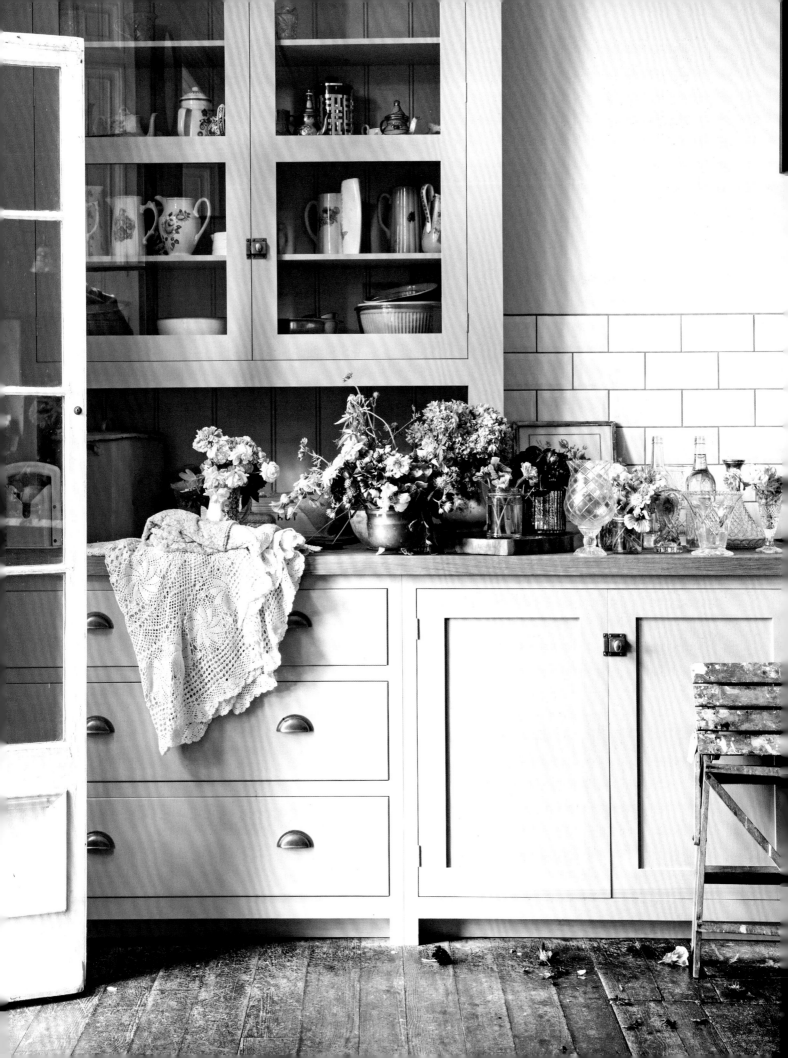

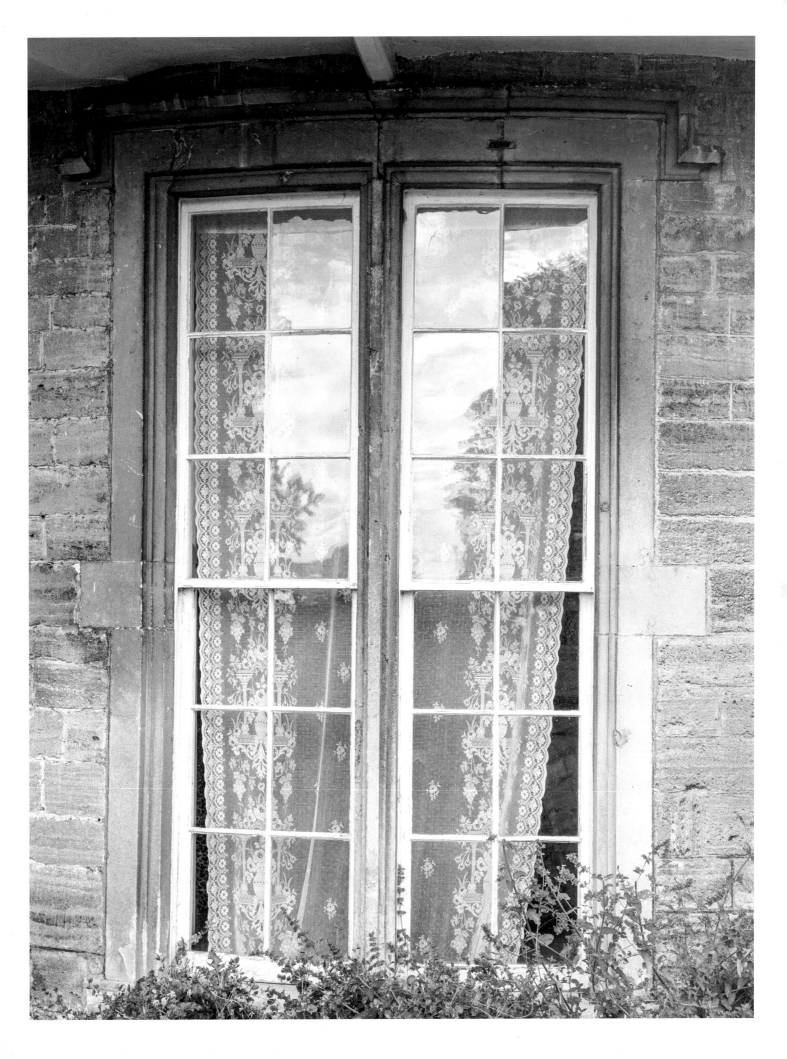

PREVIOUS PAGES For all the attraction of wonky floorboards, ancient plumbing, and making do, the one area Pearl insists on being totally functional is the kitchen. I used the worktop as a staging post for floral offerings. The units, which are bespoke, were made to Pearl's specifications by deVOL Kitchens. A view from outside celebrates privacy thanks to one of Pearl's fabulous lace panels.

ABOVE Dogwood roses reaching a beautiful end to their lives. **RIGHT** This gypsy caravan goes everywhere with Pearl. If only it could talk—the stories it could tell and roads it must have traveled! In their previous home, this was a playhouse for the children. Now it is parked, with all its gypsy floral prettiness, at the far end of the property, waiting for a new purpose.

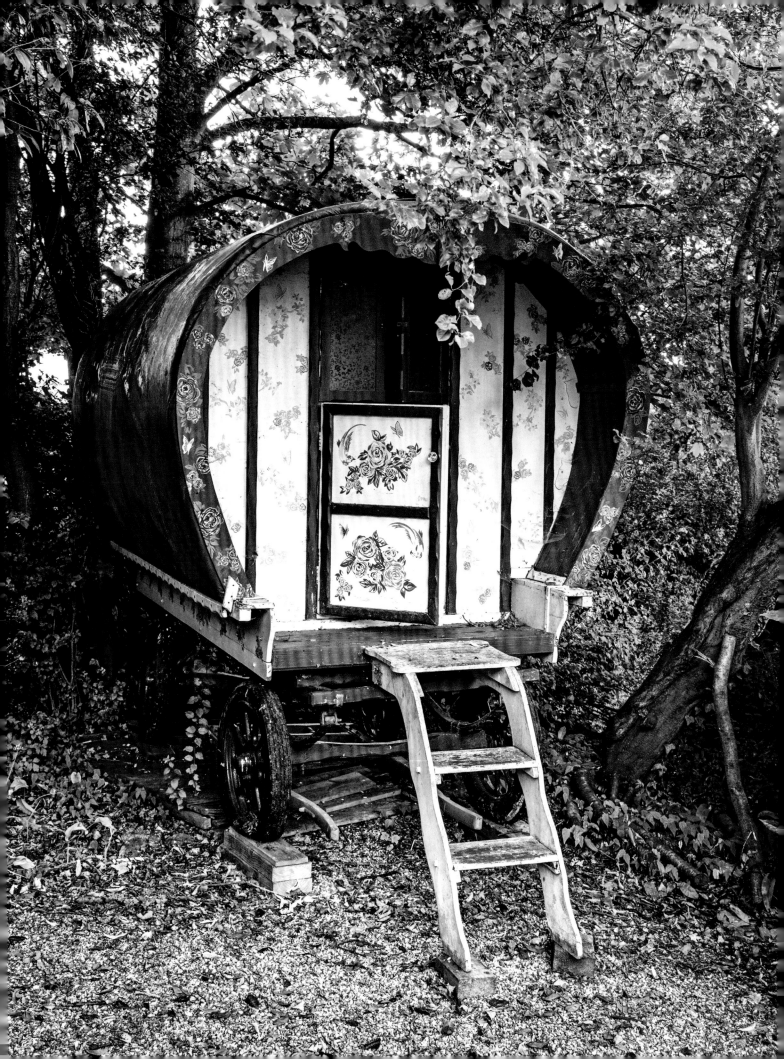

GORGEOUS GARDEN FLOWERS

When you start talking about flowers to flower people, names and connections spring up, and in this case it was the name of an Oxfordshire couple, Daniel, a television commercials director and a childhood friend of mine, and Judith, his wife. Judith has devoted herself to an English country-house garden that is just spectacular. It ticks every box for me about what an English garden should be: color-coordinated planting beds, a cut-flower garden meandering as far as the eye can see, nature controlled but in such a way that, while aware of the underlying structure and logic, what you see looks gloriously haphazard. It is a garden very respectful of nature, with clever planting and mulching that eliminate the need for chemicals and a thriving community of bees, that on the day I was there were busily going about their business making honey.

Judith, a former designer and now full-time head gardener, knows and cares for every seedling, every bush, plant, tree, and blade of grass in this extensive garden—with help, of course—but the whole enterprise is very much her vision. Whatever the size, a country home interior isn't complete without the accent of flowers, and Judith used to do all the floral arrangements herself until along came Magdalena Juszczyk-Pindel, who over time became a protégée of Judith's floral designs and lives in a cottage on the property. Now Judith concentrates on growing the flowers that Magda takes responsibility and great pride in arranging. The house is often full of family and friends who all take an interest in the beautiful surroundings, and the forever-changing glorious displays. As grand as the house and property is, I love how the arrangements of flowers are substantial but natural, considered but not contrived. As with all well-planned enterprises, there has to be a routine and a well-equipped place to work. Due to the huge amount of floral arranging, there is a dedicated potting shed where vases are stored, cut flowers assembled, and magical whimsy is created for the coming week's displays.

I left this glorious garden humbled and inspired. Watching the knowledge that Judy has taken the time to learn, along with the appreciation she has for every living plant and flower, it was clear to me that her passion is enjoyed on a profound level due to her personal efforts. Her hands work the soil and it fills her heart.

RIGHT A little pop of poppies, roses, and sweet peas destined for the kitchen table, with appropriate culinary touches of mint and rosemary.

OVERLEAF Views of the potting shed with work in progress and potted up honey. Mesh screens protect Judith and Magda from bees and bugs buzzing in to check on progress. The raw materials in the green bucket are wildflowers including yarrow, sage, fennel, valerian, bladder campion, verbena, masterwort, and giant bellflowers. The greenery is hornbeam and feather reed grass.

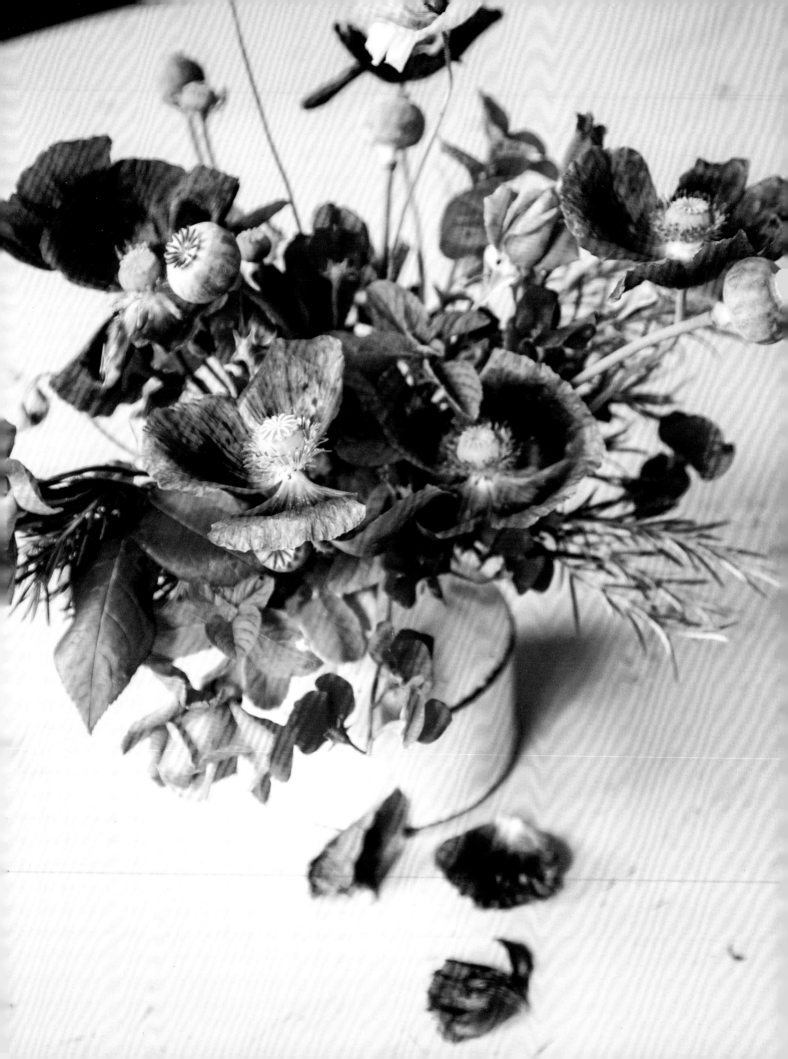

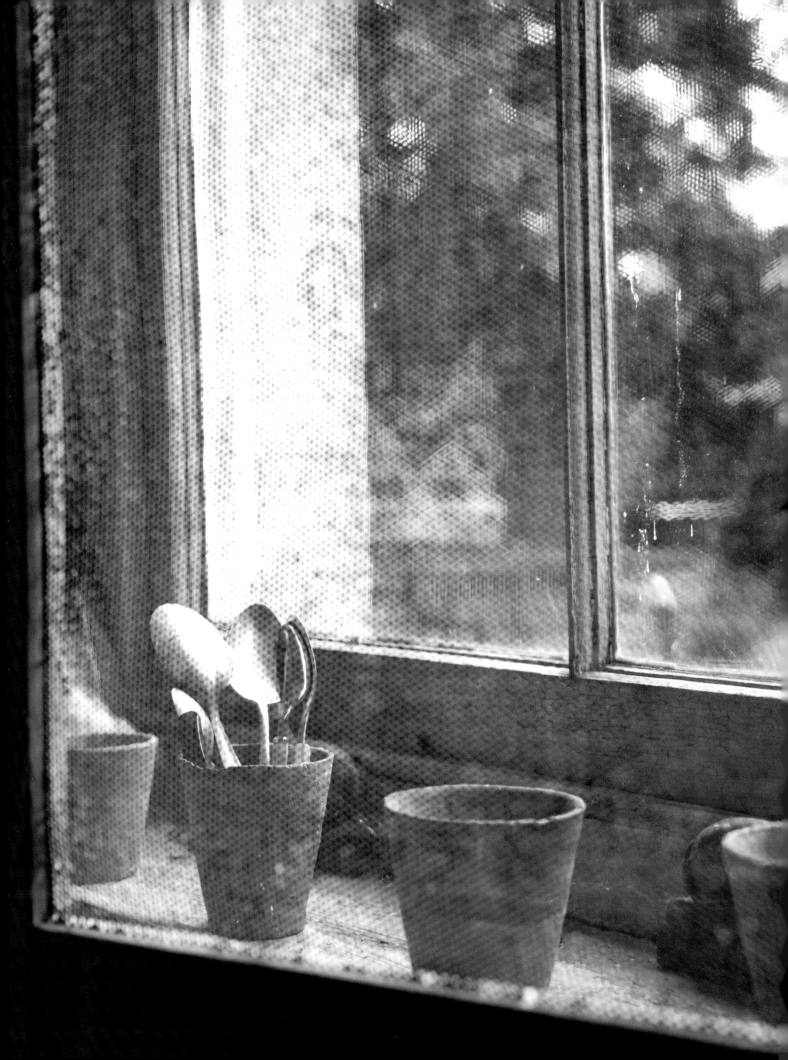

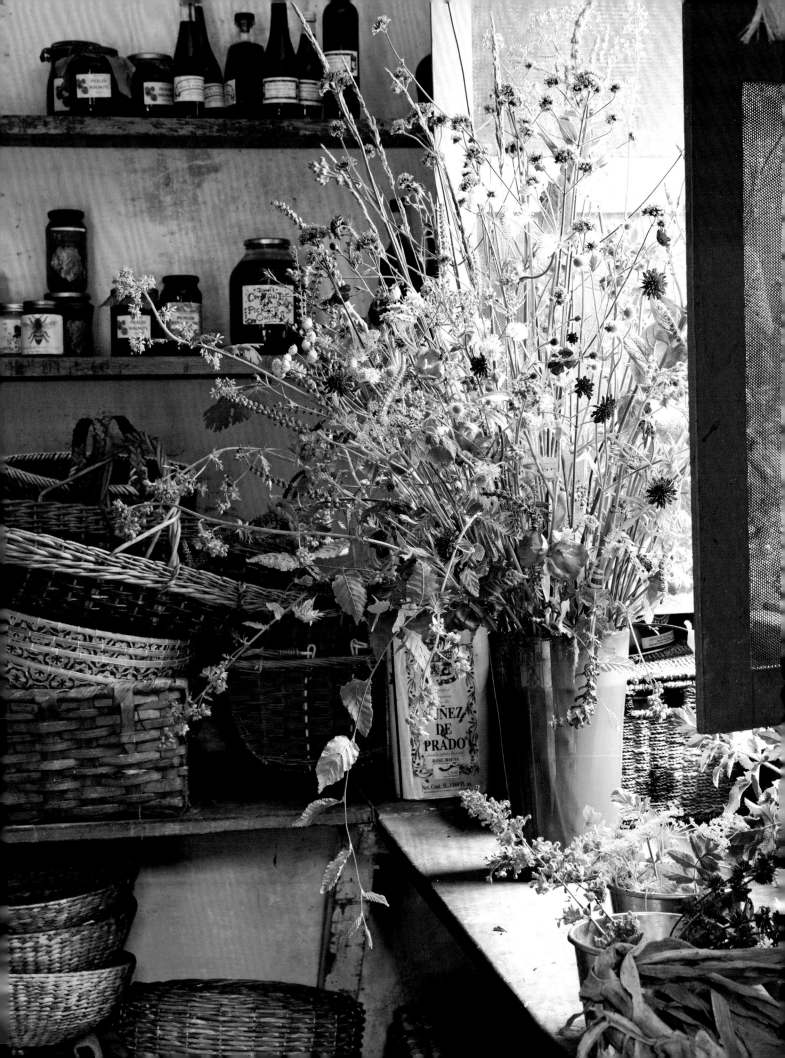

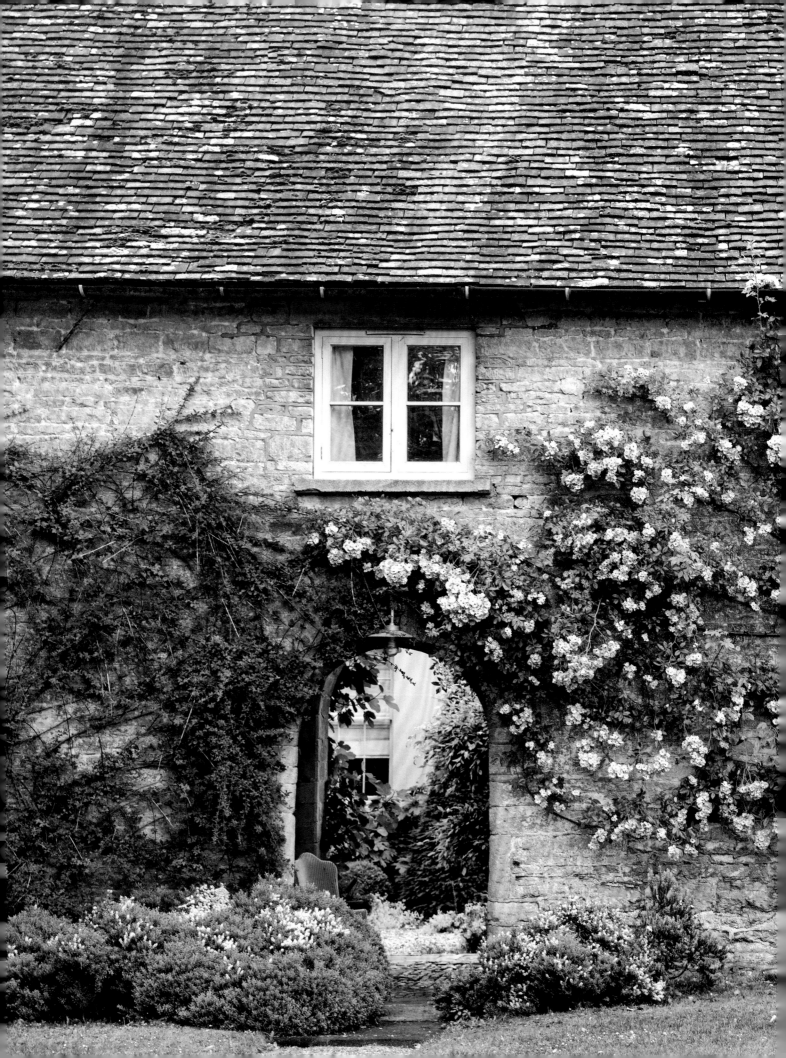

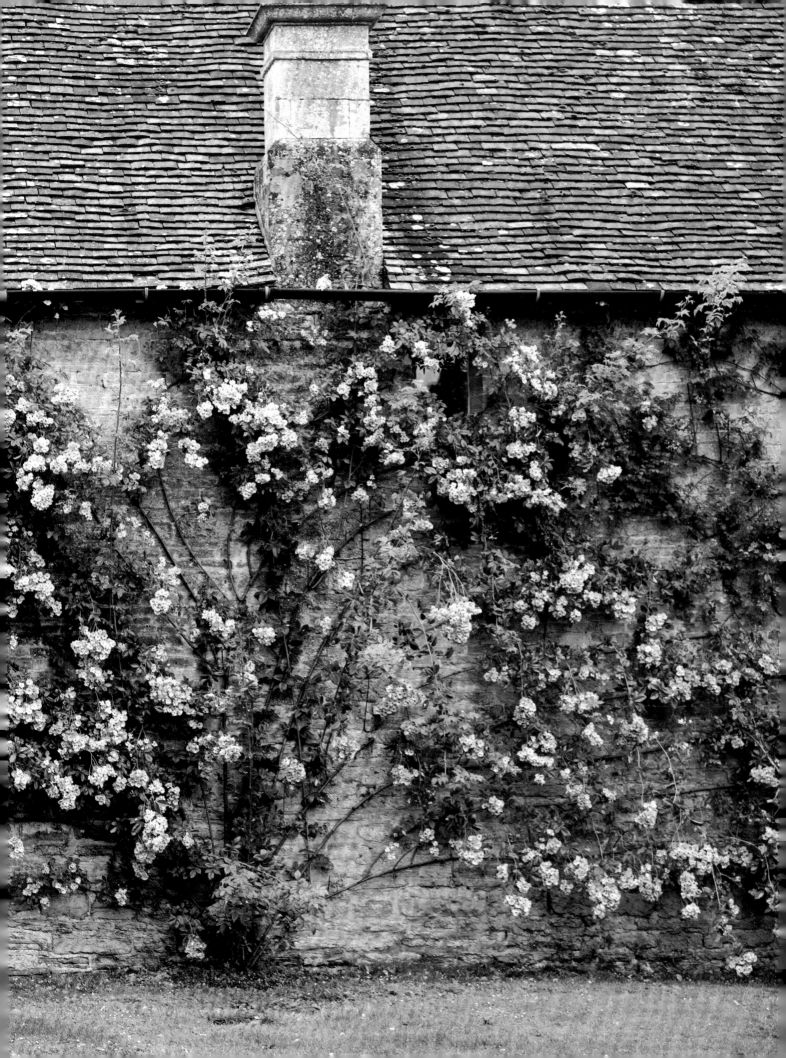

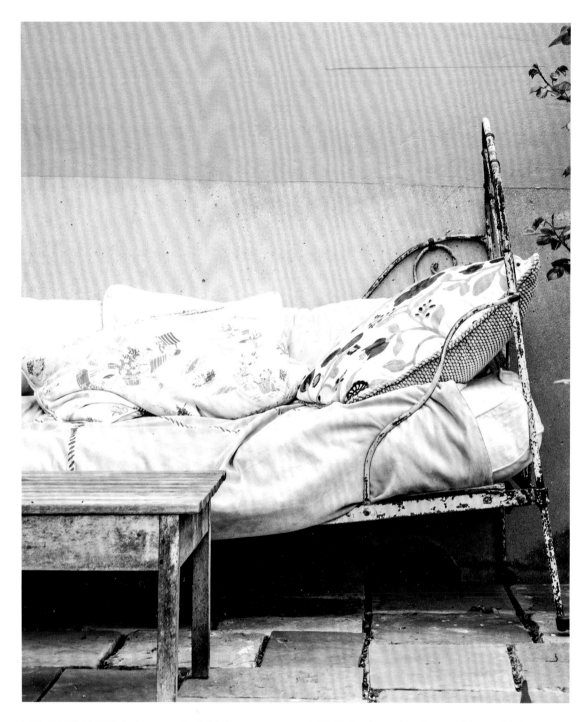

PREVIOUS PAGES As I approached this house up the long gravel drive at journey's end, it felt like a storybook finale. Old mellow stones, mossy tiles, an espaliered David Austin Ballerina climbing rose, and clouds of beautiful planting. The house is beautifully maintained without tipping over into overly-polished perfection. Judith kept apologizing for the cold misty rain in July, but to me it was heaven.

ABOVE Gardeners' resting spot in an old stone-flagged outhouse. An antique French iron daybed with rather precarious legs takes the strain. Pretty floral cushions mush up a bit of comfort. **RIGHT** Against the rich patina of well-worn paintwork and stone cobbles, a zinc bucket of wild meadowsweet, sweet peas, dusky spikes of wood sage, and mountain cornflowers await their destiny.

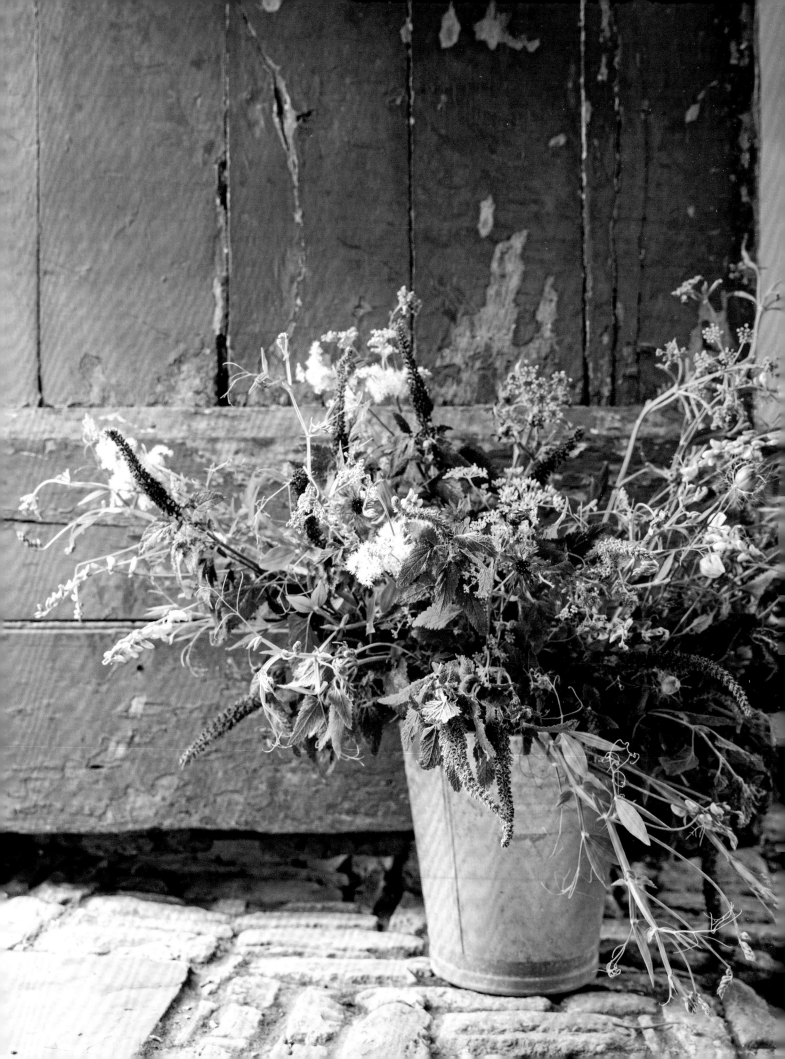

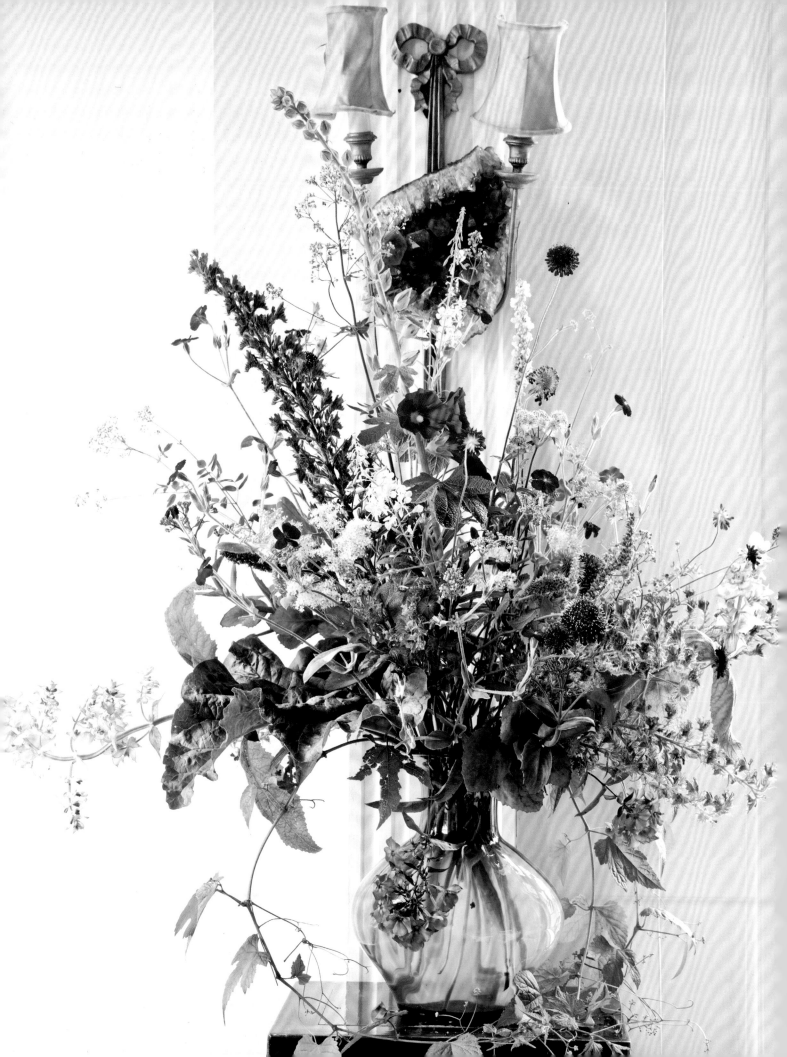

PREVIOUS PAGES One of the copious cutting beds is a tapestry of color, this one favoring the purple and white of allium, wild feverfew, and nepeta with stipa grass dancing in between. **LEFT AND ABOVE** The finished bouquet with a natural, wild sweep sits proudly in the glamorous setting. The formality of the décor is delightfully undermined here with the raw purple crystal balanced in the wall sconce. Flowers and foliage include meadowsweet, wild fennel, viper's bugloss, clematis, hollyhocks, willowherb, rose campion, scabious, sage, phlox, and lamb's ear. **OVERLEAF** Petal remains of the day.

A WELSH TREASURE

A life in flowers offers many different paths. Lucy Hunter said goodbye to London and found herself a treasure of a home in the beautiful green folds of the Vale of Clwyd in North Wales. Wydene was originally built in 1830 as a billiard hall for a grand manor house, long since demolished. When she found the building and the overgrown garden, it had been empty and crumbling for twenty years. Determined to turn it into a home, Lucy kept faith with its early Victorian roots, adding an extension and a second floor. She sourced everything for the house, including the antique French cement tiles in the hall, which date from the early 1900s. It is still a work in progress, and along with all this, she's also created an award-winning landscape and garden design business.

Lucy has a real interest in sustainability, sourcing her flowers and plants from her own garden according to the seasons and from traditional growers, like Carol Siddorn, of Carol's Garden in nearby Chester, who, like Lucy, is a great champion of home-grown British flowers.

Lucy's love of flowers led her to the world of weddings and events in between her landscaping work, and this is now a flourishing part of her business. There's a nook in her home set up with backdrops and props so she can photograph her bouquets and post them on her popular Instagram stream. An inspiration for us all. Lucy shares her home with her husband, son, a Maine Coon cat called Fred, Wilson the dog, and several chickens. This was one of the locations where we were invited to stay and had yummy country meals. The house has a lovely fluid feeling, helped by the presence of massed seasonal flower displays that, while often cleverly structured with wire and foam, have the freedom to be themselves. There are no forced shapes or unnatural angles, just encouraged direction so all flowers flow gorgeously free.

On departing this treasure of a home, I spent time on the drive back to London thinking how beautifully balanced Lucy's life seemed. A quiet, quaint cottage housing a dynamic, meaningful business, while still maintaining family values and a mindful quality of life.

RIGHT The entrance to the house acts, by happenstance, as a thoroughfare and parking place for flowers and a variety of vessels coming in and going out. It is often in those fluid moments in time that a symphony of beauty transpires. And speaking of beauty, the antique *carreaux de ciment* tiles were sourced from The Antique Floor Company, based in France.

OVERLEAF The buddleia in this tin bucket look as if they've been artfully plonked, but the lovely flowing lines are entirely under Lucy's control thanks to a hidden wire grid. On the mantel, in an antique pharmacy jug, a couple of droopy Echinacea with their straggling pink tresses add a humorous touch to the Queen Anne's lace, Sweet Antike roses, and sea-lavender. Exotic as they are, these plants were all grown locally.

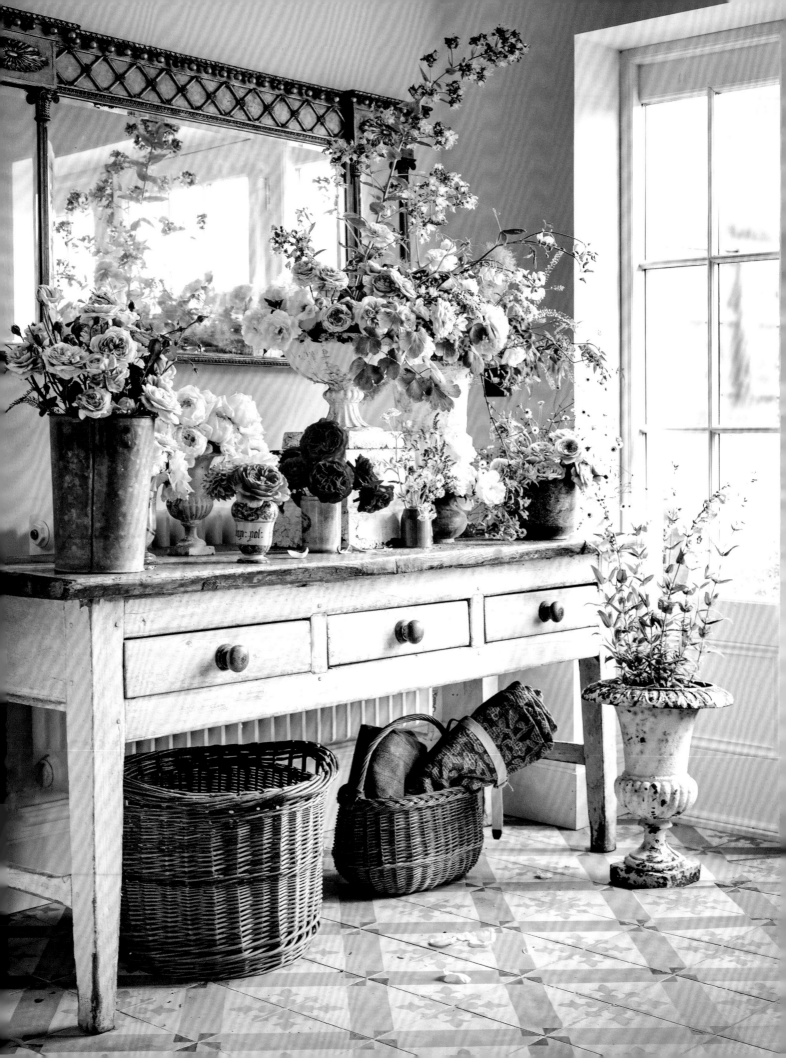

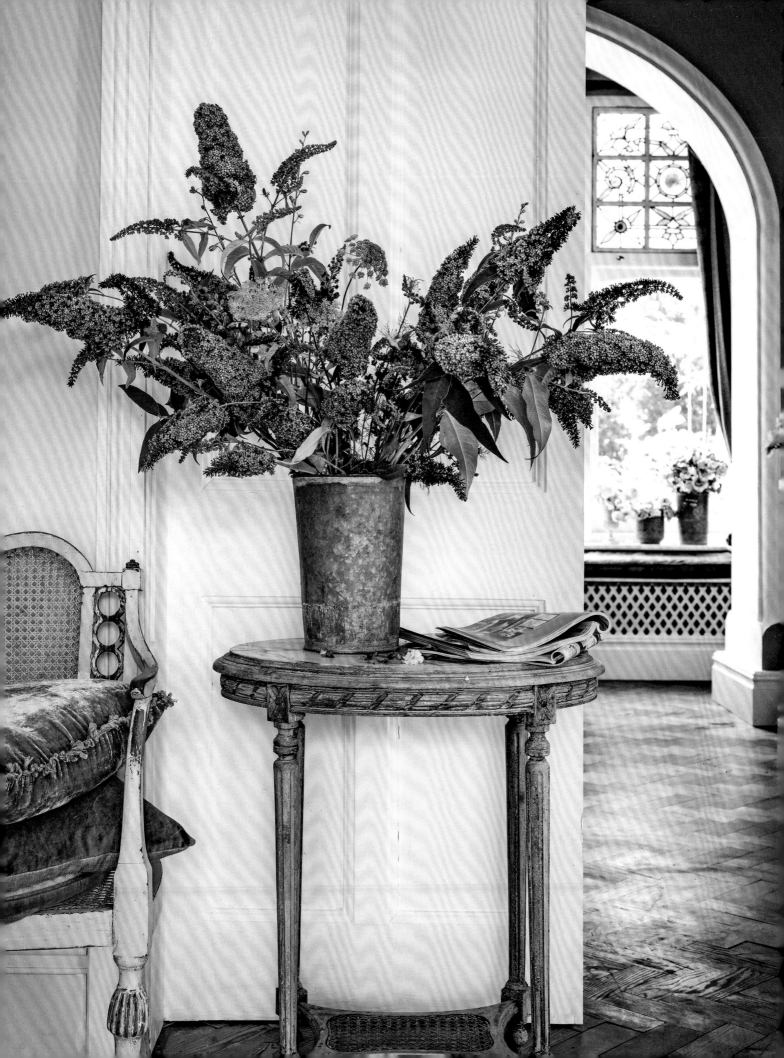

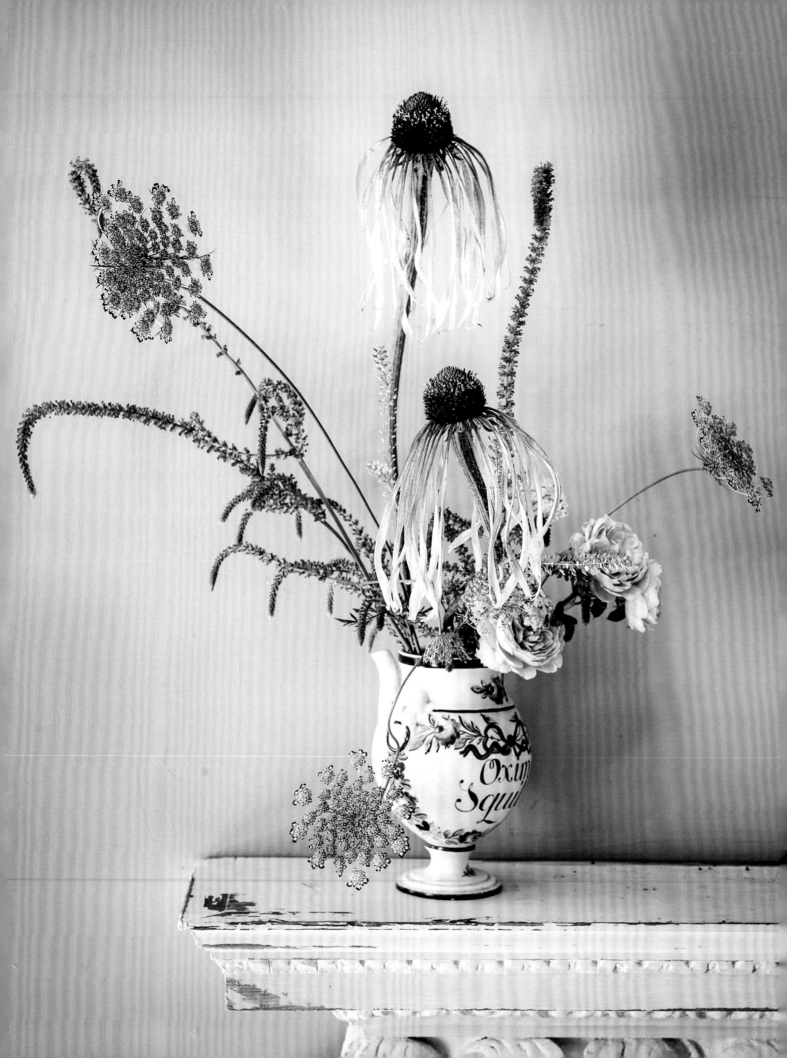

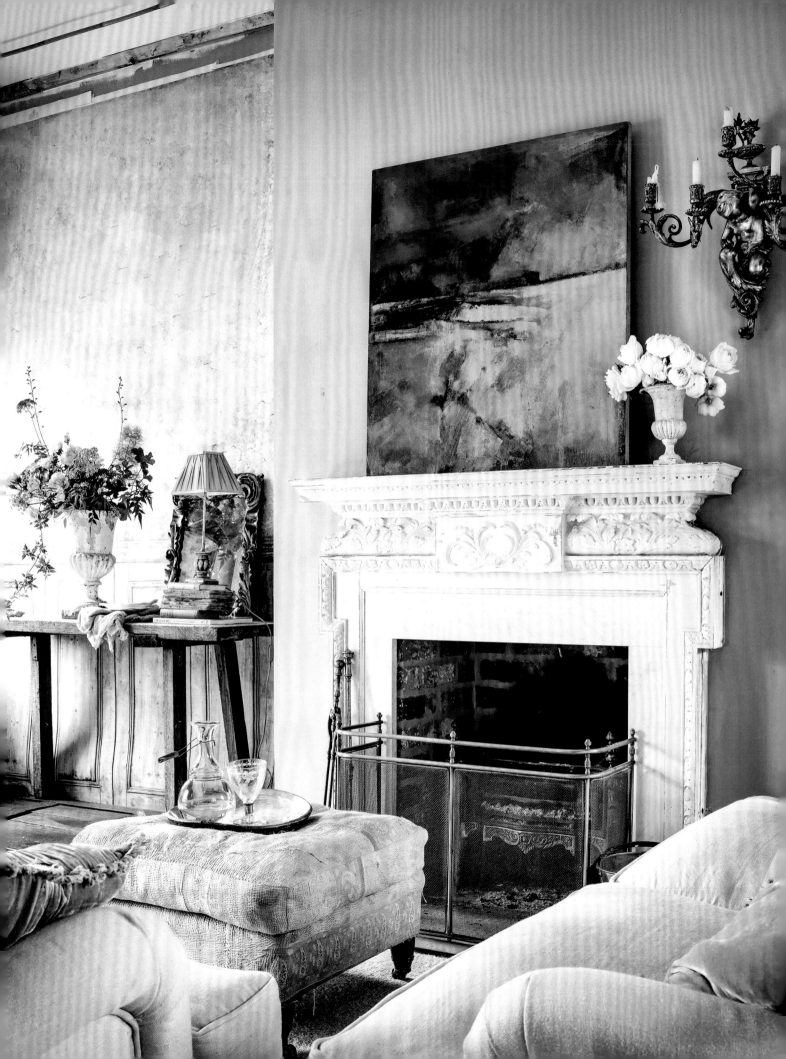

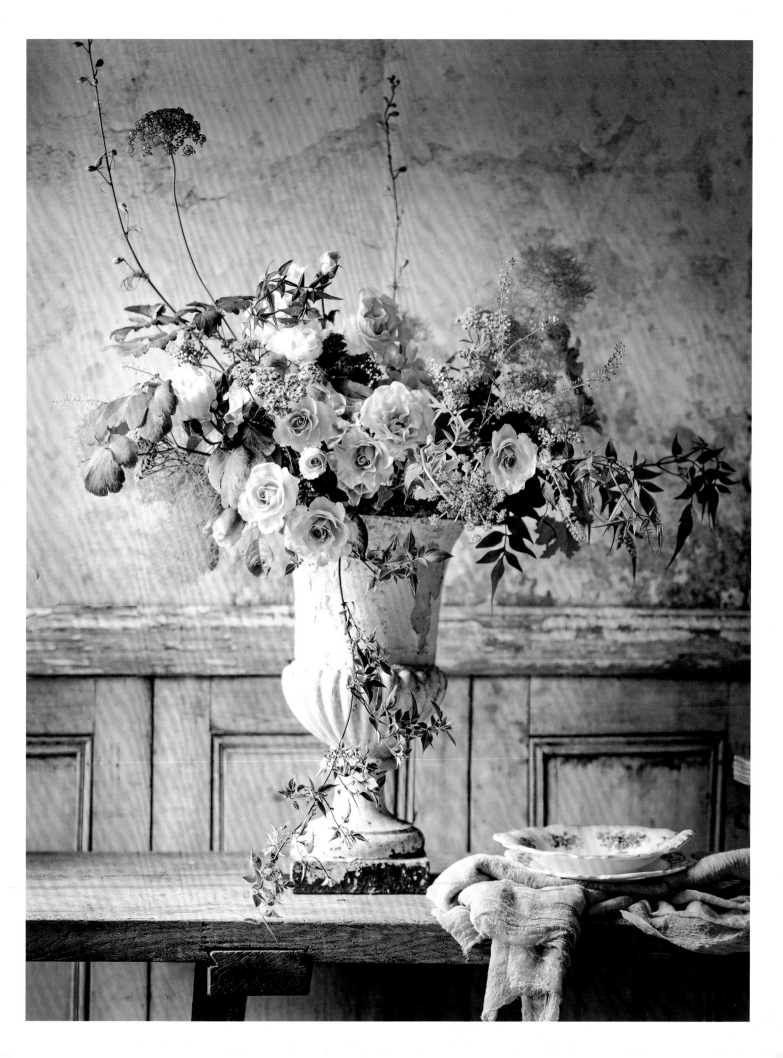

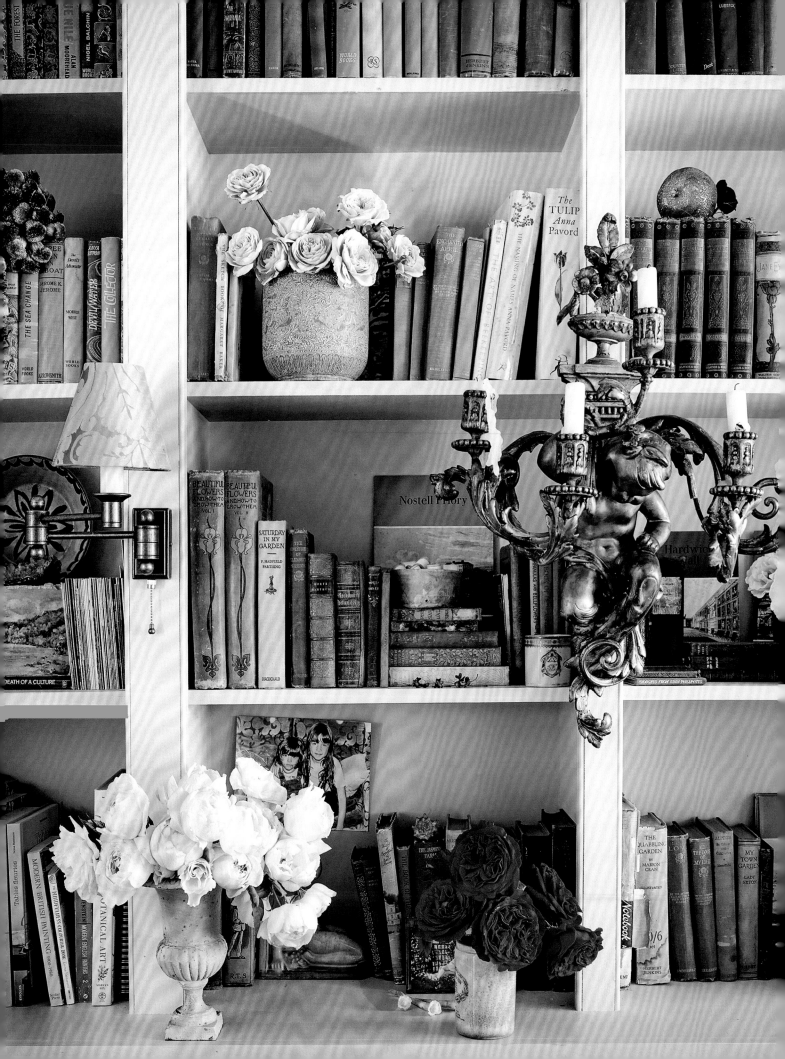

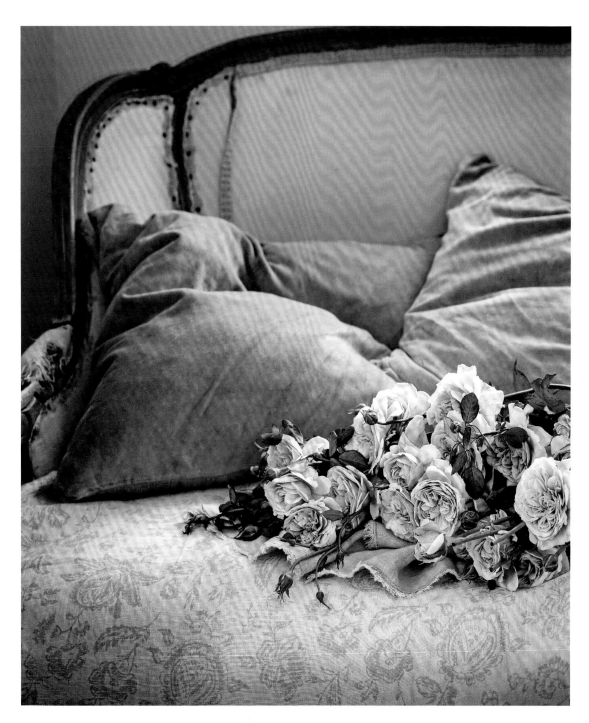

PREVIOUS PAGES The living room has a subdued pale palette of whites, pinks, and blues, just lovely, and all whimsically traditional except for the abstract painting. To the left of the fireplace is the backdrop Lucy uses to photograph her displays. The little urn of white roses, casual as they seem, are pinned into foam for support. On the right, one of Lucy's displays exudes large doses of glamour. The overall effect has a painterly quality. Lucy's huge love for the Georgian and Victorian periods, the proportions, and the pared-back elegance, filter through to her work, epitomized here. See page 232 for bouquet breakdown. **LEFT** British garden roses give the books a pop of color and a nod to the scrolling floral shapes of the random candle sconce. Sweet Antike on the top shelf, cream Piaget in the urn, and David Austin Kate in the little pot. **ABOVE** I had to displace Wilson the dog to put down my simple bunch of Sweet Antike roses in this shabby spot with its lovely, floppy velvet pillows.

FRENCH FLEURS

France speaks to the eternal romantic in me, so it was inevitable it would become part of my floral affair journey. I had been to Paris many times, but now I had a specific purpose: to discover and capture for my book the diversity of Paris, from the grand to the humble via the unexpected through the world of flowers, from decorative architecture to the haute couture floral workshops of days gone by. My dear friend Laurence Amélie, a French artist who lives outside Paris and paints whimsical abstract flowers, became the anchor to my French journey. She introduced me to Amy Kupec-Larue, a true American in Paris (we nicknamed her French Amy so as not to confuse her with my photographer). French Amy's life is flowers, gardens, and Paris, and she opened up Paris through the eyes of a local. She's had careers in advertising and design, but now designs the floral displays for the US Embassy and leads secret garden walking tours all over Paris, exploring the unexpected delights of the City of Light. I had never been a good scholar in the classroom, but Amy's storytelling technique was an effortless way to absorb the history and understand Paris in the most inspiring way.

Laurence's glorious romantic, bohemian country cottage was our starting point, then to Paris, where nestled in the beautiful meandering backstreets, up the most wonky wooden stairs, I was introduced to the legendary Maison Légeron, creators of sublime handmade forever flowers since 1727, and still using many techniques of years gone by. That was an absolute revelation for someone who loves floppy silk and velvet vintage flowers as much as I do. By way of contrast, we then visited a tiny, modest Parisian apartment owned by an enterprising Brazilian lady, Adriana Anzola, who has created in her homey home a perfect showcase for the beautiful antique market finds that she buys, restores, and sells. And lastly, on a long ago visit to Paris when my children were little, I recalled visiting the elegant Ladurée Tea Rooms near Palais Royale and being in awe of the petal-strewn trompe l'oeil ceiling surrounded by intricate floral moldings, and, again thanks to Amy, we were invited to photograph there.

Here is the France I discovered, held together with a floral theme and decorated with a symphony of petals.

WHIMSICAL BEAUTIES

Many years ago, French artist Laurence Amélie, perhaps sensing that my Shabby Chic aesthetic was in alignment with her own, sent me a precious little parcel containing some examples of her art painted on an organza scrap and a little note, that I have kept to this day. I totally love and identify with her work, which I proudly own and sell in my Shabby Chic Los Angeles store. Her work has an abstract quality and a loose beauty about it that comes from a meticulous process of layering of paint, which I have observed with my own eyes over the years, when Laurence comes to LA to spend a few weeks painting in my barn at the bottom of my rose garden. There's nothing haphazard about her methodology—she's an intuitive talent and says when she paints: "it's like a journey into my dreams." We call ourselves soul sisters, we share our love for authentic, mindful, and meaningful beauty that can only be created from our souls. When she is in LA, she is excited by the light, the bright blue skies, and the pink palette of my garden, contrary to her French countryside studio where her albeit equally beautiful paintings often reflect gray rainy days; in LA her work is brighter, pinker, and bluer. Not surprisingly, when she visits, I have to keep her fans at bay, so she can concentrate on creating her magical works of art. She has fans worldwide, and sells and exhibits not just in the USA, but in Paris, London, Dubai, Japan, and Hong Kong.

Laurence's father, Gérard Schneider, was a renowned artist, starting with academic still life in his early years at the turn of the century, moving toward abstraction as he grew older. It is interesting to note that flowers were his main subject matter, just as they are for his talented daughter. Laurence recalls her father saying to her when she was 13, "I think later you will love to paint, so I have two hours to teach you some tricks of the trade." That brief lesson proved to be invaluable. Laurence's childhood house, now shared with her husband, Ubaldo Franceschini, also an abstract painter of note, is a cultural, paint-splattered haven with evidence of the intertwining of their work and life. Shelves are stacked with books on art, and paintings, mostly sold, is hung on every wall. The house exudes substantial creativity—the most beautiful state of organized chaos.

Laurence's world was a vital piece of My Floral Affair. We spent a memorable few days creating whimsy at its finest, sustained by delicious feasts that appeared as if by magic, laid out as pretty as any picture.

PREVIOUS PAGES The stage is set with an oversized unfinished floral painting by Laurence propped up against the wall of her studio, the old wood floor splattered with paint by a legacy of artists. The romantic chair, from around 1830, was recovered with scrap fabric. Following Laurence's unique, painterly approach to upholstery, the fabric itself was painted a beautiful blue.

RIGHT There's a lovely dreamy feel to this painting of floating lilies, which demonstrates Laurence's Los Angeles palette. She achieves this loose beauty by applying many, many layers of greens, blues, and pinks. I put a straggle of pink strawflowers in front of the painting to play with the palette.

OVERLEAF I love the hodgepodge whimsy of the living room in the small cottage that Laurence shares with Ubaldo Franceschini, also a painter, and their six visiting adult children. I love the balance and character of low ceilings, large windows, and wonky beams combined with Laurence's smoky moody palette, explosive large-scale paintings, and furniture gathered from nearby antique markets, some unified by her painting them in shades of gray. The raw wooden floors and hints of black décor defy any sugary sweetness. It's a beautiful and hugely creative space. Laurence has a cutting garden, so we were able to combine flowers we bought in Paris with flowers from her own garden. A bucketful of hydrangeas, peonies, strawflowers, and Queen Anne's lace is a visual symphony. See page 232 for bouquet breakdown.

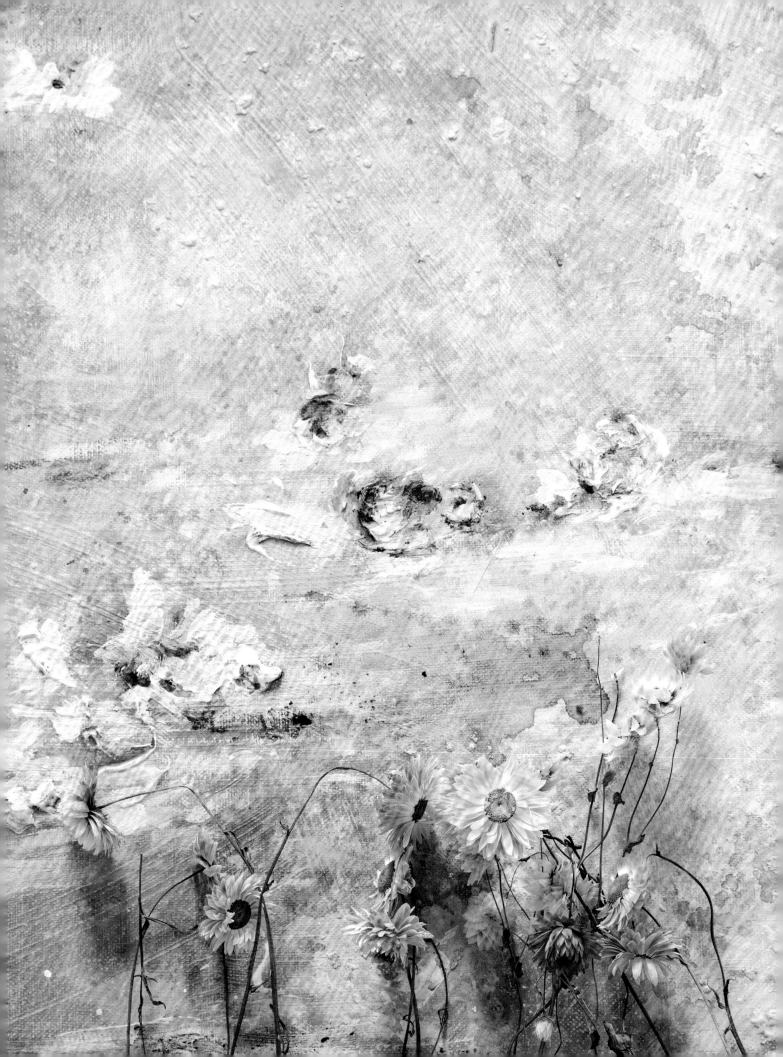

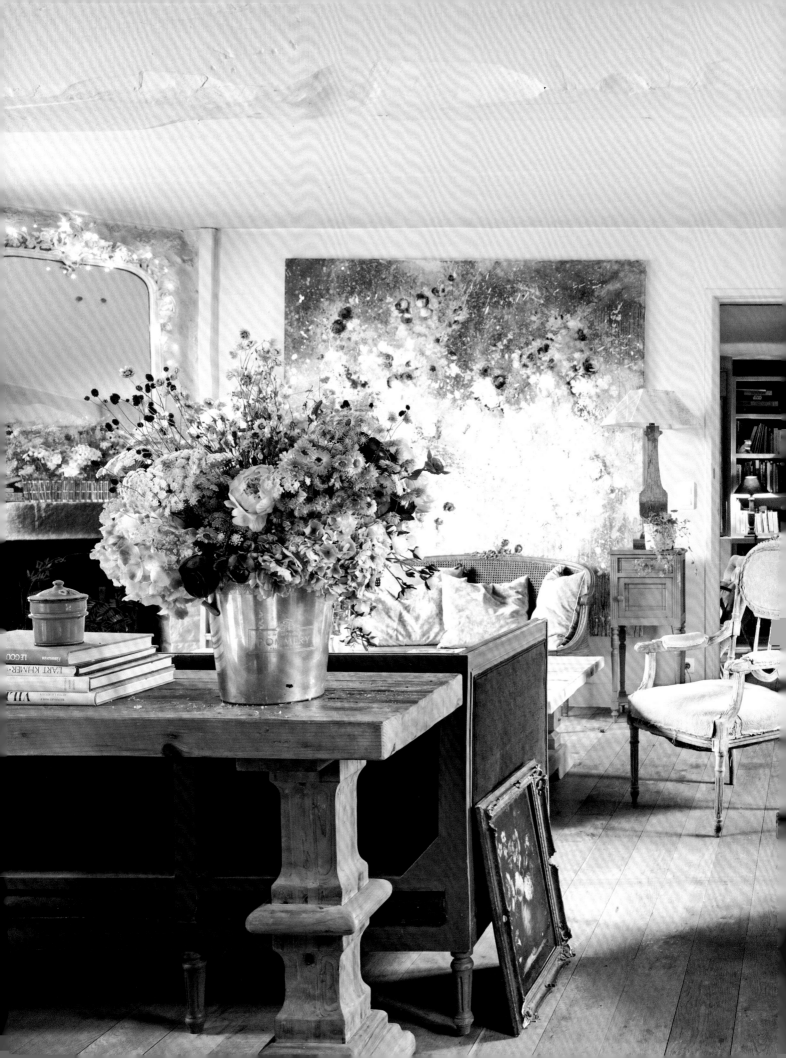

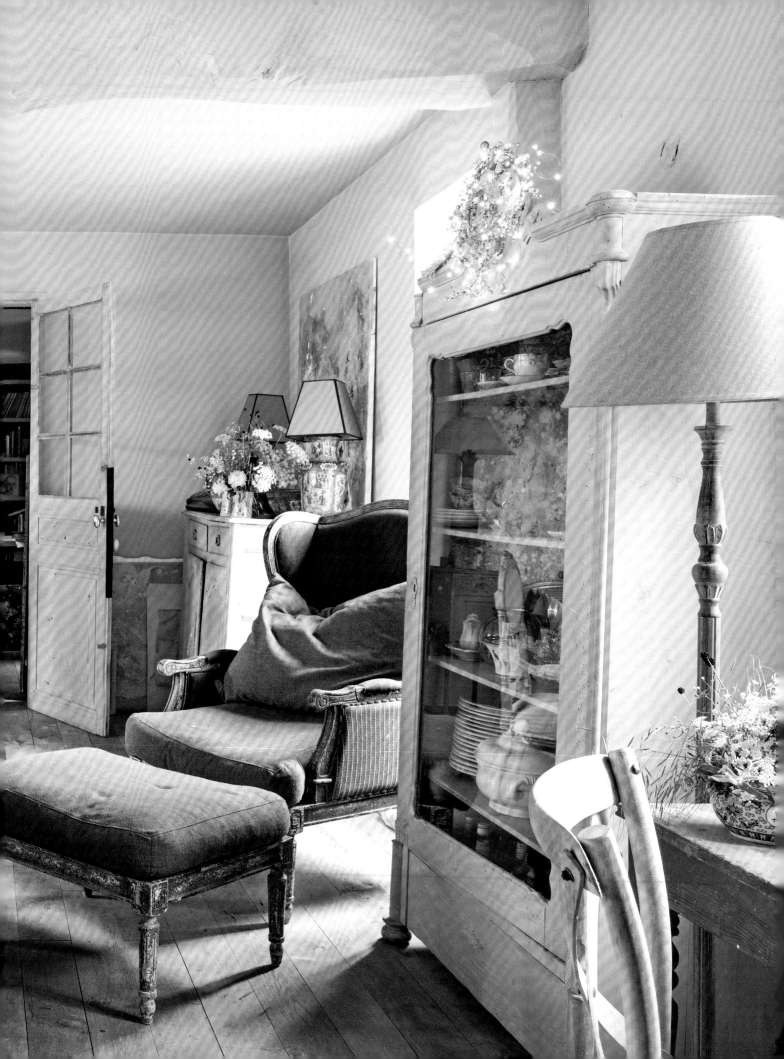

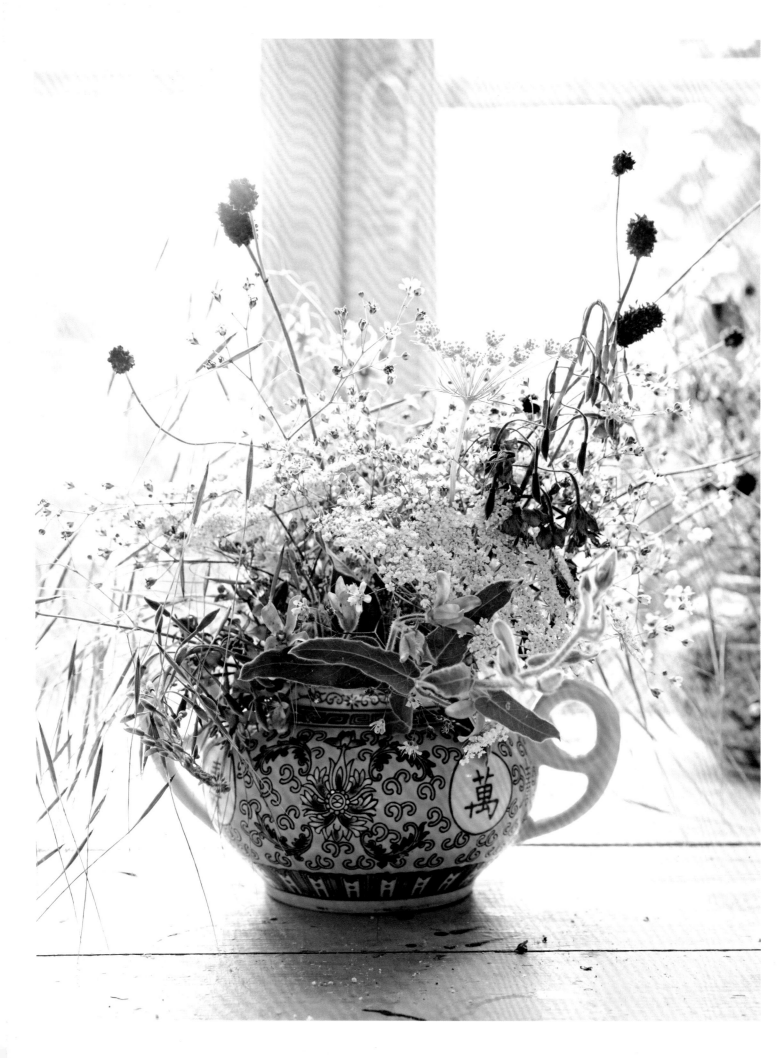

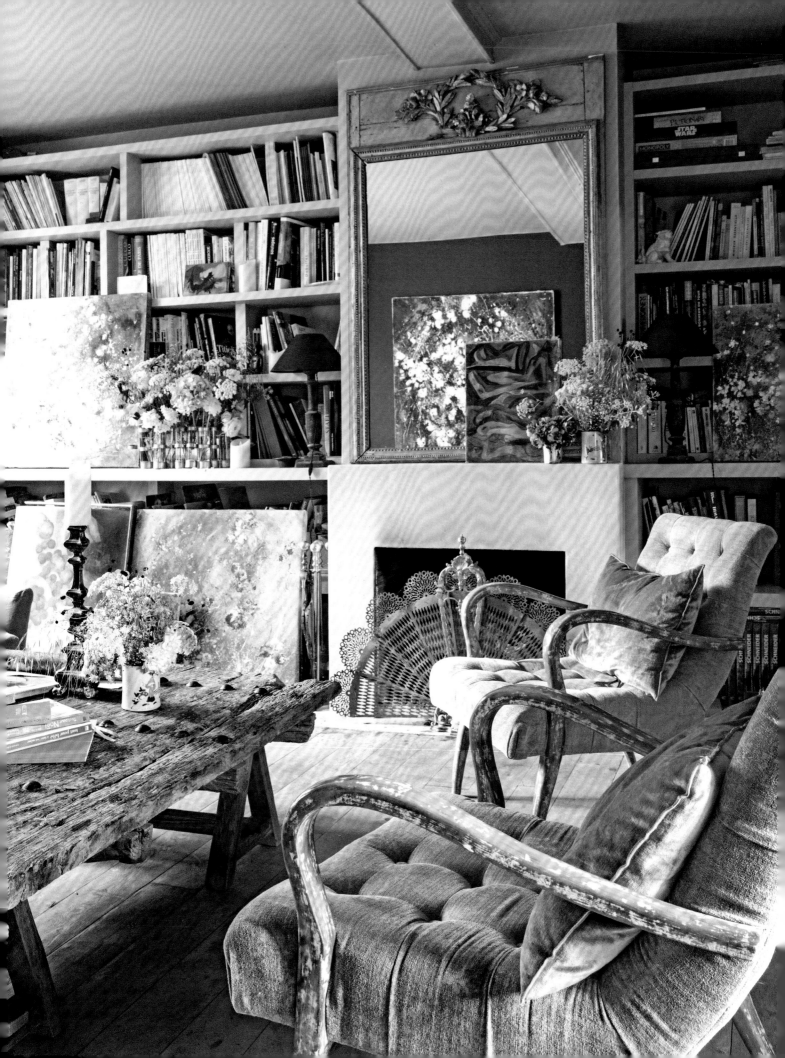

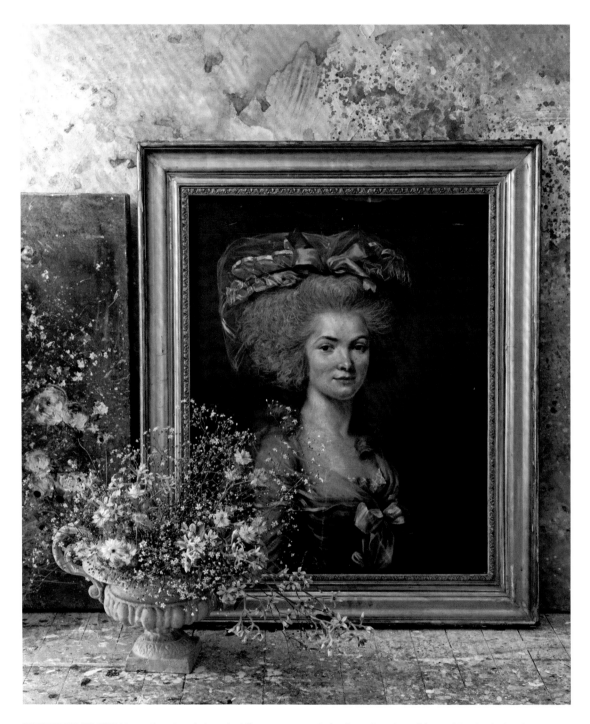

PREVIOUS PAGES I love the simple tangled flower arrangement in the playful Japanese vase. See page 233 for bouquet breakdown. A once-upon-a-time stable is now the library, packed with art books both from Laurence's painter father and her own world. The gold Trumeau mirror was her starting point of inspiration, reflecting the shimmer of the velvet silk pillow. Surprising myself, I loved the darker palette, the black walls, and gold accents —a romantic room with a sensual energy. Laurence did most of the floral displays intuitively and artistically, reflective of her whimsical, airy, but complex work. To me they are tiny symphonies.

ABOVE AND RIGHT I was captivated by this eighteenth-century painting that appealed to my palette. I asked Laurence to create a display to echo the lady's disproportionately large wig and her decadent teal blue dress. She created this with the same emotions as she paints. She used garden flowers and arranged them in a plain little ivory urn, that she painted in five minutes to look dusty and vintage. See page 233 for bouquet breakdown.

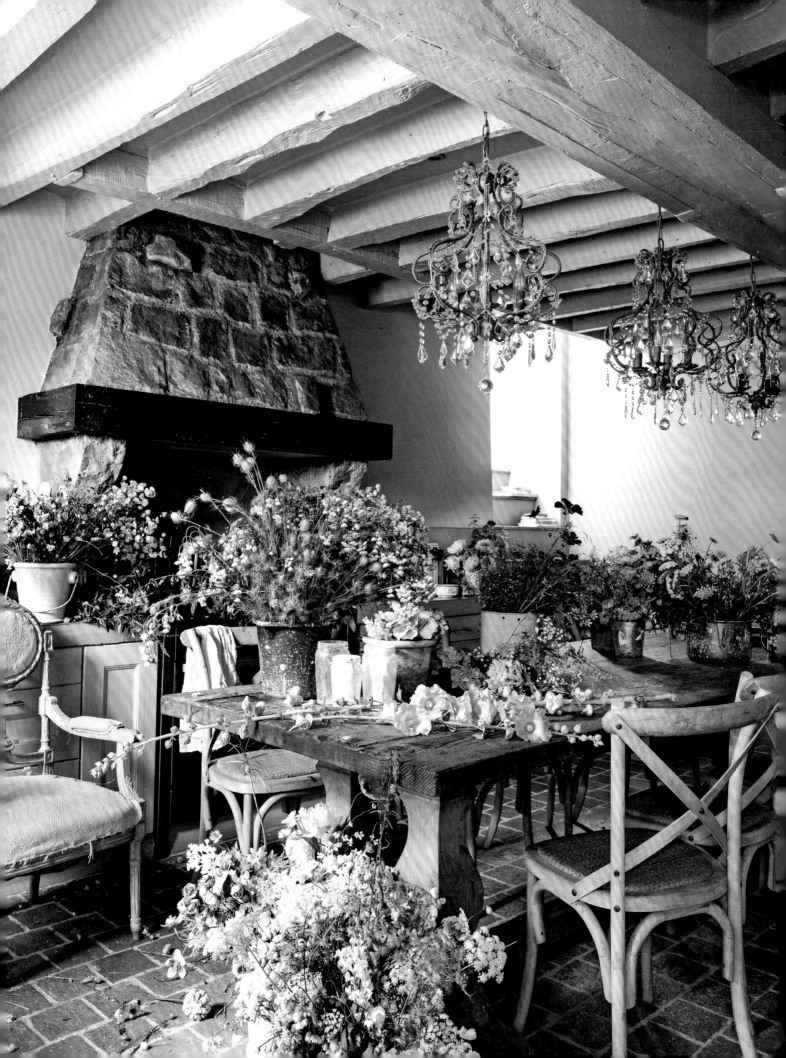

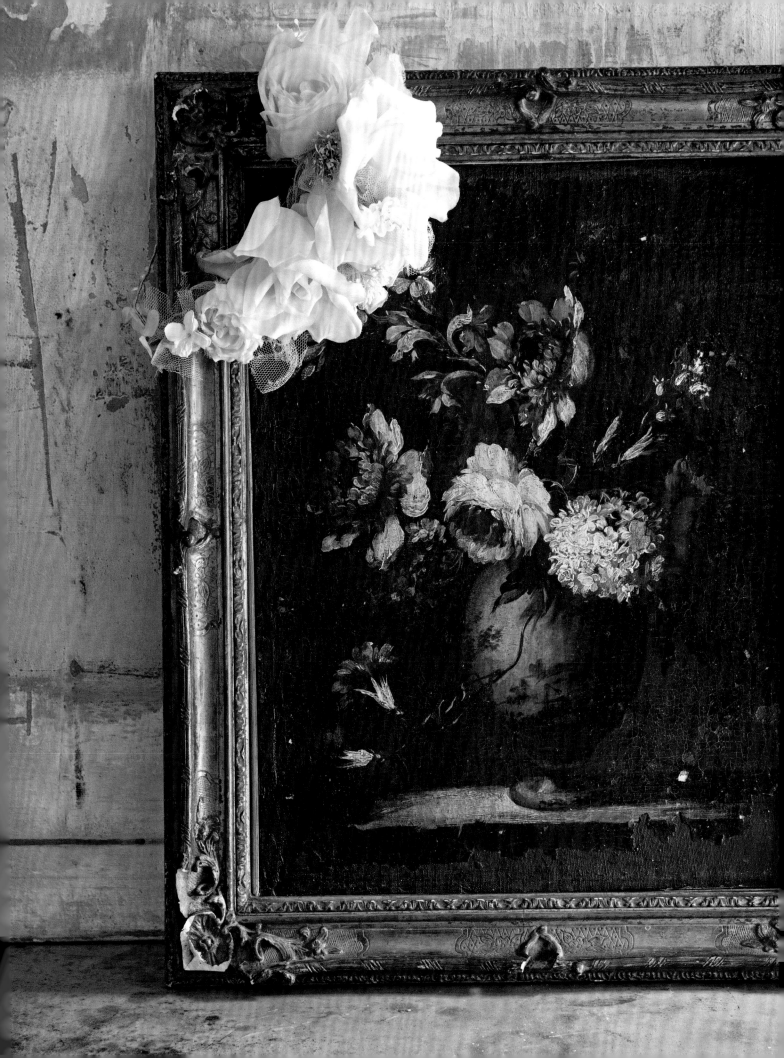

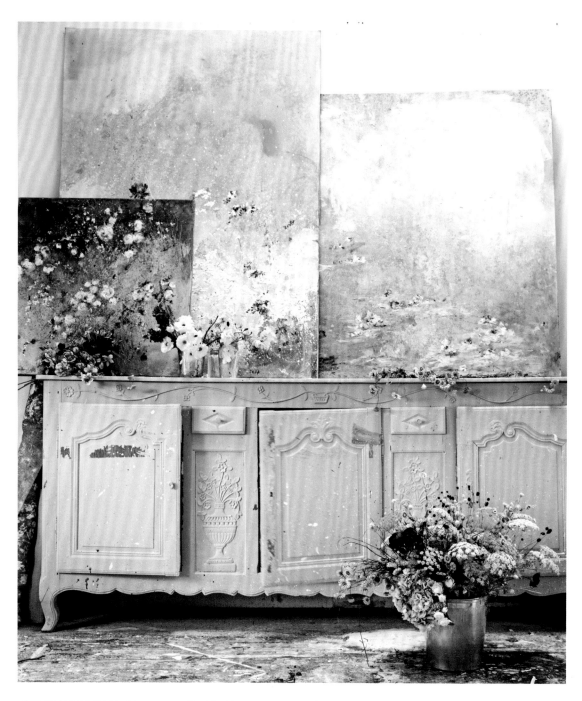

PREVIOUS PAGES In his own studio, Ubaldo Franceschini works on his paintings, using a language of color very complementary to Laurence's work. Bottles on the cement counter and crystal chandelier drops play off the icy, fluid feeling of his work, along with fuchsia hollyhocks. The charming food cover is by talented neighbor, Tanya Boureau. **PRECEDING PAGES** In this kitchen the cooking becomes the mode of artistic expression. It has the essence of a culinary boudoir where friends and family gather. The kitchen also served as the work station: our raw materials on glorious display. On the counter sits a wonderfully

early painting by Laurence's father Gérard Schneider, who became a pioneer of Abstraction in the 1950s —his teacher, Ferdinand, taught Toulouse Lautrec, Matisse, Soutine, and Vincent Van Gogh. The silk flower crown is by Tanya Boureau. **ABOVE** The paint-splashed floor of the studio and a wonderfully wonky Louis XVish sideboard, with naively carved geraniums in the scrollwork. An array of paintings is waiting for departure to an exhibition. **RIGHT** A play on life mirroring art: a euphoric jumble of roses and strawflowers in a cobalt blue pot, chipped, broken, and repaired, embracing the beauty of imperfection.

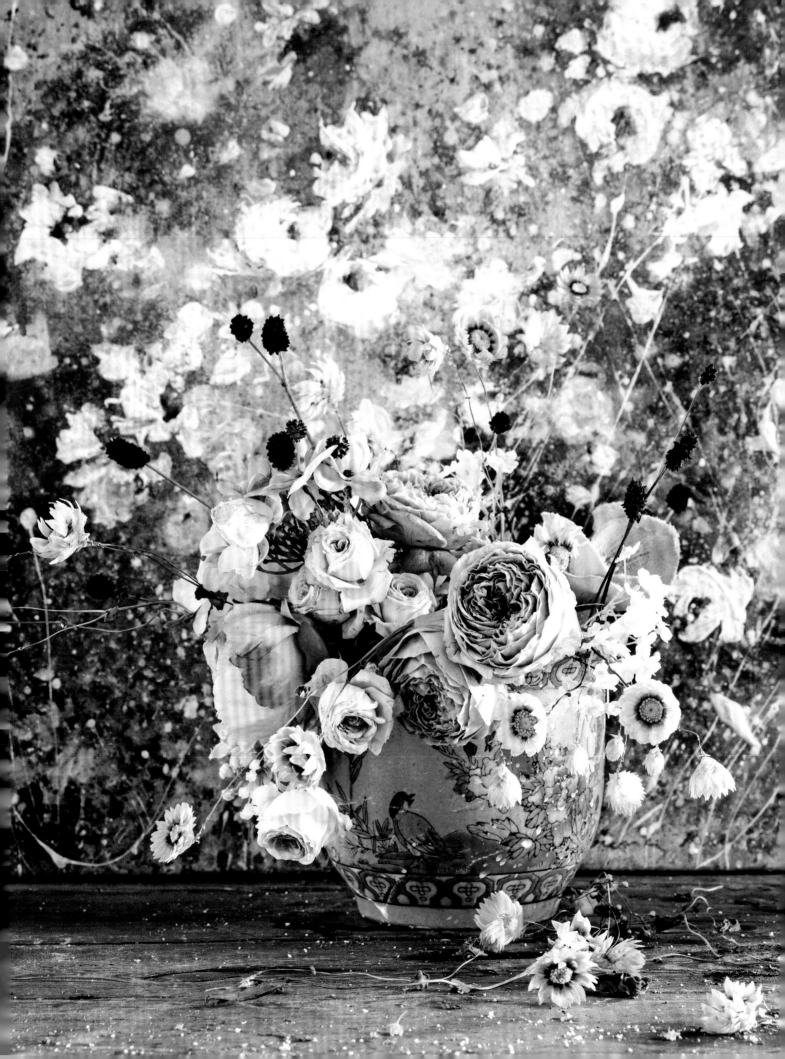

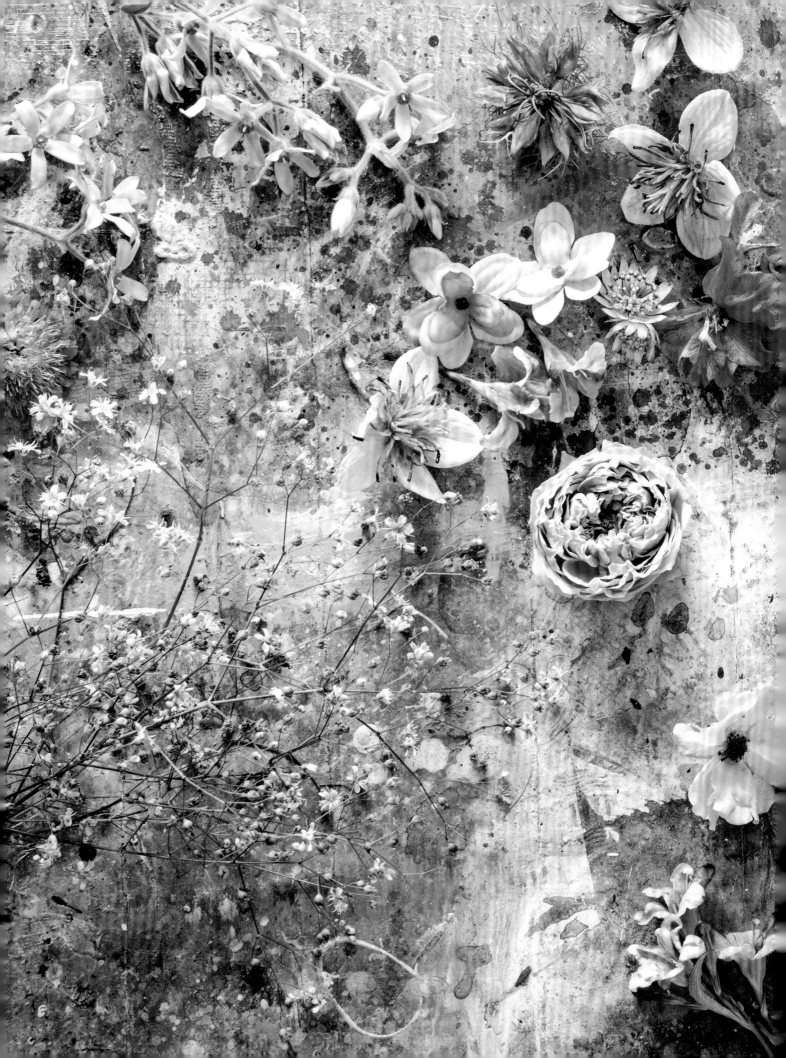

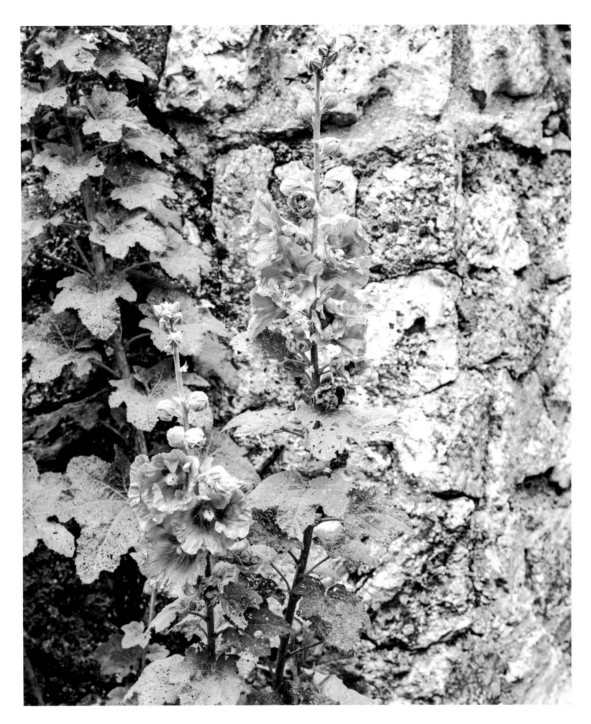

PREVIOUS PAGES The remains of the day. A recap of Laurence's day of flowers, strewn on her magical paint-splattered floor—pink baby's breath, blue star amsonia, love-in-a-mist, cabbage and fairy roses, hydrangeas, strawflowers, purple pincushion, weigela, and astrantia. **ABOVE** Hollyhocks from the neighbor's garden, which they generously let me cut for our photo, are a characterful garden flower that you rarely see in a florist shop. **RIGHT** I loved this enchanting wisteria-clad deck, looking romantic and inviting even on a rainy, cold July day. I created a moment for storytelling by adding some dreamy tulle.

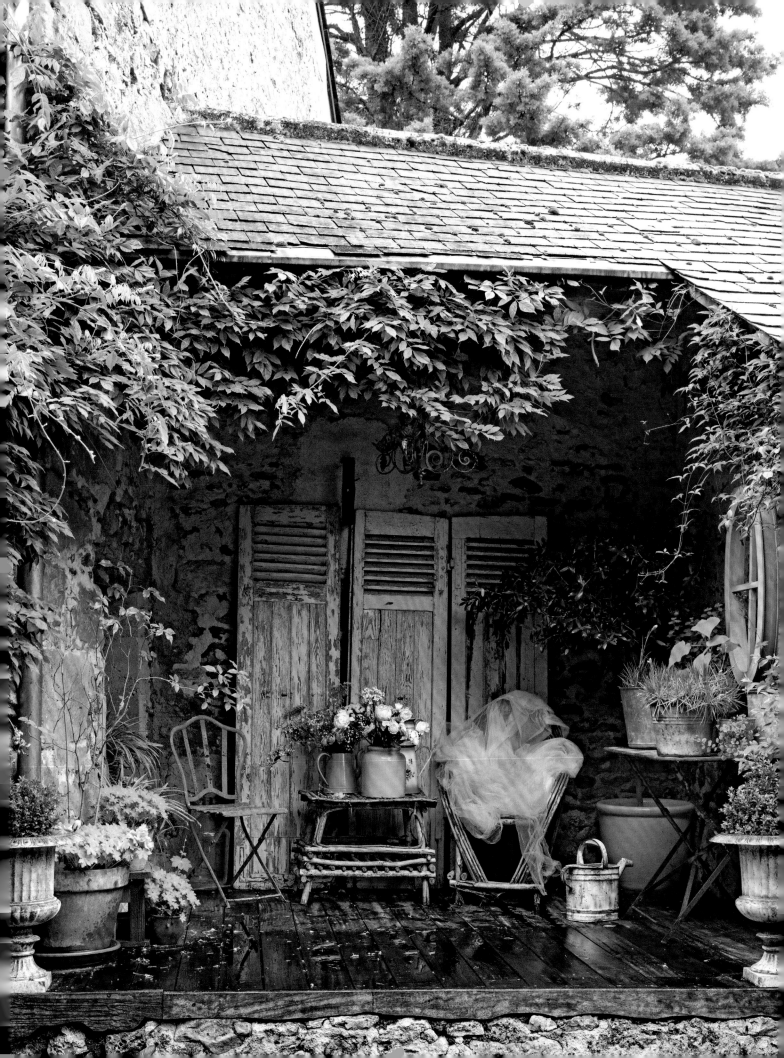

FOREVER FLOWERS

When I set foot in Bruno Légeron's world, there was not one area of his quaint, crowded atelier that wasn't eye candy for me. This handmade flower business, founded in 1727, has been in the same family since 1880 and Bruno was keen to share the history, mainly through hand gestures in lieu of our different languages, and pulling out albums from his great-grandfather's, grandfather's, and his mother's time. Their work has been an integral part of the Paris haute couture business since the eighteenth century—a lovely thought that fashions of days gone by share these same moments of magic today.

The Légeron studio is on the third and fourth floors of a classic eighteenth-century building, up a wonky staircase that could only be found if led there by French Amy. This has been, and still is, a family business fuelled by passion. On the day of our visit craftsmen and women were at work in each room, proudly and silently concentrating either on cutting, painting, or assembling little floral works of art. We were there just before Paris Fashion Week, and the whole team was working diligently to supply whatever embellishments the grand couture houses such as Yves St Laurent, Dior, or Chanel required, or a thousand white silk rosebuds for a wedding dress for a lucky bride. This kind of work is never hurried, there are no short cuts to perfection, and every order takes as long as it takes. It was an inspiring experience for me, a lover of the beauty of imperfection, to understand the beauty of a perfection that takes its cue from faithfully reproducing the delightful imperfections of nature. As someone once said to me "imperfection needs to be perfect".

These works of floral art are a bit of an investment, but they are heirloom blooms. I was so taken with a range of pale blue pastel roses that I treated myself, adding them to my traveling roadshow of favorite props, knowing they would last forever. As I walked back down the wonky stairs, I reflected all those years ago when I would go out with my mum, searching through the flea markets, looking for smooshed vintage silk and velvet flowers, excitedly returning home where I would watch her bring them back to life with steam. I wonder now if any of them originated from Légeron, the land of forever. How Mama would have loved this place.

RIGHT Another fake flower story caught my imagination while I was in France, and this was the story of Tanya Boureau, a neighbor of my friend Laurence Amélie. Tanya, who blogs about her floral creations under the apposite heading "Magic is what you make," turns lace, tulle, wire, and cut silk into miniature, unexpected masterpieces. The act of creating her magic also serves as a form of meditation for her. Here are some of her treasures, spilling out of a beautifully distressed chest of drawers. Tanya also made the charmingly wonky netting food cover on page 107.

OVERLEAF Boxes of leatherbound sample albums, archiving size, material, shape, and color, date back to the origins of the business and are used today as references for clients to choose their palette and designs. Centuries of records of customers' orders and requirements are still kept in handwritten ledgers.

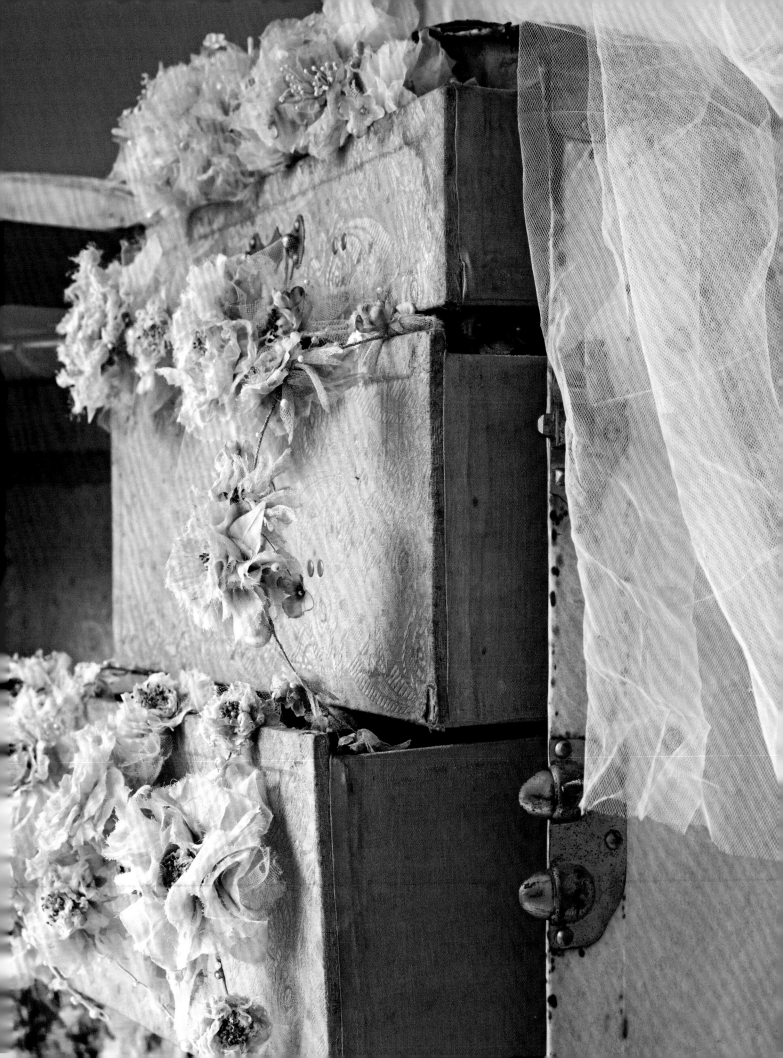

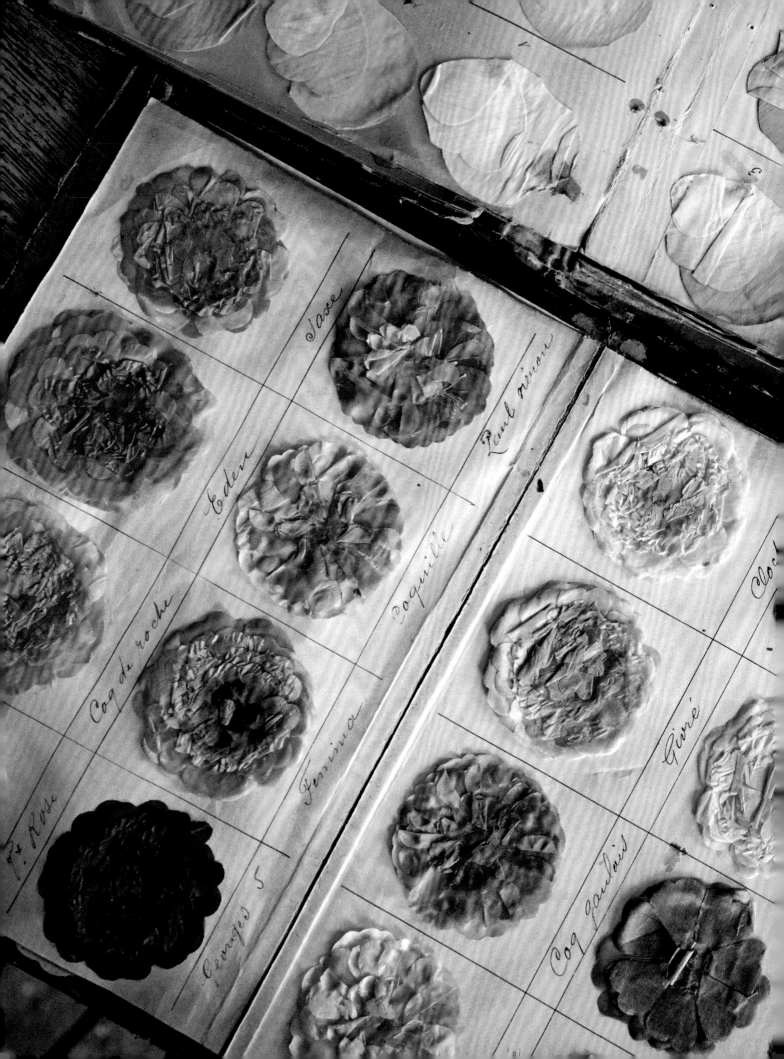

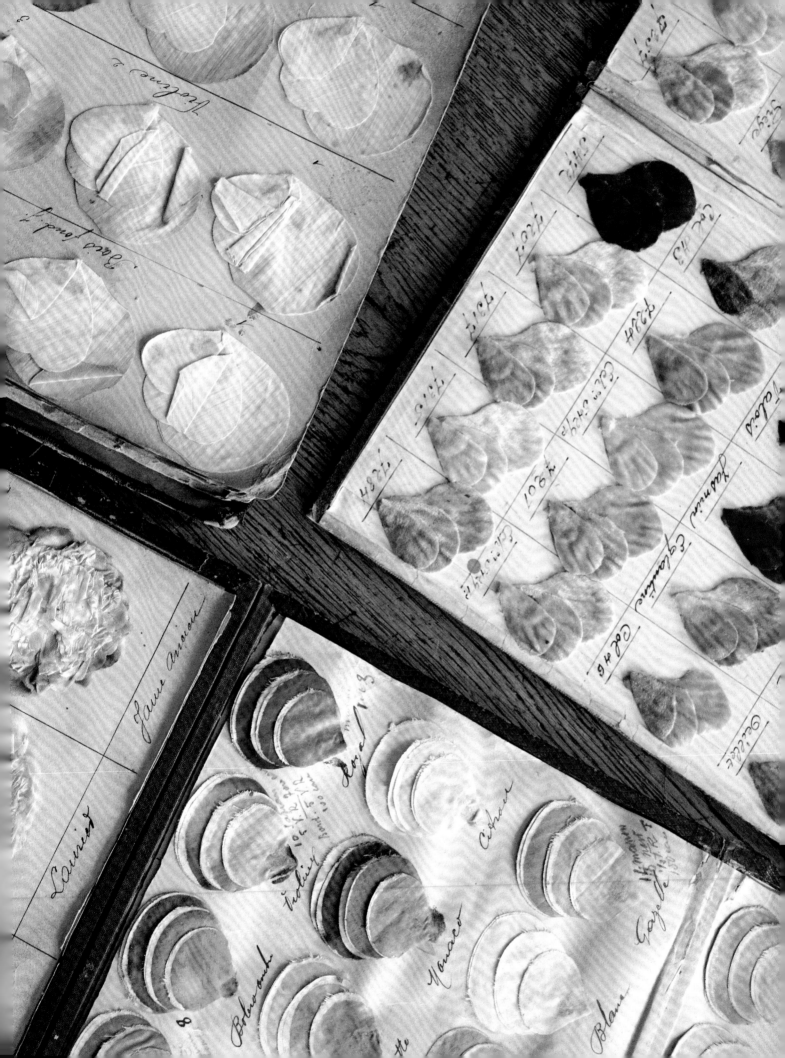

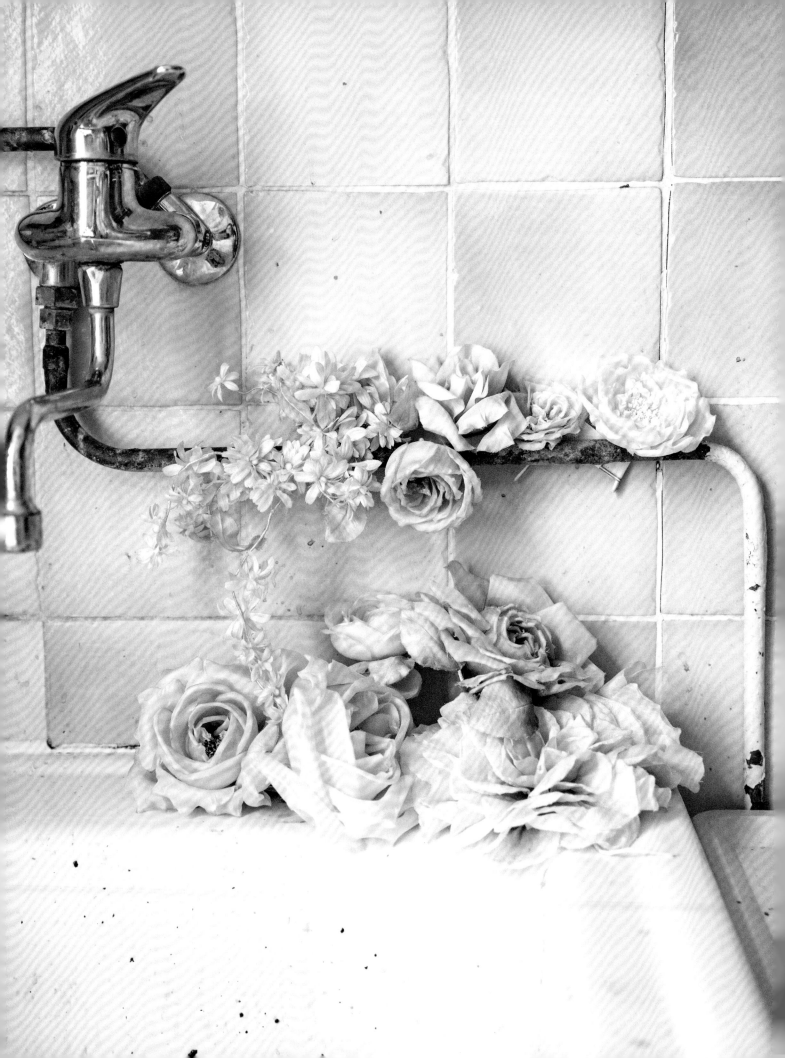

LEFT A collection of blue silk flowers so lovely I couldn't resist buying them, although I normally gravitate toward pink. I stumbled upon a wall of watercolor-like ombré blue tiles in the painting room, and wanted to capture the sublime with the mundane. I am not a gifted painter, but I love when I feel inspired to combine the shabby and the chic and create a vision. **ABOVE** As befits the artistry that goes on in the workshops, the ceiling roses and cornicing are decorative beauties. Hanging upside down across the room on wires is a chorus line of white tissue flowers, keeping their delicate skirts in shape until called upon to perform. **OVERLEAF** This is the work of Tanya Boureau, a neighbor of Laurence Amélie. Her day job requires discipline and an outgoing nature. Her other life as a creative artist is very different: tucked away quietly in her studio, crafting floral confections in silk, tulle, netting, silver wire, and beads, all hand-dyed and tinted. I have long been a fan of Tanya's whimsical creations, which are mostly made for weddings and romantic events.

TRÉS JOLIE

My previous visits to Paris had always been as an outsider looking in, staying in sometimes rather fancy hotels and somewhat removed from the reality of local Parisian life. However, on this floral journey I wanted to experience behind-the-scenes Paris. From within my ever-inspiring Instagram community, I sought out Adriana Anzolia, who lives in a tiny apartment in one of those faded grandeur, eighteenth-century residential blocks in the 9th arrondissement, not far from the Paris Opéra. The minuscule interior is humble and modest, but beautifully proportioned and ornamented with classical plasterwork and cornicing that just drip with bygone opulence. Humble fancy at its finest, reflecting a romantic life of pretty passion.

Adriana, whom I can only describe as something of a gypsy Marie Antoinette, is a beautiful, warm, and outgoing character with an innovative take on retail. With her eagle eye for beautiful things, she haunts the antique markets and brocantes of Paris and the outlying suburbs, bringing her finds back home, dusting them down, repairing and renewing where necessary, and showcasing them, via the internet. So this is a home where most everything is for sale—as long as it can be put in a box and shipped. She loves and appreciates her treasures but appears not attached to them, knowing by letting them go she can enjoy the search for more.

This apartment is a lesson in slightly shabby faded elegance, but nothing here is contrived. It's all absolutely authentic from the antiquated hardware on the doors to the slightly chipped ceiling roses. The decoration is very much an expression of Adriana's femininity, but it seems her boyfriend is quite happy living in this pretty space, and used to objects appearing and then disappearing. She has a way of constantly moving things around, partly so you won't miss them when they're gone, but also so that things don't have a strictly set place, giving a feeling of fluid design. Without feeling cluttered, every square inch of space is used, cared for, and curated. It's a clever balance of feeling like home while also being the stage for an innovative business and a visual merchandising tool: inspiring to me.

RIGHT The sitting room of this tiny Parisian apartment is in effect the hall, with doors opening off every wall, but they're pretty paneled doors, so interesting in themselves. Her palette is faded pinks and blues, offset by neutral, fitted coir matting layered with faded vintage rugs, and paint finishes of bright white and ivory—always a good stage for layering decorations, especially mobile ones. These oh-so-French double doors open directly from the sitting room into the bedroom. The internal architecture is a beautifully proportioned delight of moldings, rails, and authentically beautiful doors, and I found Adriana's eye-candy world completely enchanting.

OVERLEAF The only bedroom is an example of a lived-in space that, with all its wonkiness and fluidity, still has beauty. The room is small with only one organized armoire, but all is united by the pale palette and the whimsical crystal touches. A bucket of effervescent wildflowers adds a casual zing of color. Normally the peony would be my go-to flower for an interior such as this, but by the time we got to Paris, I was suffering from peony overload, so the only request I made to Adriana was to hold the peonies, otherwise I left the choice of flowers and vases entirely to her.

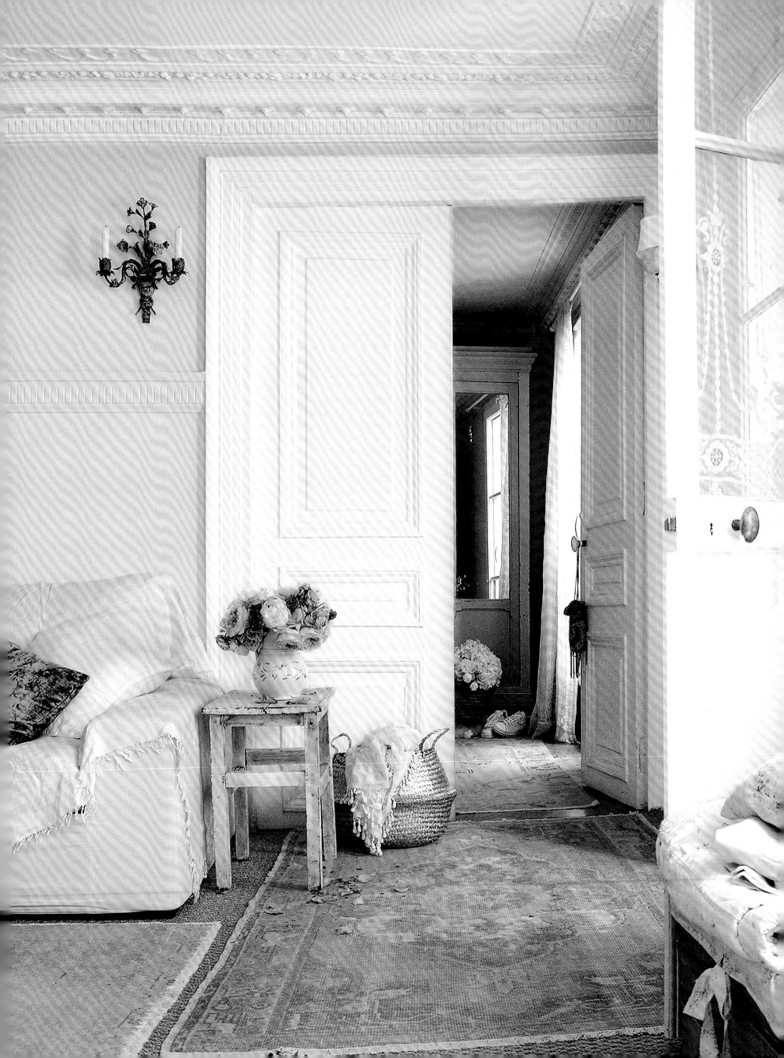

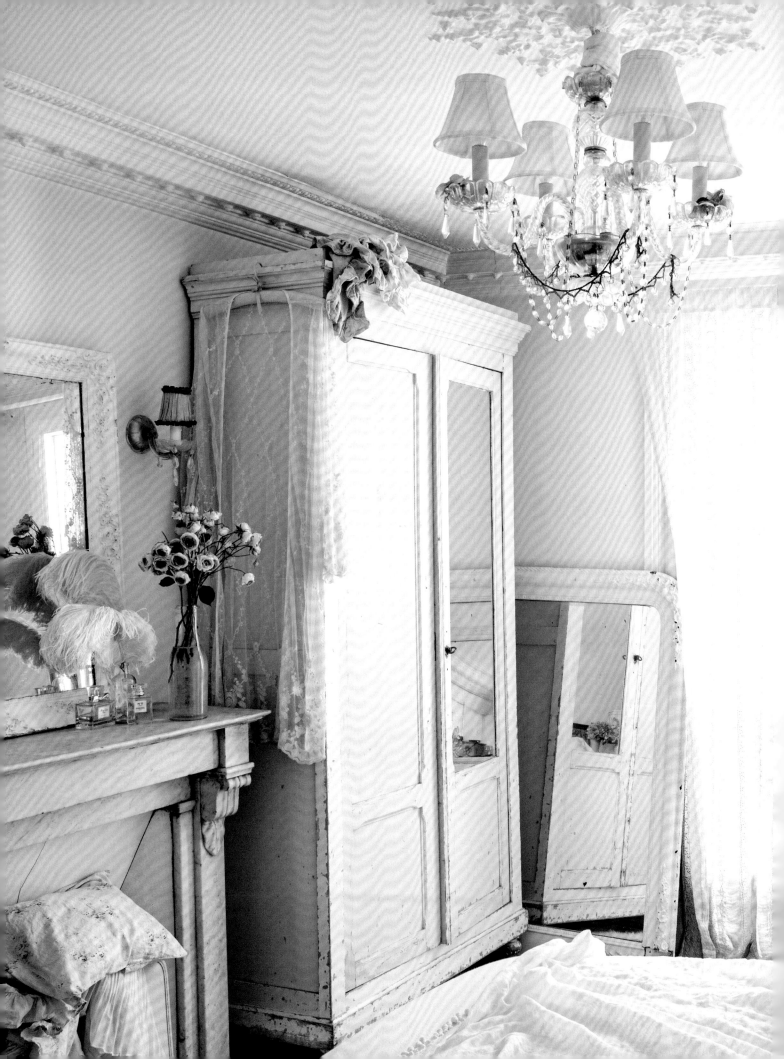

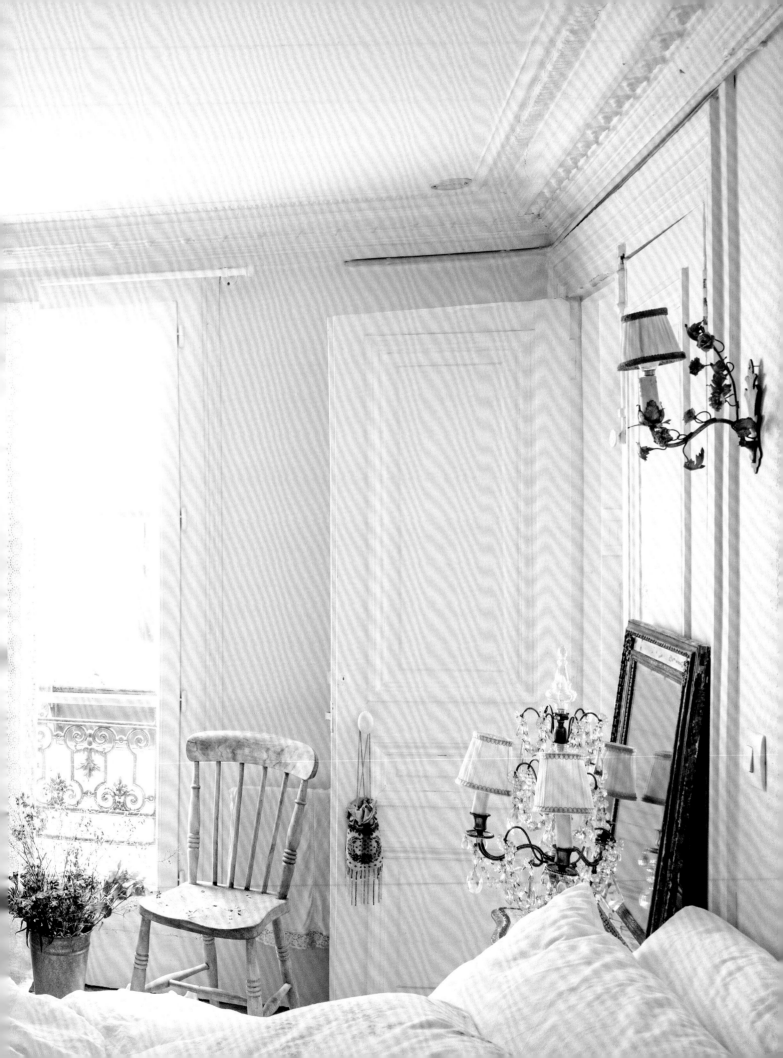

LEFT A silk flower and a necklace, casually draped within the light fitting hanging from a precious pretty ceiling, didn't go unnoticed or unappreciated by me. They were likely all for sale and could be gone tomorrow, to be replaced with a new-found treasure. **ABOVE** Porcelain flowers subtly twined into a bronze sconce. An example of the joy that decorative forever flowers can bring, adding whimsy to something traditional. **OVERLEAF** The sitting room is a thoroughfare, but Adriana has succeeded in making a cozy, comfortable space. I liked the darker shade wall behind the mirror, giving the room a focal point. A pitcher of just-about-over-the-edge cabbage roses in two shades of pink is the perfect embellishment, and a common thread signature in much of My Floral Affair. Another treasure that lives here on a temporary basis is a Tunisian birdcage with a cluster of dried roses: a little art piece, a past and future heirloom.

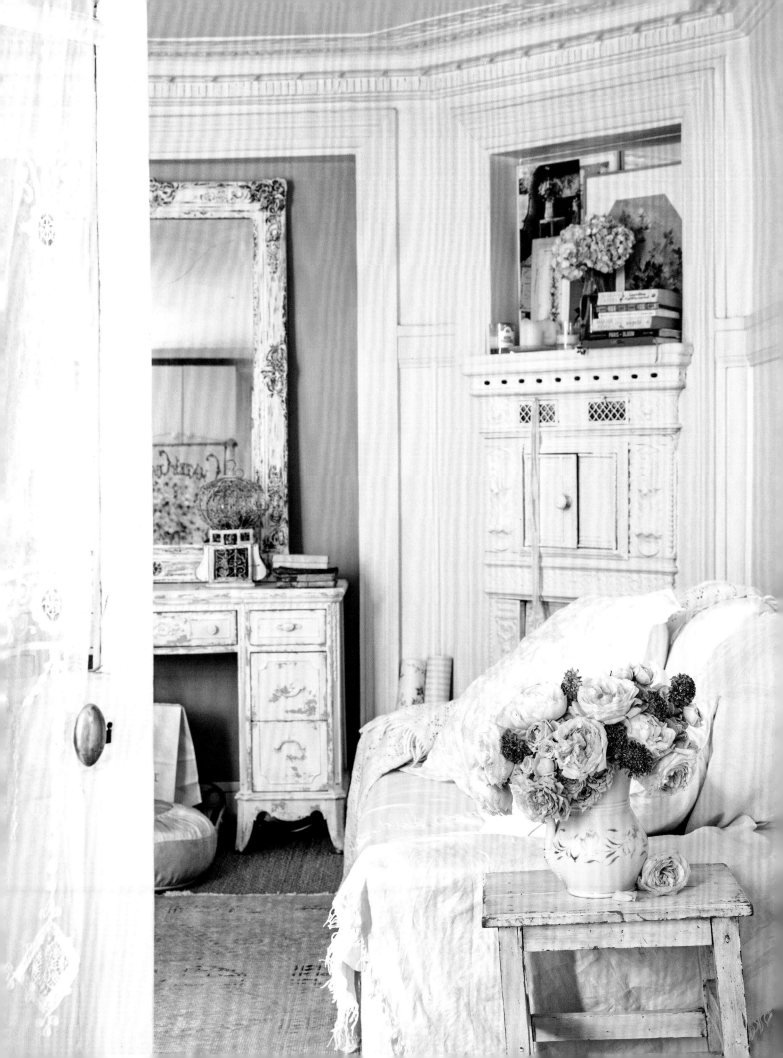

ABOVE I found some decorative humor in the painted birdcage with some dried strawflowers —just a pretty moment. **RIGHT** A faded straggle of fresh strawflowers in a charming chunky pot. Strawflowers, which belong to the daisy family, are an amazingly versatile flower. They last forever, keeping their color, and dry easily as they contain less moisture than other daisies. **OVERLEAF** Amongst the teacups, two tones of garden roses, as beautiful as the day they were in full bloom, maybe a little faded and dried, but heavenly nonetheless. A peek into the kitchen, with pretty floral plates, glassware, and pitchers on the shelves, perhaps one day to be sold and boxed up. Adriana's flower choices included hydrangeas, roses, and ranunculus, with all the green stripped away, effortlessly and casually placed, but still a precious bouquet.

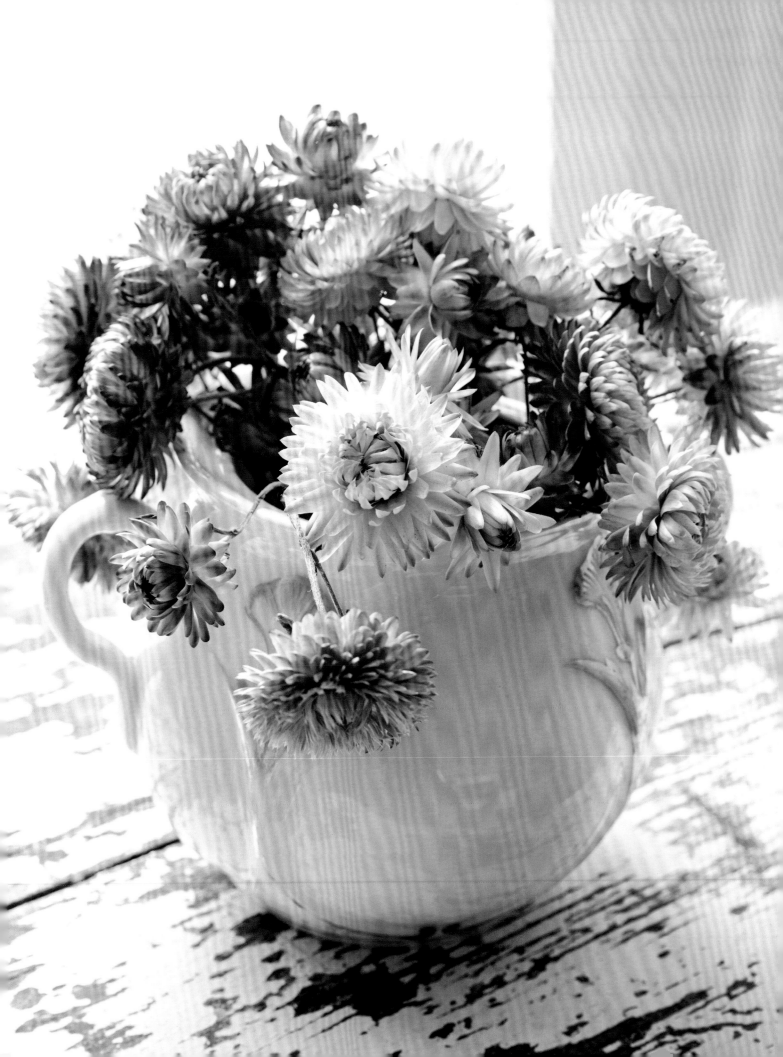

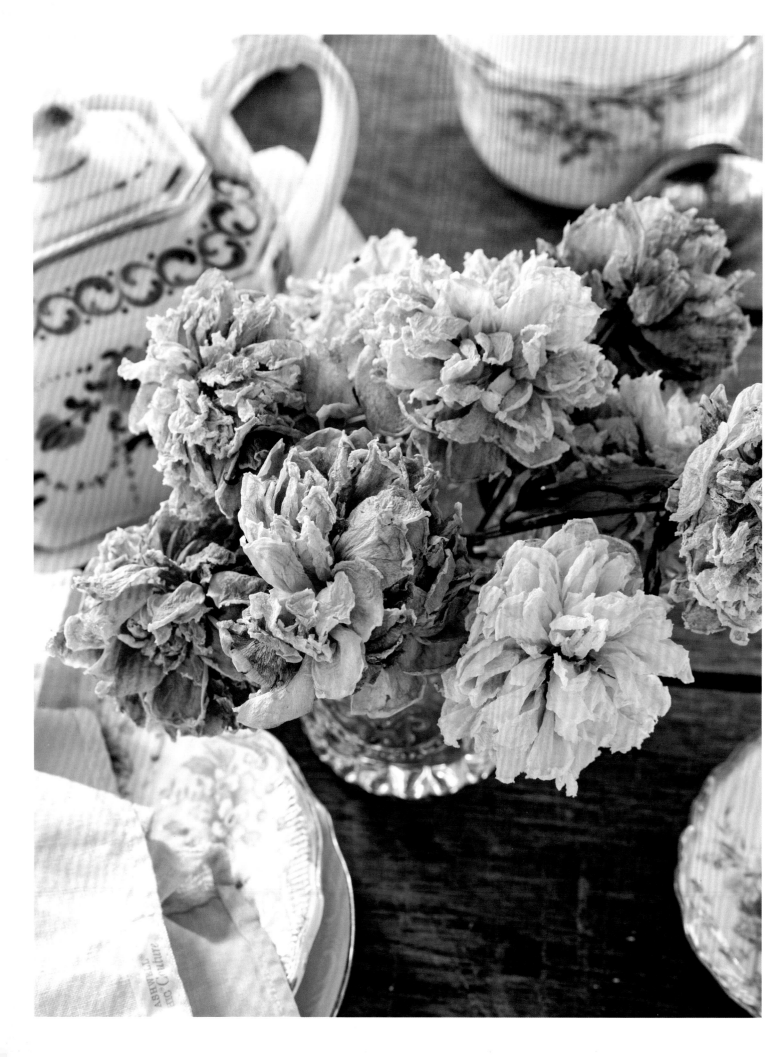

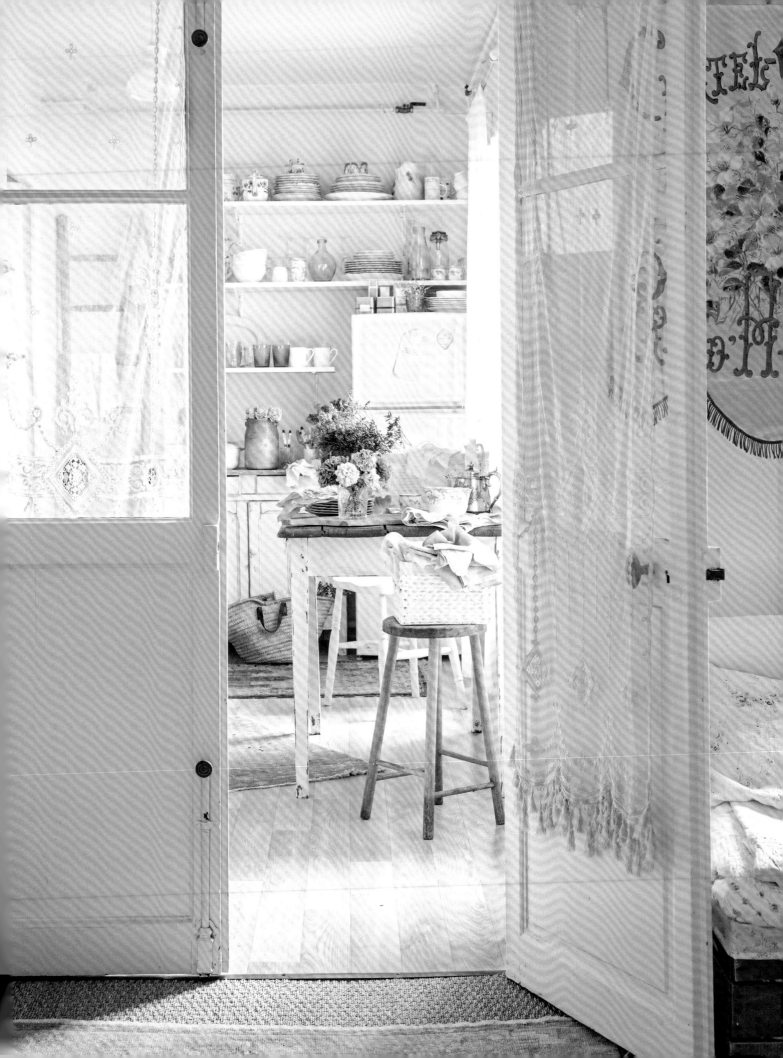

SWEET PETITE PARIS

An experience in ultimate French decadence has to include a visit to the Champs Elysées Maison Ladurée, flagship of this renowned global chain of pâtisseries, famous for their gloriously colored macarons, and doubly famous for their yummy double-decker macarons sandwiched with a creamy ganache filling. The interior of this special place was decorated by Jules Chéret, a graphic artist of the early nineteenth-century Belle Époque era, who was famously the first poster artist of his day to depict women not as prostitutes or barmaids, but as free-spirited women with a life of their own who maybe liked to gather in tearooms to discuss the affairs of the day and consume macarons. It was M. Chéret who created the chubby cherub dressed as a pastry chef, the emblem of Maison Ladurée, and he also painted the petal-strewn ceiling that set me off on My Floral Affair.

This classic Belle Époque interior is painted in celadon green, which is my favorite shade of green. The vintage color mirrors the exterior of the building, and is the perfect backdrop for my signature palette of blues, pinks, and whites. This was a special treat for my traveling crew and I to be surrounded by such beauty, reflected in the macarons in every subtle hue—the perfect location for any floral affair. Our permission to shoot this palace of delights was made possible by Amy Kupec-Larue, florist to the US Embassy and inspired tour guide to the gardens and parks of Paris. Amy began her career as a floral designer, creating floral arrangements for this very tea room. All the flowers here are Amy's designs in her collection of vases, with just a tweak for two from me. She designs with a combination of wire and foam, and her own special organic way of putting blooms and macarons together.

Even now that there are many Ladurée locations, there is still something so magical, unique, and special about teatime at Ladurée. Apart from the decoration being my perfect palette, the Ladurée experience is that of days gone by. Genuine conversation is supported by the atmosphere of quiet and gentle good manners. To me, teatime is such a valuable moment in the day, to take a moment and regroup. When travel allows, there is no better place than Ladurée for teatime.

RIGHT A Belle Époque bouquet as pretty as any painting, put together by Amy Kupec-Larue, our indispensible guide to the flowers, florists, and gardens of Paris. A mass of hydrangeas, roses, and peonies comes together in a breathtaking burst of themed color.

OVERLEAF As I came across this painted exterior in another, more humble, quarter of Paris, I was inspired by the common thread of the palette of Ladurée's macarons. A Ladurée table setting, embellished with pink roses. Their lovely bone china is made in the same beautiful tones as their macarons. Simple and sweet.

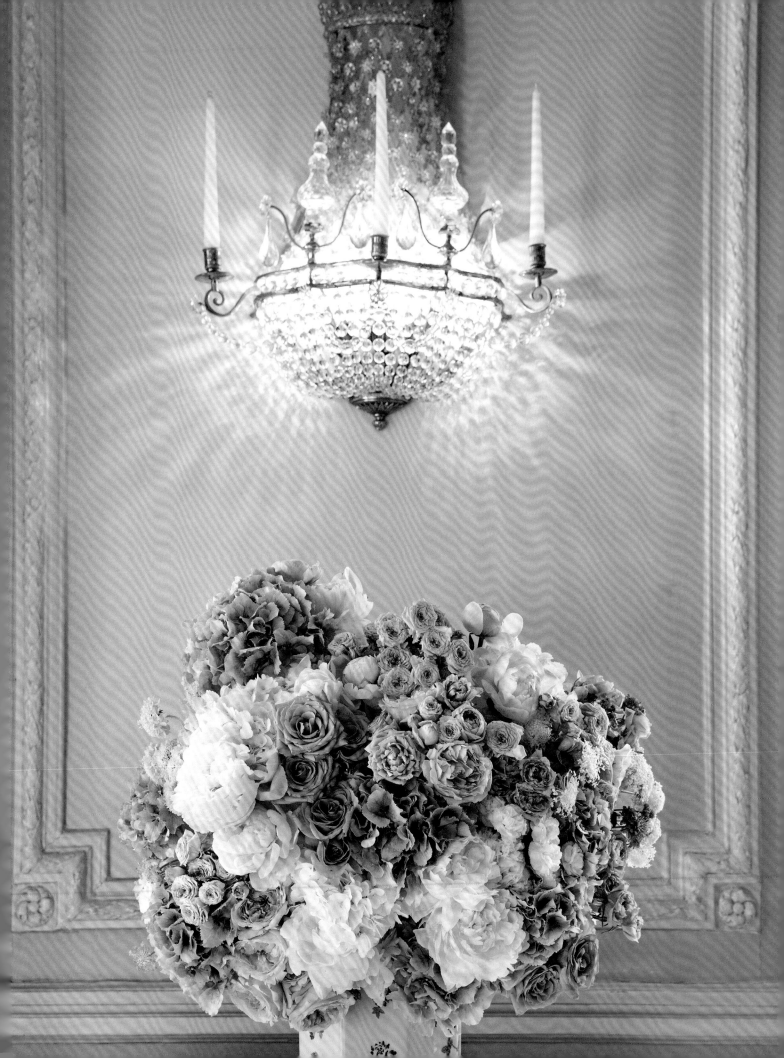

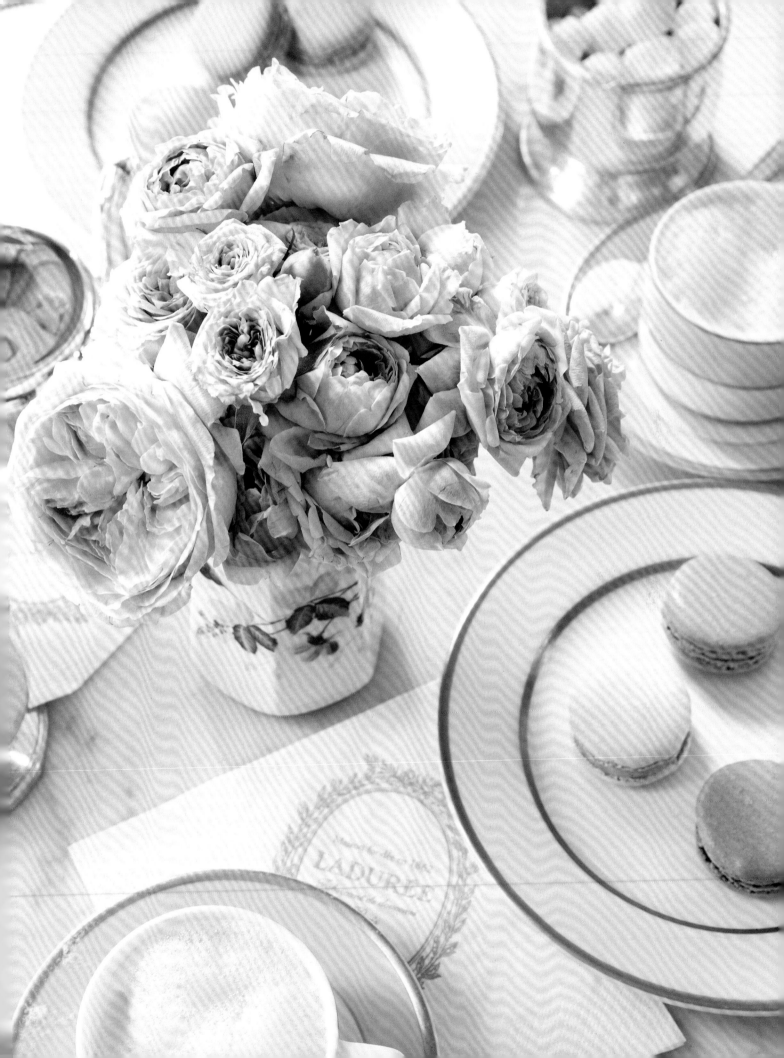

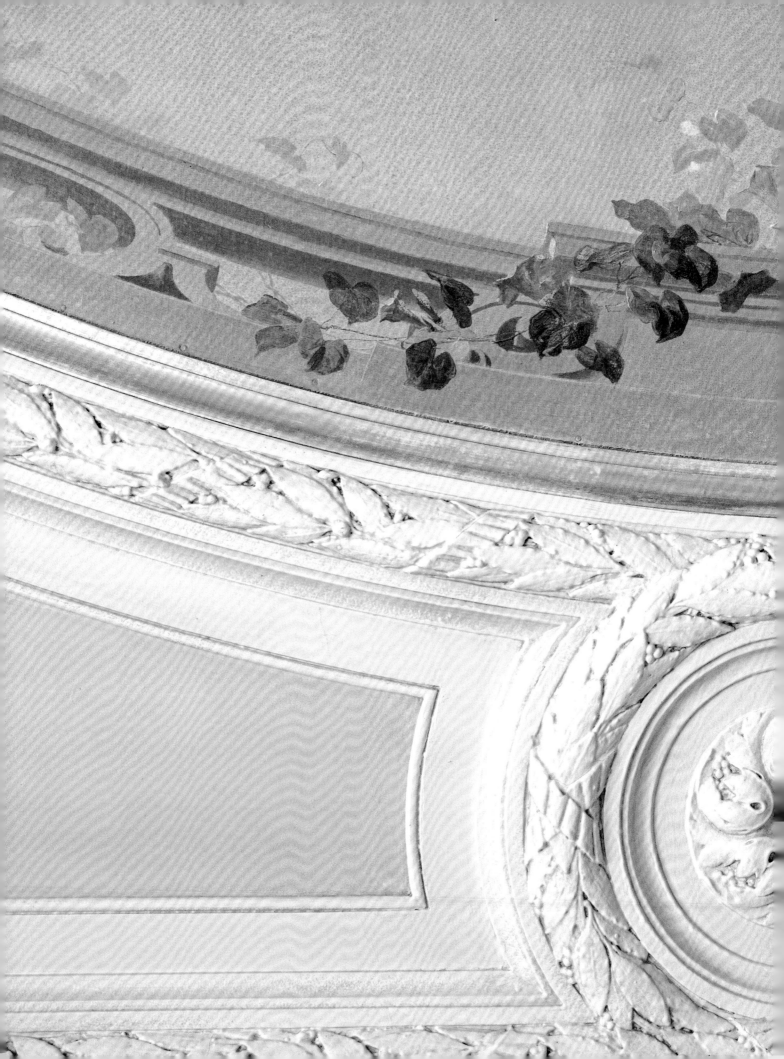

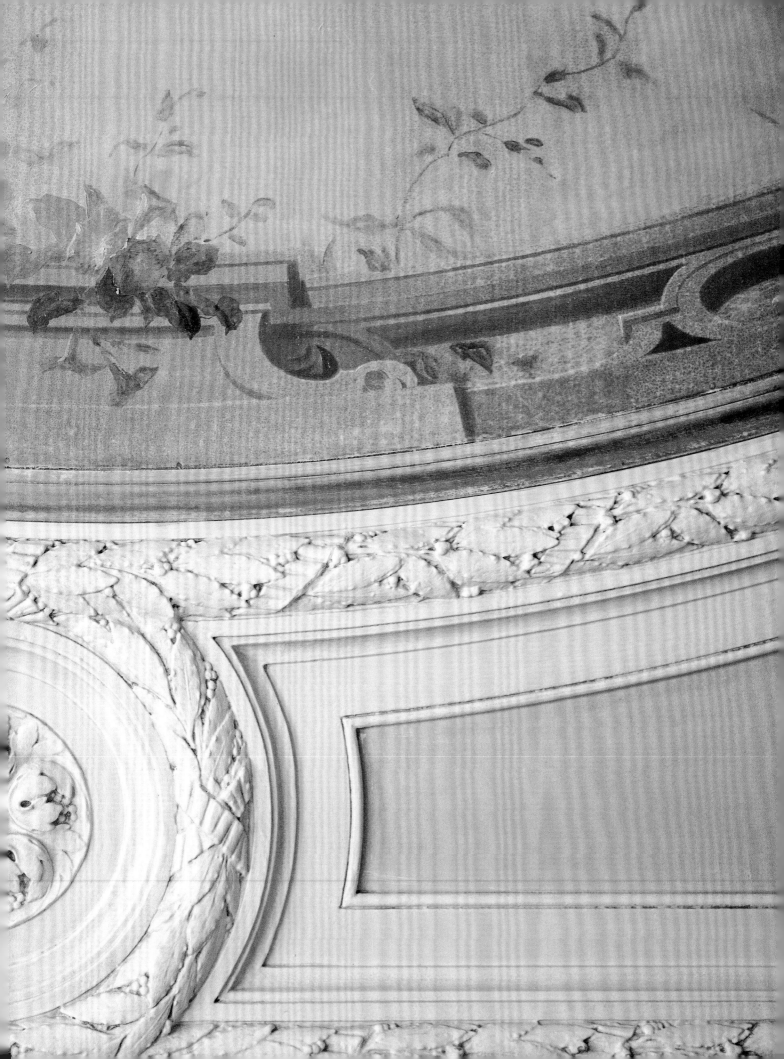

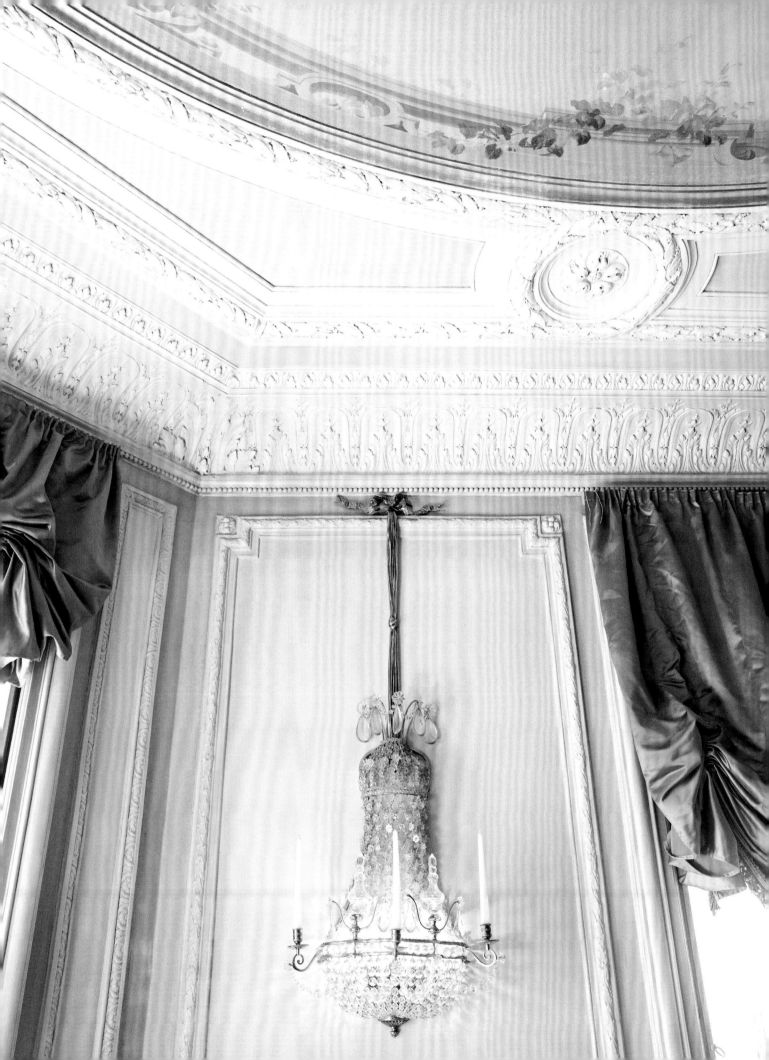

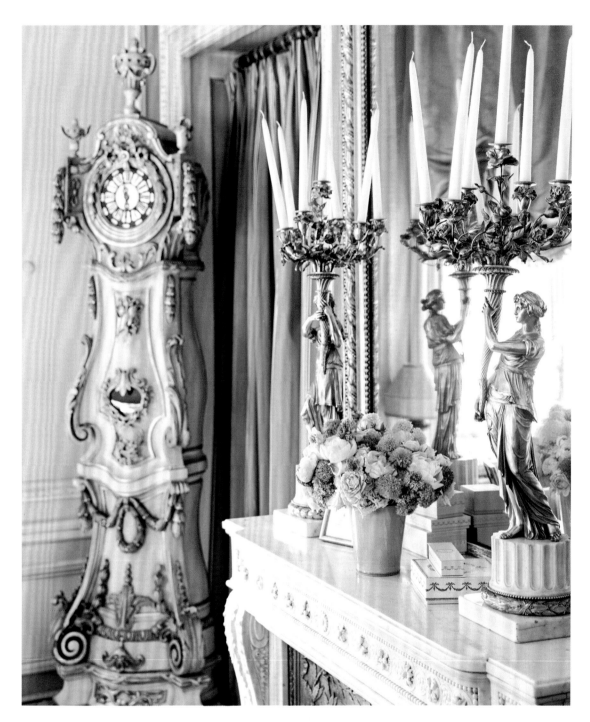

PREVIOUS PAGES Another chance to appreciate the beautiful interior architecture of this unique Parisian landmark. Handpainted flowers on the ceiling of the Ladurée Tea Room are glorious to me in both palette and design—while completely traditional, the floral handiwork has a whimsy to it. **LEFT** Belle Époque decoration at its most belle: against a background of celadon green and dusky blue silk, tiny flower-shaped crystals make up a grand chandelier candle wall sconce, complementing the petal and floral décor. **ABOVE** Ladurée opulence captured in the corner of the tea room, with a perfect palette of greens and golds and unashamed Baroque twiddles. Their signature packaging in pink and green with gold swags has remained unchanged for many years. Amy added lilac, pink peonies, and roses.

NORWAY FLORAL DREAMS

This was definitely a voyage a long way from my comfort zone. The cool, pale light of Northern Europe is not something I've experienced before. I live in a consistently warm climate with windows open to a warm breeze, abundant nature, and mostly blue skies all day long. My curiosity to explore Norway came via the soulful paintings of Norwegian artist Jorunn Mulen, of whose work I have been a fan for many years, and that I now collect and sell in my shops. Jorunn uses a palette that has always intrigued me. It is pale and pink and blue with dashes of drama, but at the same time there's a mystic veil of light that complements my romantic world.

So, with my small team, we set out for Jorunn's home town and the magic of her mystical Northern light. We journeyed to Bergen, Norway's second city on the southwestern coast, an area surrounded by mountains, fjords, and glaciers. It was a long way to come for one location, so I asked Jorunn to find us an interesting second location in contrast to her tiny white painterly apartment, to discover more about northerly flowers and floral decorations.

Jorunn steered us to the most amazing place: The Damsgård Museum, a beautifully maintained grand country mansion dating from the 1770s, now a museum of the life and times, and a fantastic example of Norwegian Rococo architecture. I couldn't have asked for more of a contrast. In these often dark, subdued, colorful, and dramatic interiors I surprised myself by discovering my inner Rococo.

On my photographic travels I always take with me a traveling roadshow of props: ribbons, fake flowers, and a couple of watercolor paintings if needed to give my signature here and there, but still I had to find some local flowers for the shoot. Through Jorunn's guidance we lucked on two amazing florists, Atelier Flora and Toneblomst, and with their selections and copious amounts of wild roadside jasmine I did floral justice to Damsgård. I found it strange that a small bunch of baby's breath (typically quite affordable) was the same price as a generous bunch of glamorous garden roses, due to the northern scarcity of baby's breath I learnt.

FADED FLORAL GRANDEUR

Bergen's heyday was toward the end of the eighteenth century. To display their wealth, rich and powerful families built large, luxurious country retreats in the surrounding areas, and the finest of all these homes was Damsgård, built in the 1770s for the then Minister of War, Gyldenkrantz. This important example of grand domestic architecture has been lovingly put back together as the family home it once was, and the restoration is a resounding success. It's a museum that doesn't feel at all like a museum, you can imagine that the Gyldenkrantz family have just popped out for a moment and will back at any time. Perhaps one of them came back a bit too soon! At one point, Amy left her camera set up upstairs while we all came down to check on something, and on returning, the camera cable was on the floor, the metal connection bent. We continued with other equipment, but on later inspection the camera was found to be completely twisted inside, as if something very angry had happened to it. I hope I didn't disturb Mr Gyldenkrantz, and once he sees the photos he will understand how much I appreciated his beautiful home!

It was a cold, rainy July day when we went there, and apart from the camera incident, the aura in this whimsical and romantic home was friendly and welcoming, as were the knowledgeable and protective live-in guides, Ingrid and her daughter, who typically facilitate tours of the property. The museum is also open for functions and events, so there are working kitchen spaces with twenty-first century luxuries such as electricity, fridges, and hot water.

The patina of centuries give the interiors that time-worn faded grandeur I so love, and although I was impressed by the breathtaking richness of some of the larger rooms, I found myself drawn to the smaller domestic spaces and forgotten little corners. The floral arrangements here are entirely my own, so no wire or foam and no symmetry, which seemed to suit the surroundings and the perfect Georgian proportions.

PREVIOUS PAGES A fantasy party, using a flower-strewn cake from Violet Cakes, a small but charming bakery in London's Shoreditch, that I carefully carried on my lap in the taxi, train, and plane to Norway. While the cake itself remained intact on its long journey, I did have to replace the signature Violet Cakes fresh flowers with bluey-pink chrysanthemums and baby pink roses. The cakes are beyond yummy, but I particularly love that not-quite-perfect home-made look of the lumpy and irregular frosting. Jorunn lent me a white lace tablecloth, which set the stage in front of a dark crudely painted Georgian mural.

RIGHT I love this storytelling photo —an Alice in Wonderland of rooms leading to rooms. The abundant display of jasmine was cut from nearby hedgerows and balanced out with baby's breath, the shedding petals on the subtle but splendid wooden floorboards and the slightly wonkily aligned chandeliers are whimsy at its finest. In any other context, mustard-colored walls with a red trim would be a no-no for me, but here I bow before a perfect choice.

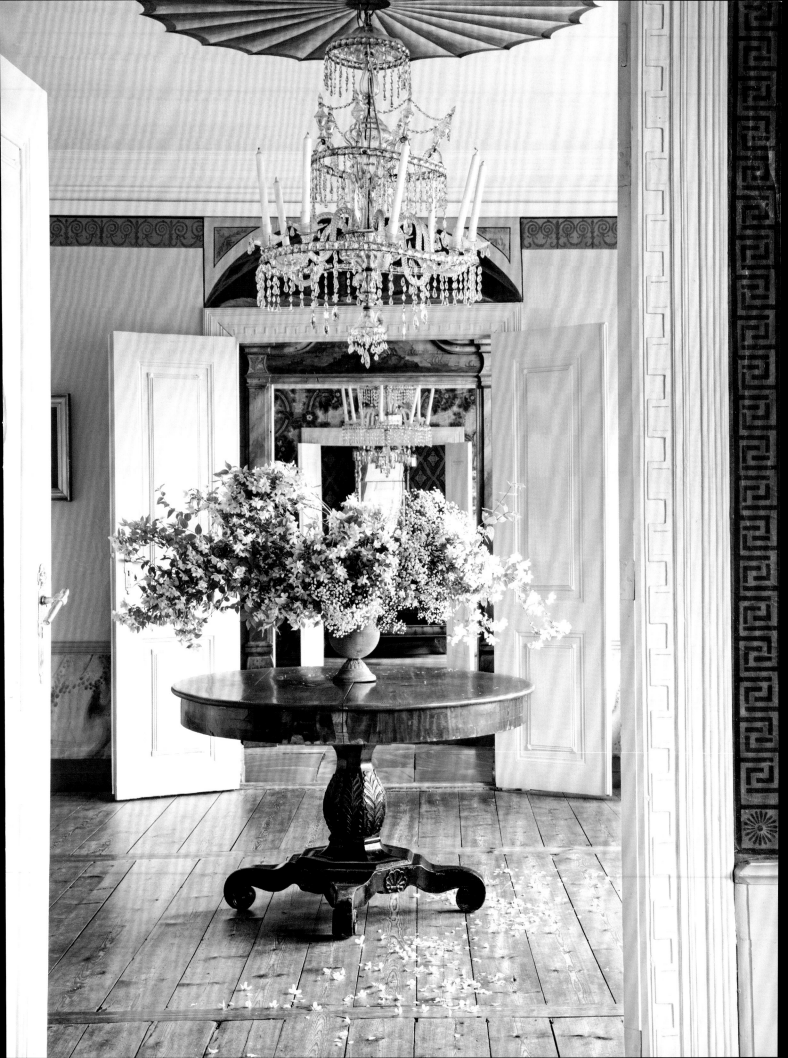

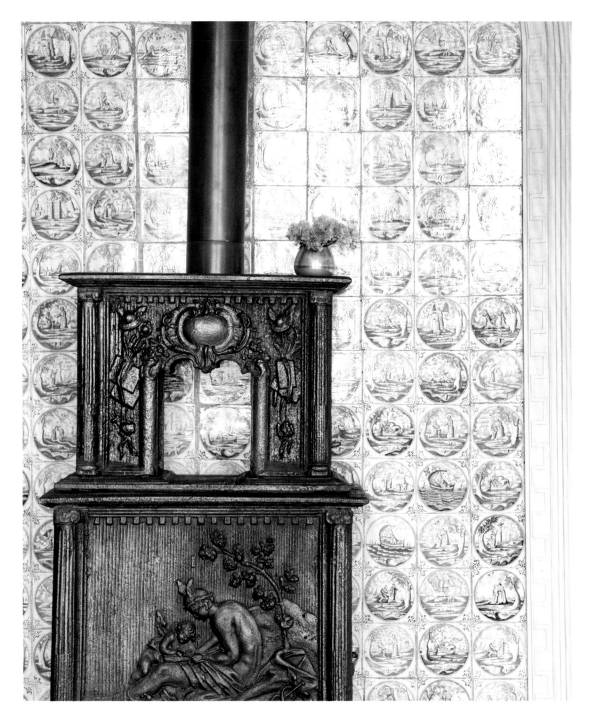

ABOVE Wood-burning stoves were necessities to sustain life way back then. I love the juxtaposition of the pretty purple Dutch tiles, which I complemented with a tiny pot of purple carnations. **RIGHT** Rooms meander from one into another. While much of the palette of this property is outside my comfort zone, like the red key pattern trim, somehow the eclectic combinations of history felt romantic to me. I loved imagining the tunes played on the piano and I left an offering of a copper pot full of roses and hydrangeas in two shades of smoky pink. **OVERLEAF** Gorgeous blue thistles were a new adventure for me, complementing the dramatic eighteenth-century wallpaper. I wanted to capture the perfect pale green door and the color key of the palette over the centuries. A perfect moment for me to leave my mark: my French silk flowers and a crochet-covered hanger from my traveling prop box.

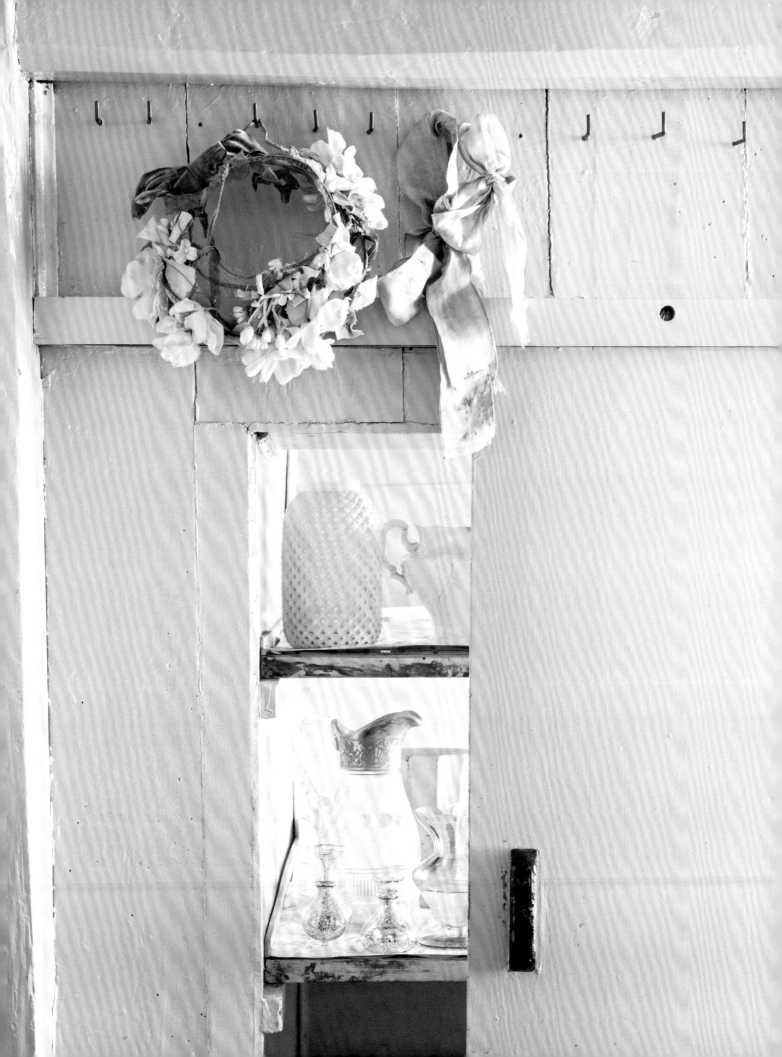

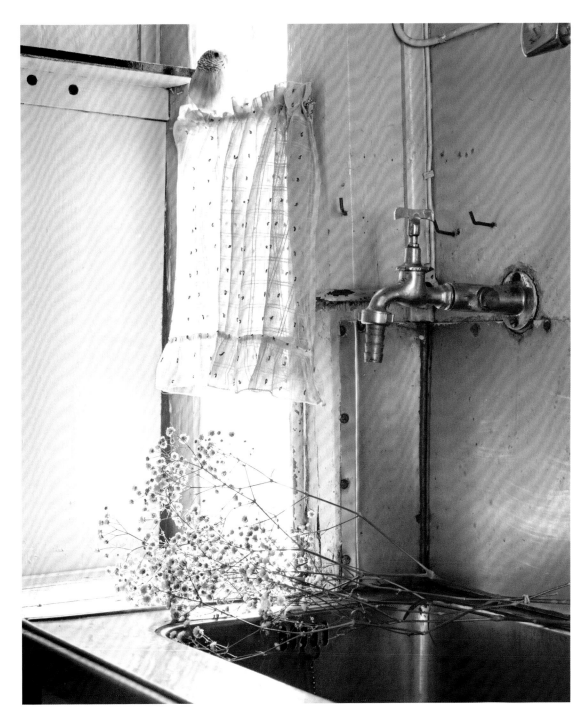

LEFT The wonderful blue of the primitively made cupboards and simple screw-in hooks are such a good example of personalized and practical prettiness. While the floral hats are from my prop box, the hodgepodge floral vases live on the property. **ABOVE** I love a utility sink, here made to feel less abandoned with a little ruffley curtain. I popped a little blue bird in just for storytelling. **OVERLEAF** The museum's pantry is an eclectic mix of historic colors that I would never have thought to put together, but in this context they sit comfortably together, and I was surprisingly inspired by them. In the dark, cold days of a Norwegian winter where a pale palette may lack warmth and light, a cheerful pop of turquoise is sure to bring some relief. I found the jasmine in the street, and used swathes of it. I often think carnations get forgotten, but to me they are the unsung hero, affordable and lasting forever. The overall tones of the flowers are smoky with a little bluey pink, which I just love (always avoiding peachy and salmon hues).

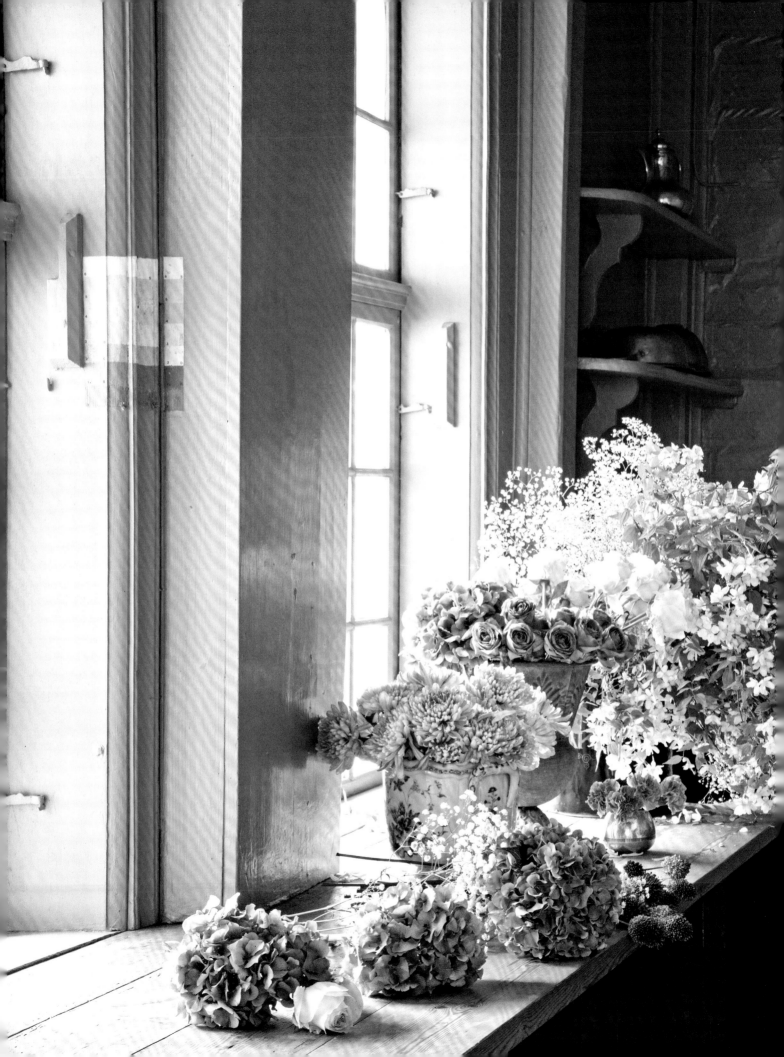

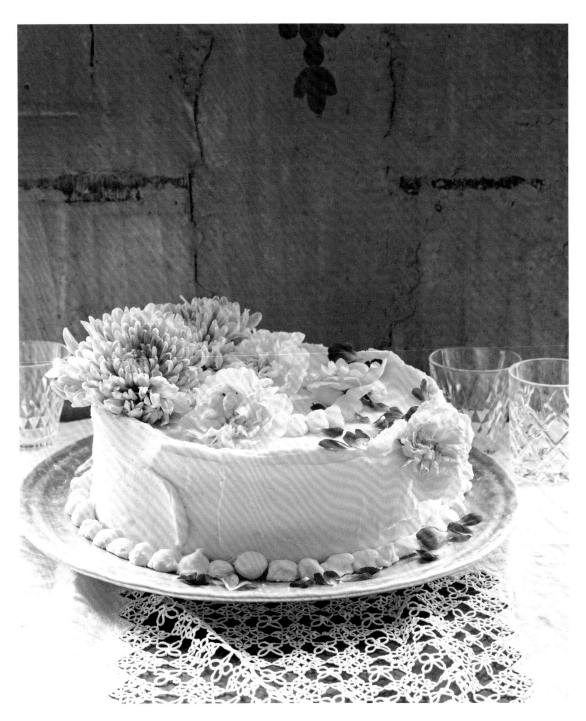

ABOVE AND LEFT The well-traveled cake just beautifully imperfect. Also from Violet Cakes are some perfect-palette cupcakes, which I placed on a piece of vintage wallpaper from my traveling roadshow. **OVERLEAF** A fairy-tale silken canopied daybed with a floral eiderdown. Not my signature palette but the faded grandeur keeps it soft and romantic. The graphic eighteenth-century wallpaper is relevant 300 years later and the tapestry-covered chair is beautifully timeworn. I chose the casualness of pinky-blue chrysanthemums with bright pink shedding roses in a wine glass to complete the study of the beauty of imperfection. Against the blue door, another touch from my treasured accents of magic: the wonkiest of hangers with a whimsical tattered floral and tulle crown, making visual poetry. **FOLLOWING PAGES** An unexpected treat was an astonishing *trompe l'oeil* mural in the formal dining room: green, dramatic, and far removed from my color comfort zone, but it's explosively romantic. Hydrangeas and roses are massed in a stone urn that just captures the grisaille of the chubby cherubs.

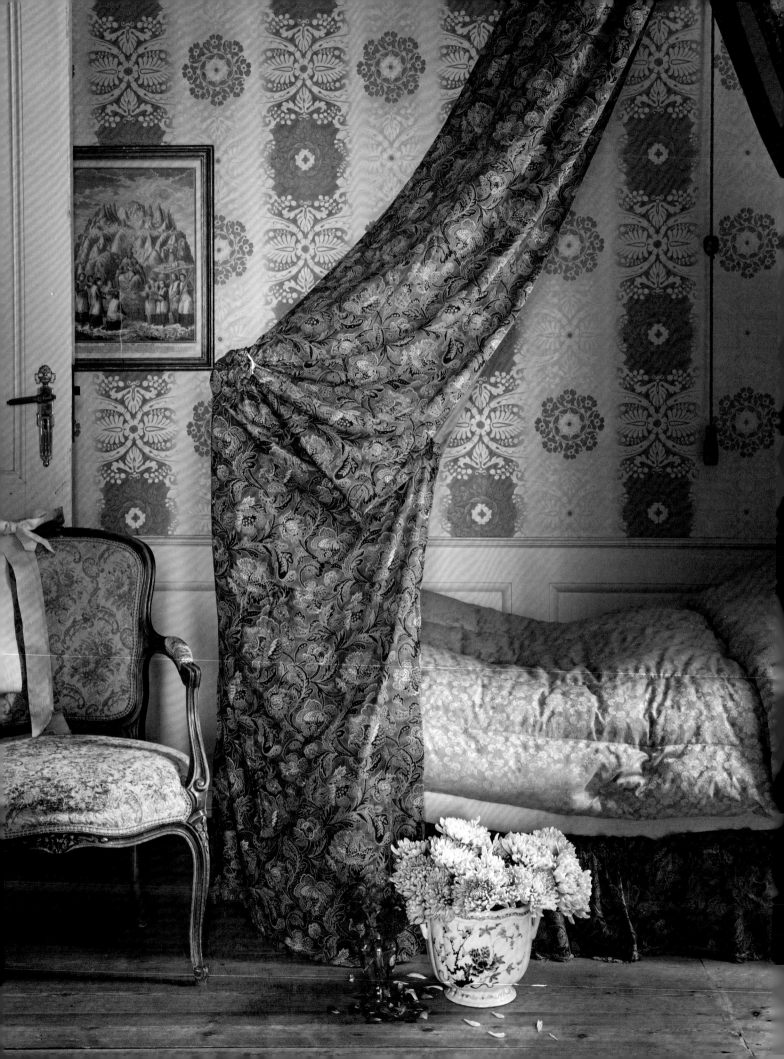

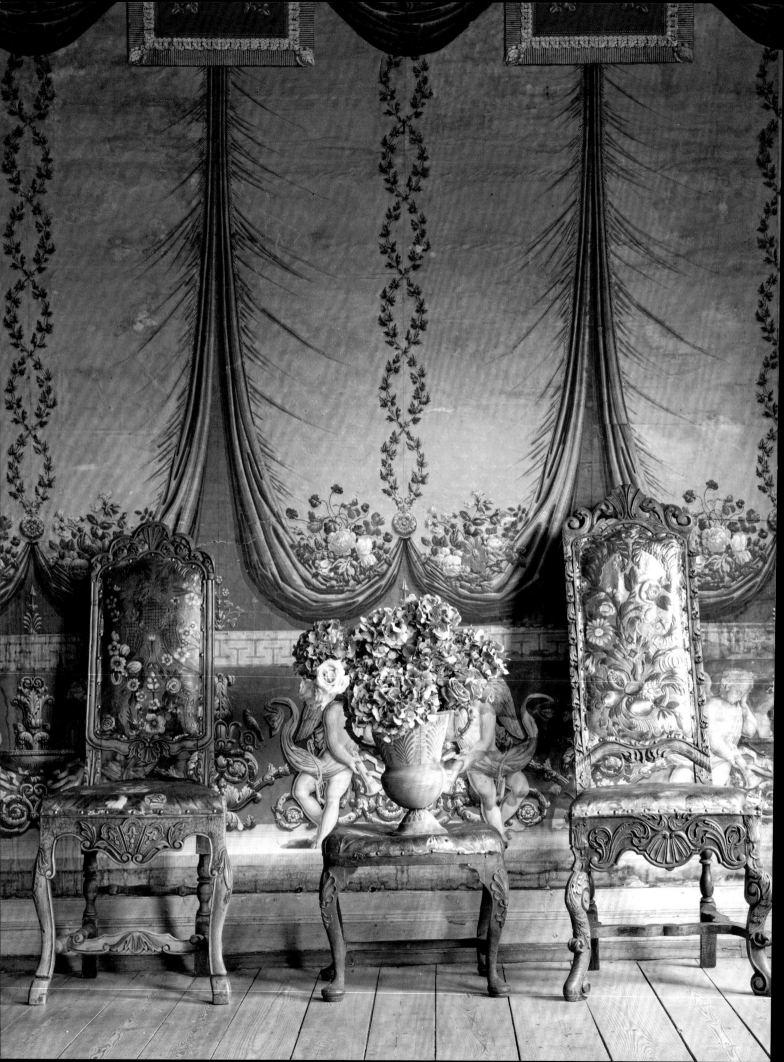

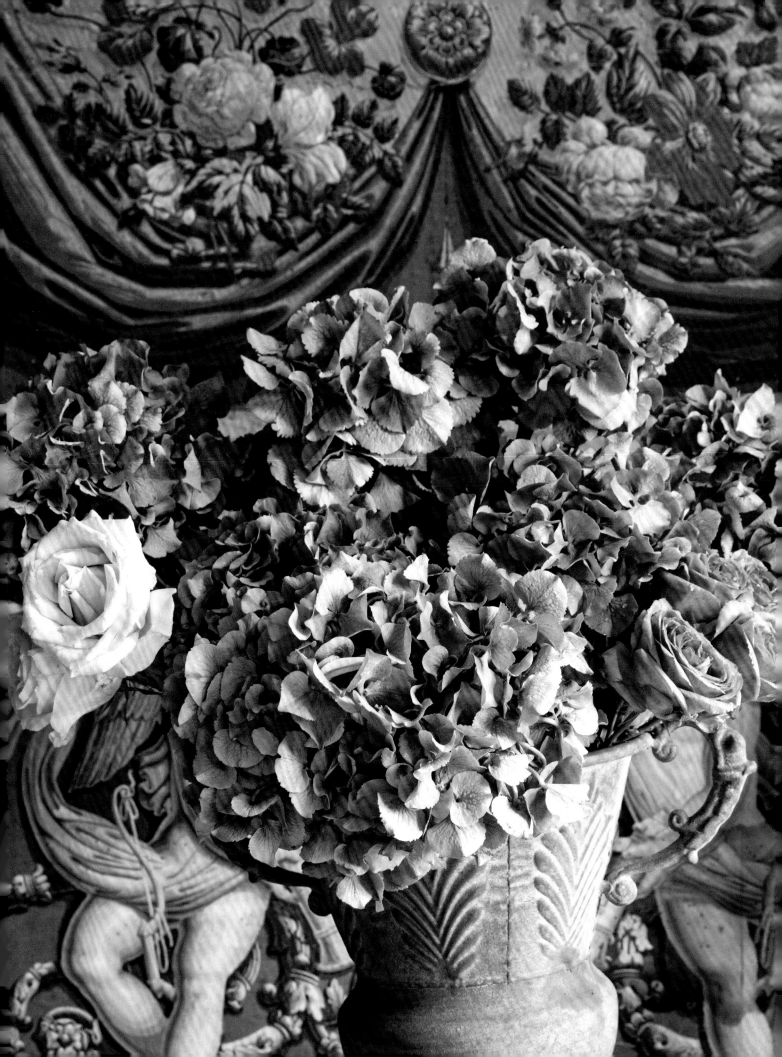

POETIC PORTRAITS

Jorunn Mulen returned to her native Norway after studying and working in Cornwall, England for many years. She now lives a simple, satisfying life with her daughter in a tiny white humble apartment on a hilly cobbled street in Bergen. I've known and loved her work for some time. She paints what she refers to as Poetic Portraits: haunting, intriguing faces that emerge from layers of watercolor on paper or acrylic on canvas. For the most part, she does not paint portraits of specific people, but rather builds up layers of experiences that result in beautiful and beguiling stories, leaving the viewer to fill in the gaps. She sells her work through galleries and shows in England and in Norway, as well as through my shops and website in the USA.

The little home also houses her studio, so when we all arrived we were a bit of a whirlwind. Jorunn's neighbor generously let us stay in her apartment. It was humble and inspiring, reminding me just how little we need to function and be happy. We were there in the Nordic summer months, where it hardly got dark. It was an adjustment to go to sleep with only four hours of darkness, but we took advantage of it, capturing the elusive quality of nearly midnight light. I'm sure the opposite of just a few hours of winter daylight is even trickier to deal with.

Jorunn's relationship with simplicity is what enables her to live in such a small, poetic space. She is content to surround herself just with what she needs as long as it pleases her eye, so her home is clean, orderly, and pretty. It also bears witness to her travels and her art, as there are works in progress pinned or clipped up everywhere, along with splashes of paint that you would expect in a working studio. Jorunn's floral contributions were appropriately simple and humble, mostly single stems of hydrangeas or baby's breath.

As I reflect back to my visit with Jorunn, I am reminded of the simple and beautiful life she leads. Her portraits are able to capture an ethereal quality of peace and calm, as though the noise of daily life doesn't enter her world. Peaceful memories.

RIGHT Jorunn displays her paintings casually, always changing as they sell and new pieces are created. This watercolor on paper portrait, *Anticipating April*, hangs from a bulldog clip attached to the wall in the dining space. On the traditional mahogany table, she placed a bouquet of jasmine, gathered from the alleyway outside the house, in a simple glass jar. I loved the slightly worn pale blue on the painted chairs—her home reflects the palette of her paintings.

OVERLEAF The tiny kitchen, with just enough of everything she needs stacked on the shelves. The little loose tiles are an installation in waiting: when she has gathered sufficient, she will attach them to the worksurface. A work in progress, *Powder Blue and Pale Pink*, is propped against the wall, and on the windowsill, hydrangeas and Cool Water roses—just a hint of pink to honor those lips. The door leading to Jorunn's studio needs no further embellishment than her paint-splattered overalls.

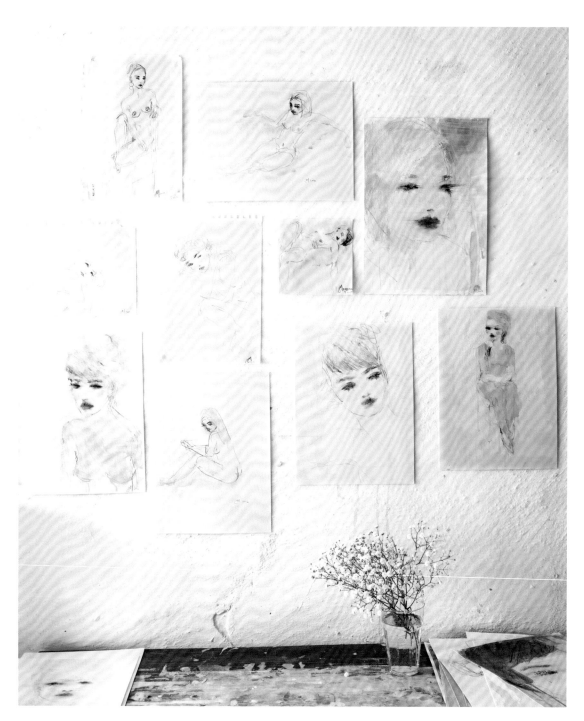

PREVIOUS PAGES The studio in all its orderly, cluttered, creative glory. Here was the magically cool light we had come so far to see, touching at the window and highlighting those wonderfully wonky walls. The humble flowers: a few hydrangea heads and a separate glass tumbler of baby's breath offer a subtle complement to this perfect, peaceful scene. **ABOVE** Sketches on the rough-plastered wall of the studio: quite the epitome of cool Nordic light. A tiny bunch of baby's breath softens and is peaceful. **RIGHT** Jorunn's daughter's tiny bedroom is pretty and cozy, like a living dollhouse, her curated possessions on orderly display. The small table could only accommodate a tall skinny vase, so I popped in some jasmine and a blushing hydrangea for a touch of pastel color. A beautiful example of humility.

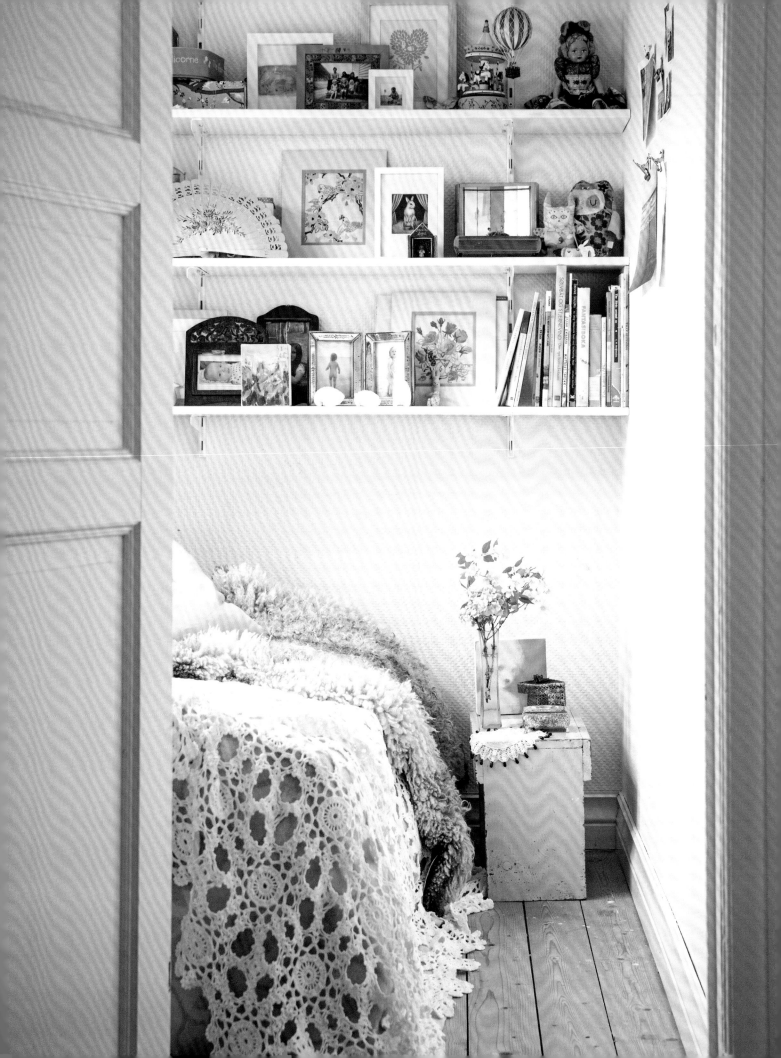

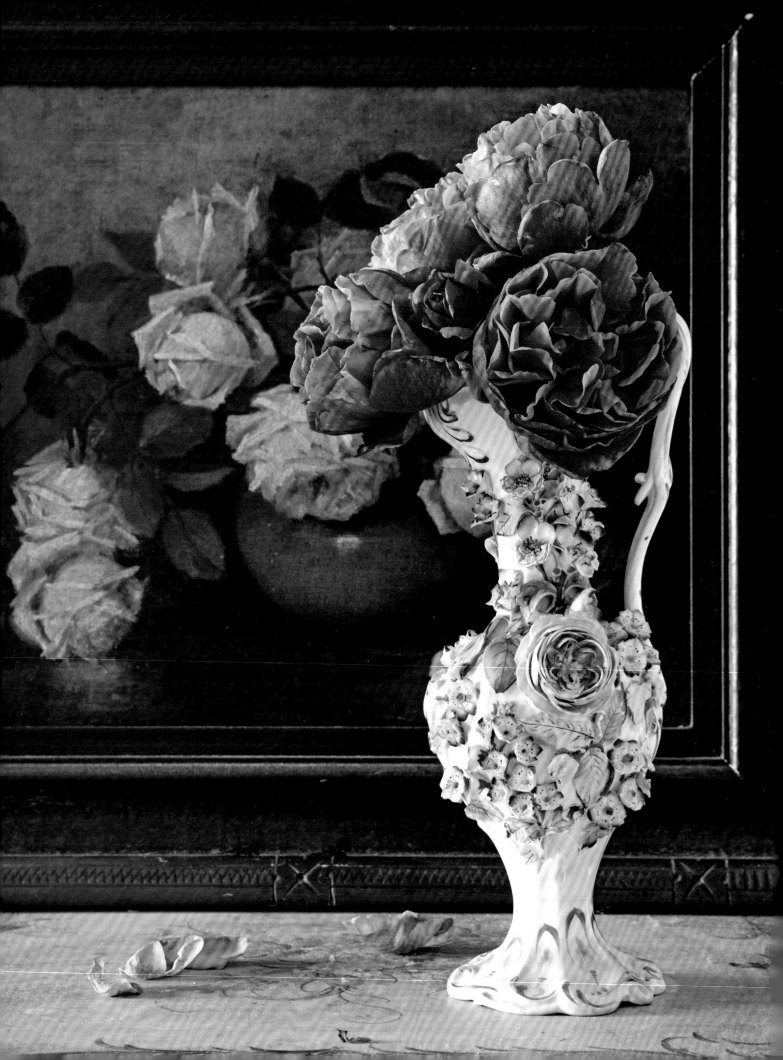

BLOSSOMS & BEAUTIES IN THE USA

Nearly forty years ago Los Angeles became my adopted homeland. While the climate couldn't be more opposite to England, it was never a consideration for me not to have a classic English rose garden. Recently, of course, there has been a big movement toward drought-friendly gardens due to climate change, but my passion for roses continues. At The Prairie, my bed and breakfast in Texas, an abundant blossoming garden just isn't an option, so there I am thankful for the small mercies of bluebonnet wildflowers, the sacred yearly visits of wisteria, and the acceptance of fabulous fake flowers from time to time.

I don't consider myself a gardener or a landscape designer, and I truly don't have a green thumb. But I do have a spiritual connection to the beauty of blooms and a vision that translates into a floral heaven in my garden. I also don't consider myself a floral designer, and I fumble with wire and foam, but combined with my forever-growing collection of flea-market vases, I intuitively find myself able to create arrangements that reflect my design values and aesthetics—the beauty of imperfection.

While typically I fill my house with flowers from my garden, I do frequent the local flower markets when I'm working on a special project or event. It is there that I am spoiled for choice with flowers shipped in from all over South America, Asia, and Europe, as well as locally-grown flowers from the nearby farms. Los Angeles, known as the land of glamour and make-believe, benefits from a plethora of choice of sometimes decadent proportions. I consider myself a disciplined and slightly restrained person, but when it comes to the flower market I have a hard time resisting "just one more."

While natural, classic, traditional flowers will always be my comfort zone, I am little by little educating myself and experimenting outside of my palette with unexpected choices, and in doing so I am finding my floral affair expanding.

MY FLORAL WORLD

My Santa Monica garden is a heaven on earth of a mass of blooms: countless varieties of floppy cabbage roses, English garden roses, sweet lavender, hydrangeas, and fragrant gardenias. It's a bit atypical now in a neighborhood of easy-care lawns and drought-resistant shrubs, but from my balcony I do get joy observing passers-by literally stopping by to smell the roses, often calling up to me asking specific names. I'm not quite sure how I ended up with so many varieties and so many flowers have multiple names that I'm not always sure what is what, but I do keep on top of my original vision, with gardening help to keep plants healthy and bring organization to the chaos. It is a sanctuary of fragrance, peace, and a visual delight that conforms to my palette of pale pinks, deep teal, pastel blues, and white.

My garden serves many purposes. Due to its picture-perfect quality it is often the backdrop for photography for my business. The garden also has a healing role. On return from my frequent travels it is my safe place to reconnect: sitting on the back stoop, reflecting on my gratitude for my garden, filling me with peace and calm, while regenerating my creativity.

My home is officially an empty nest, even though my kids both have rooms for when they visit. But I feel it's too lovely a home not to share, so there always seem to be house guests. There is a sense of serenity as well as an inspiring creative energy in the house and I think the influence of forever-evolving beauty from the garden plays a valuable role. The interior of my home is a romantic floral delight, with flowers present in wallpapers, on dishes, and on painted furniture and fabrics. Romance doesn't stand a chance of escaping and while it is not overly sweet, it is overly beautiful, and my palette is consistent indoors and out. It is a very peaceful, fragrant, and calming environment that I am constantly curating in order to enhance its beauty and whimsy.

My floral world also encompasses The Prairie, my bed and breakfast in Round Top, Texas. Here, a harsher climate prevails, but I have worked around that to create a welcoming environment that feels refreshing to the spirit and as it is true to my palette, patina, and philosophy, it is a peaceful sanctuary of floral beauty.

PREVIOUS PAGES My preciously imperfect, fantasy over-the-top vase that I found for just a few pounds at Kempton Park antique market, near London. Filled with Yves Piaget roses, eccentrically brilliant it stands on a floral painted table in front of a rich painting of fading roses I bought when I opened my first store in Santa Monica. It's one of my few forever-to-keep treasures.

RIGHT My dining space opens onto the garden. All senses are satisfied by way of the captivating fragrance from the Yves Piaget and Francis E. Lester climbing roses and breeze wafting in, along with sounds from a little water feature in the stone basin on the left.

OVERLEAF My living room seating is slipcovered with my signature white linen slipcovers. Originally the floors in my house were all different types of oak floorboards, so to neutralize them I stripped them all, then whitewashed them and finally used a flat non-yellowing sealer. The robin's-egg blue over-sized trunk is a treasured flea-market find. Recently I made a pair of wood doors with glass embossed panels to give privacy without compromising the loss of light. In my own abundant and unstructured approach to flower arranging, I plopped two huge bunches of hydrangeas and Yves Piaget roses from the garden into a stoneware vase. Among the decorative art pieces, there's a painting by Laurence Amélie propped on the log overmantel. I don't often hang paintings on the walls as I like to keep them fluid, but I made the exception for my friend Kim McCarty's watercolor *Lovers* on the wall.

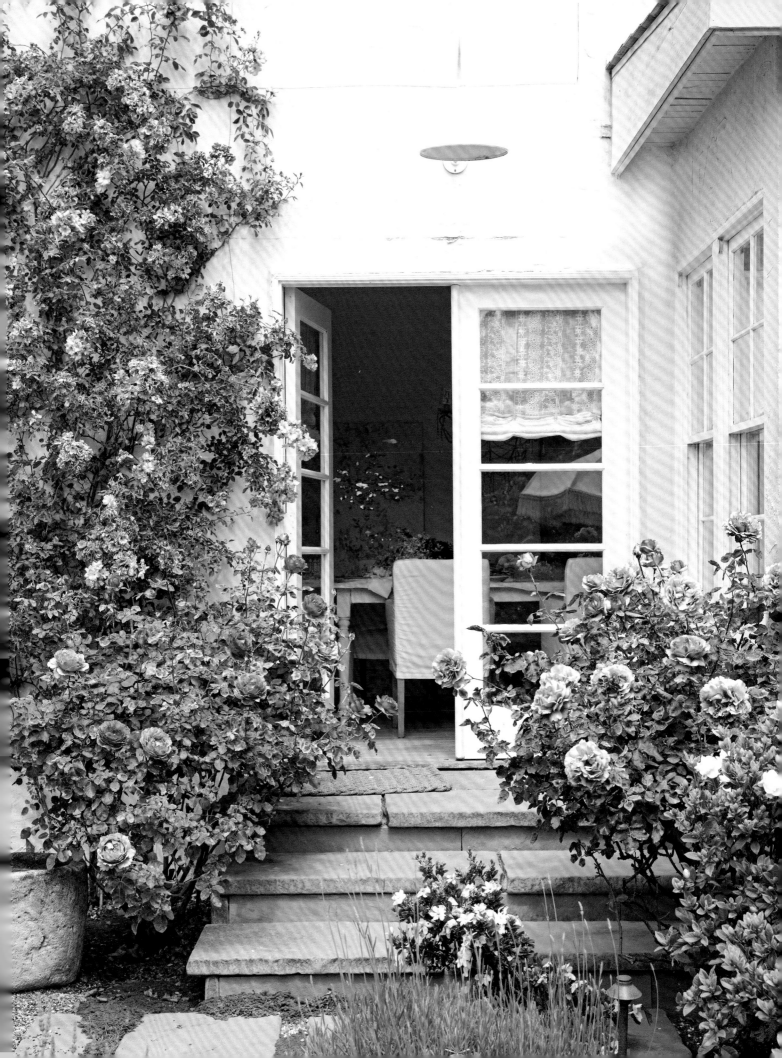

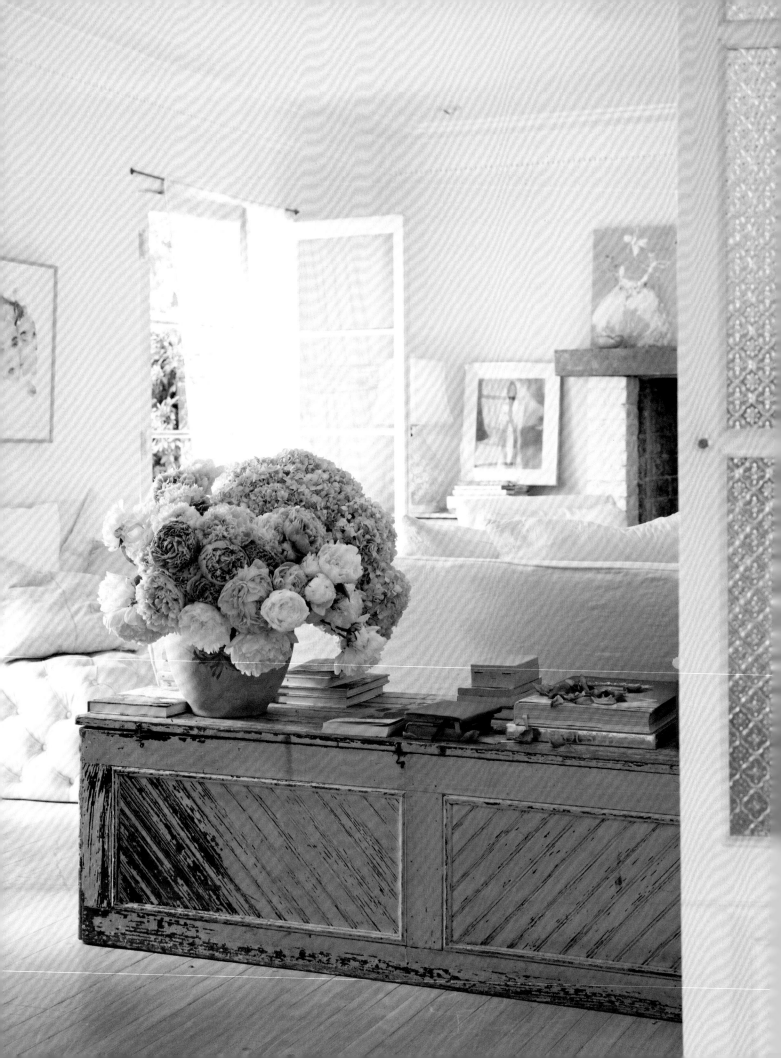

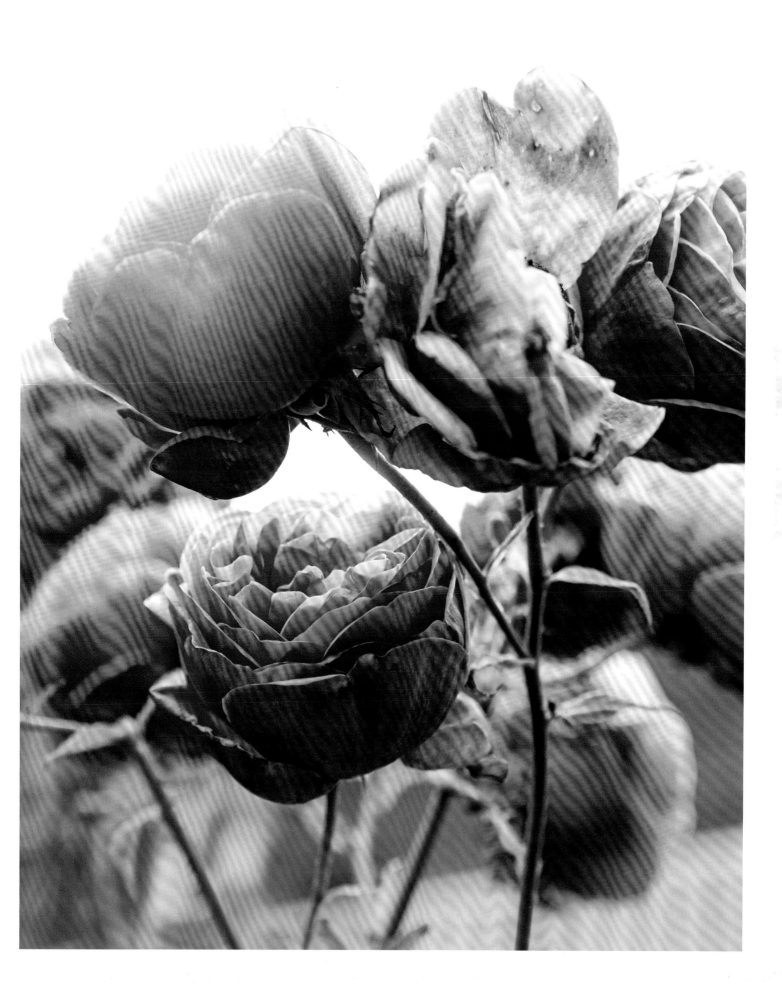

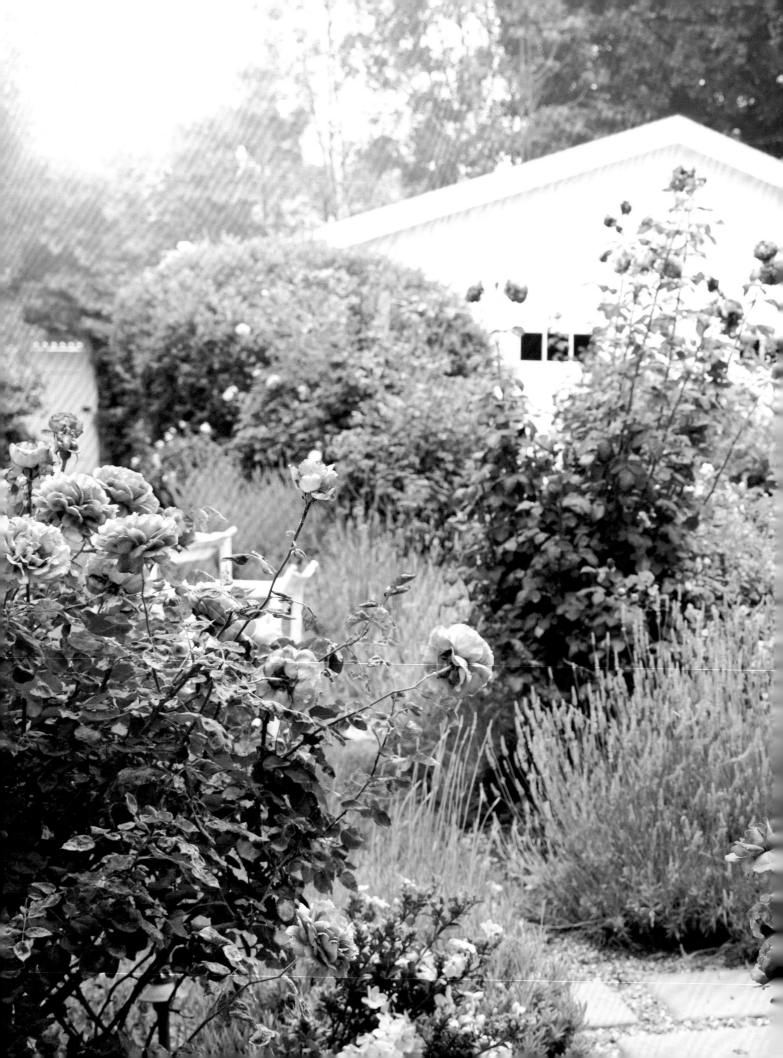

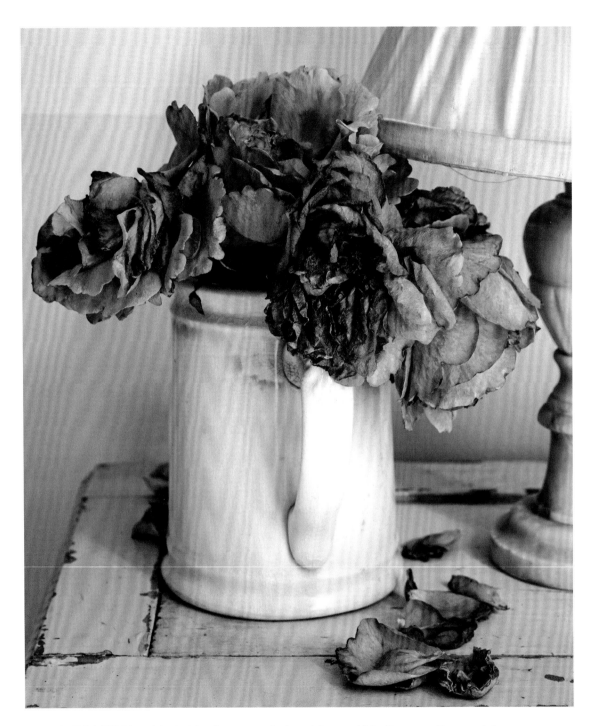

PREVIOUS PAGES My original vision for my magical garden was to have a wonky stone path, with billowing lavender and roses leading to my back gate. These are mainly a mixture of David Austin roses. The big white barn at the back is used for photo shoots, parties, and from time to time as a painting studio for Laurence Amélie, visiting from Paris. **ABOVE** A jug of roses toward the end of life, but not yet ready to depart. **RIGHT** My kind of art project, simple and quick, made with a branch, some string, and fake flowers, with no real rhyme or reason. Just layering the flowers until a sweet something came together. **OVERLEAF** A primitive floral hutch in my kitchen that celebrates the beautiful patina and stained imperfection of vintage wallpaper panels. All my everyday vintage dinnerware is stored in the chicken-wired cupboard above. The silver lining to it not being dishwasher-safe, due to the floral designs fading, is the time for after-dinner conversations while washing and drying by hand.

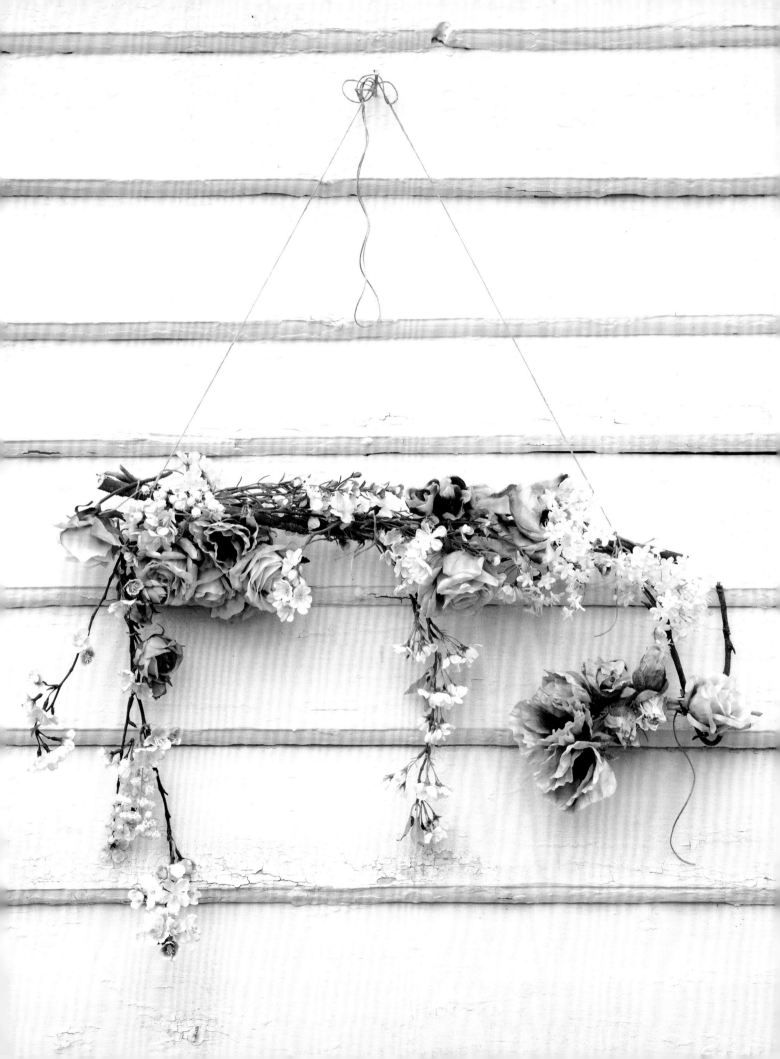

13 11 95

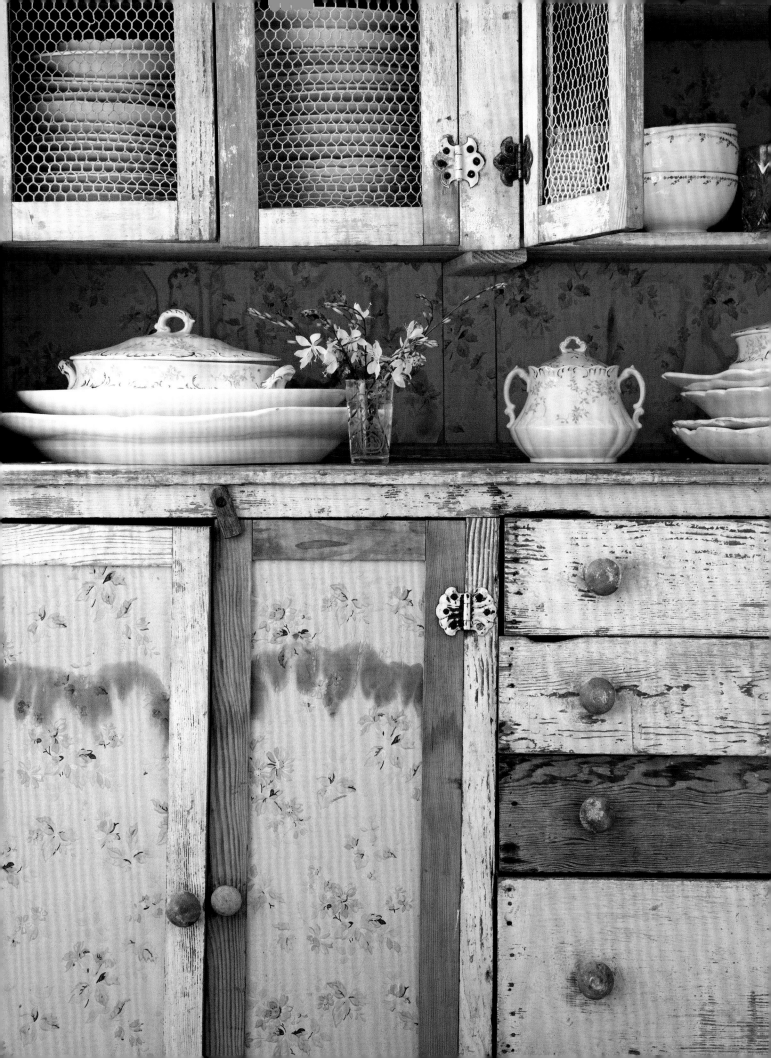

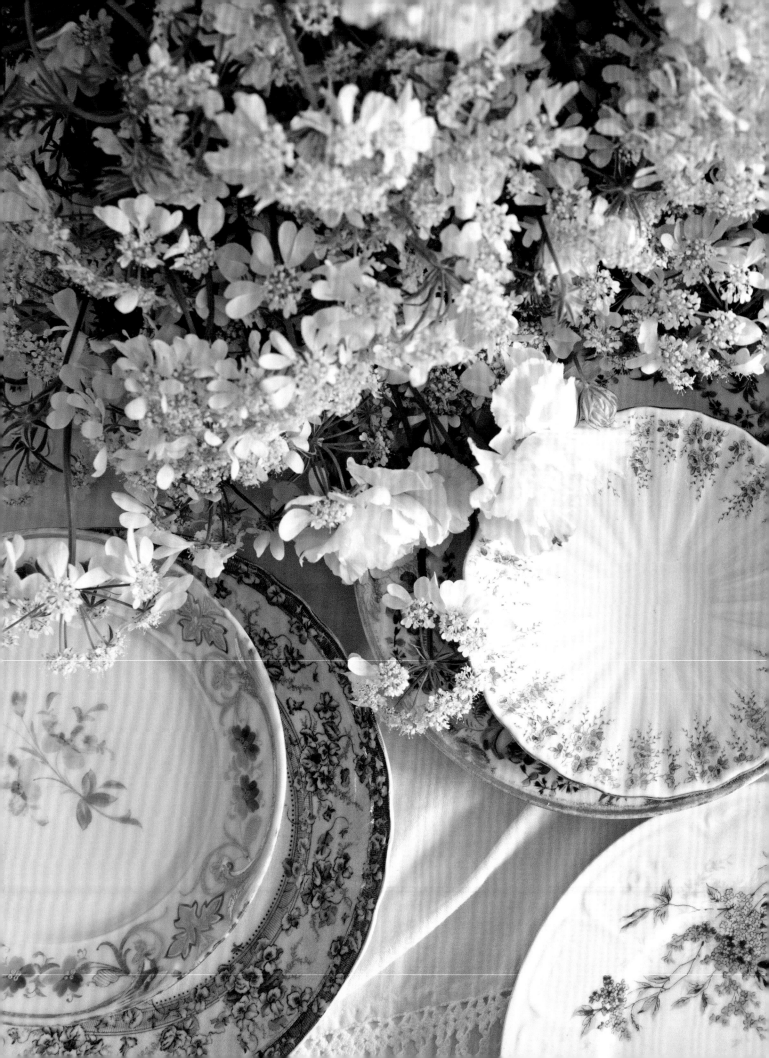

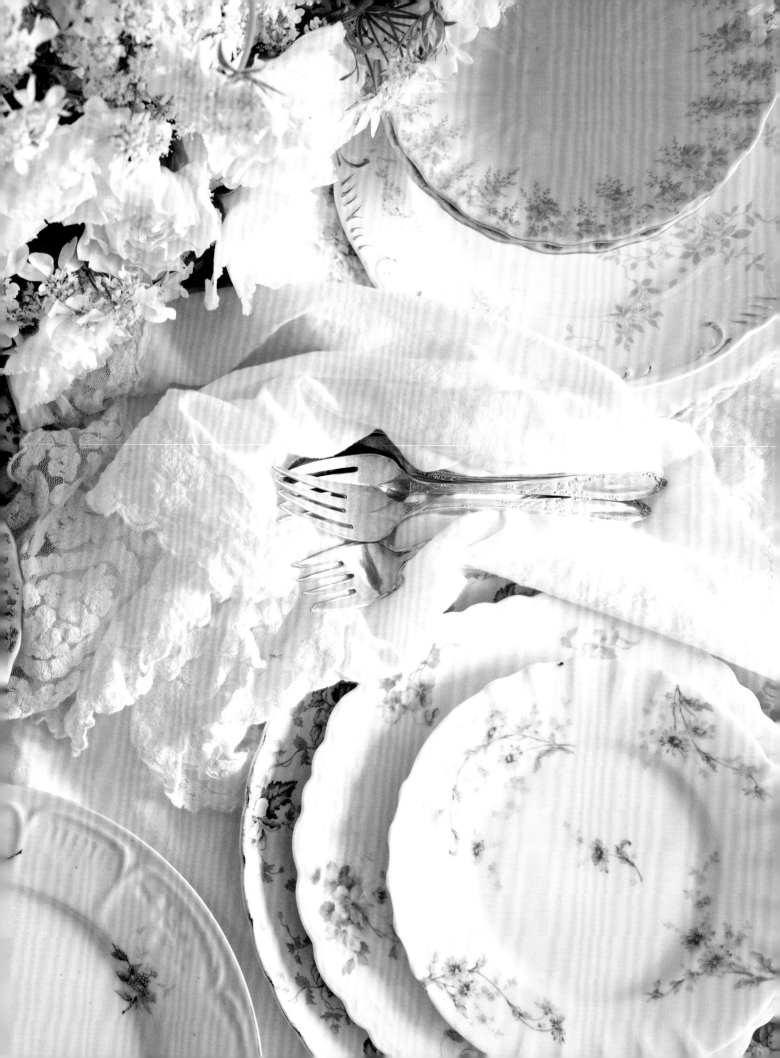

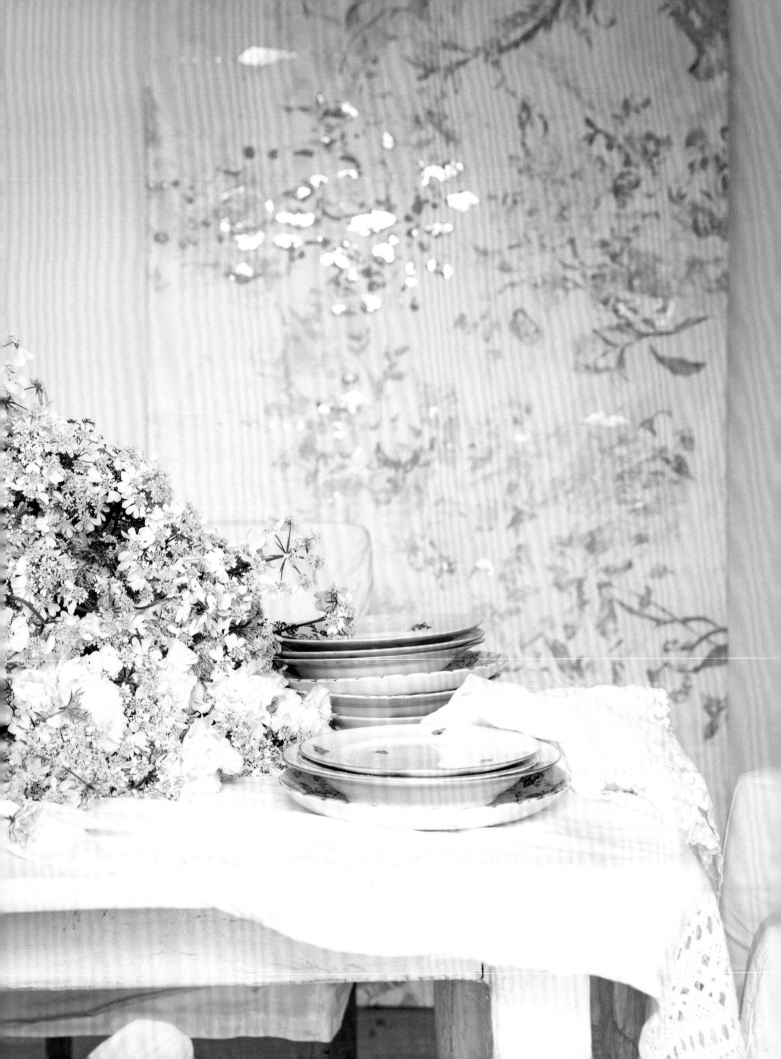

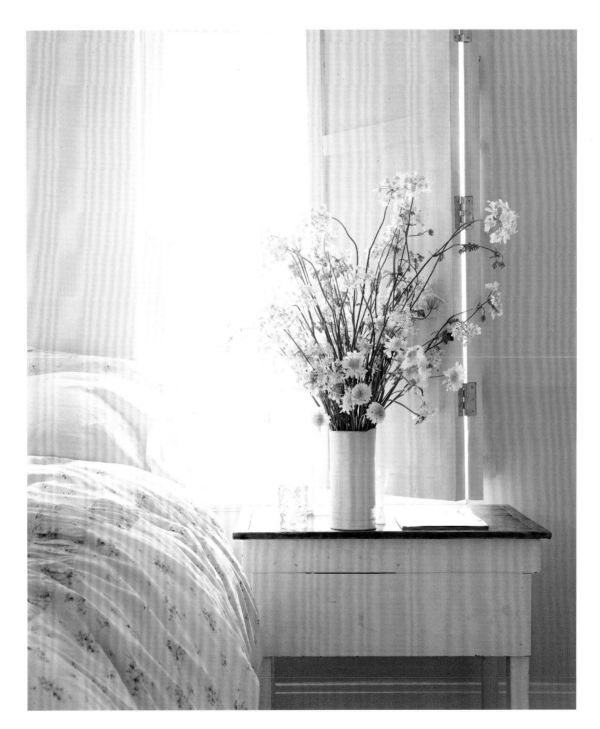

PREVIOUS PAGES I have quite the collection of mismatched dinnerware, typically quite affordable as often they are leftovers from larger sets. These mismatched beauties may have had a more glamorous life but now they are put to use for humble as well as decadent meals. **LEFT** Against the backdrop of a floral painting by Kinley Winnamen is a table stacked with mismatched dinnerware and a huge unstructured mound of flowers: lisianthus and white saponaria. Silver accents in the painting give a sparkle. **ABOVE** This is my son's room. Now it doubles as a spare room, so a floral duvet has crept back in. The whimsical white-on-white flower arrangement is bachelor's buttons, saponaria, and Queen Anne's lace. **OVERLEAF** A glorious straggle of gaura in my garden, wispy and whimsical.

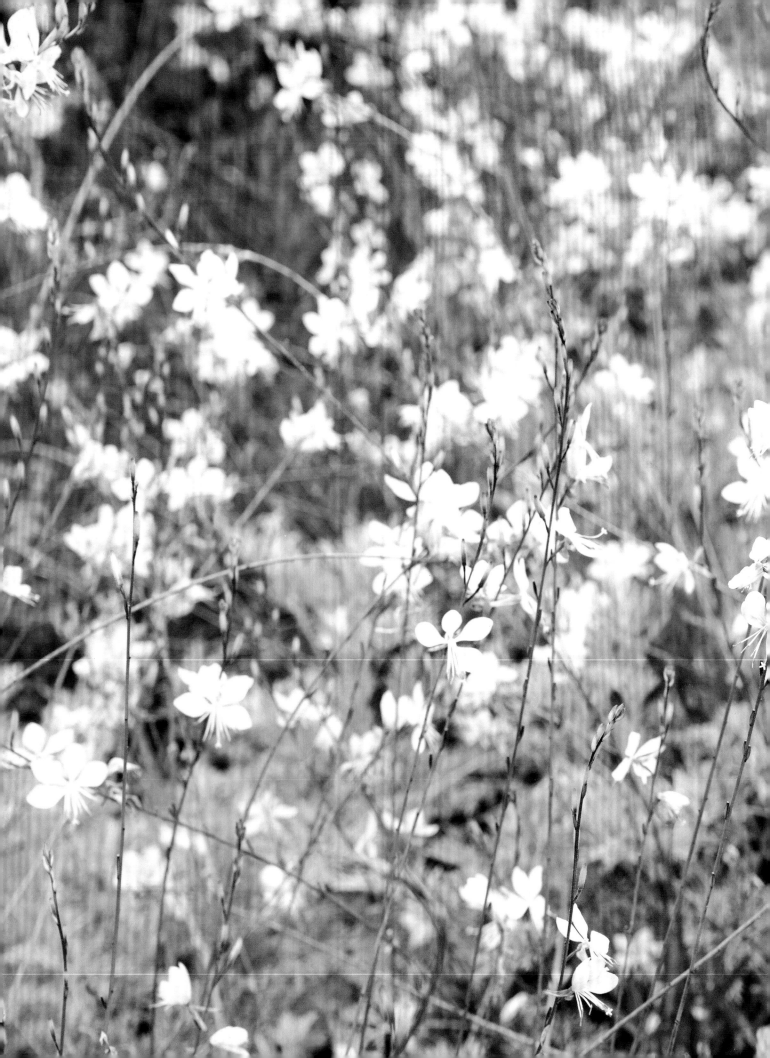

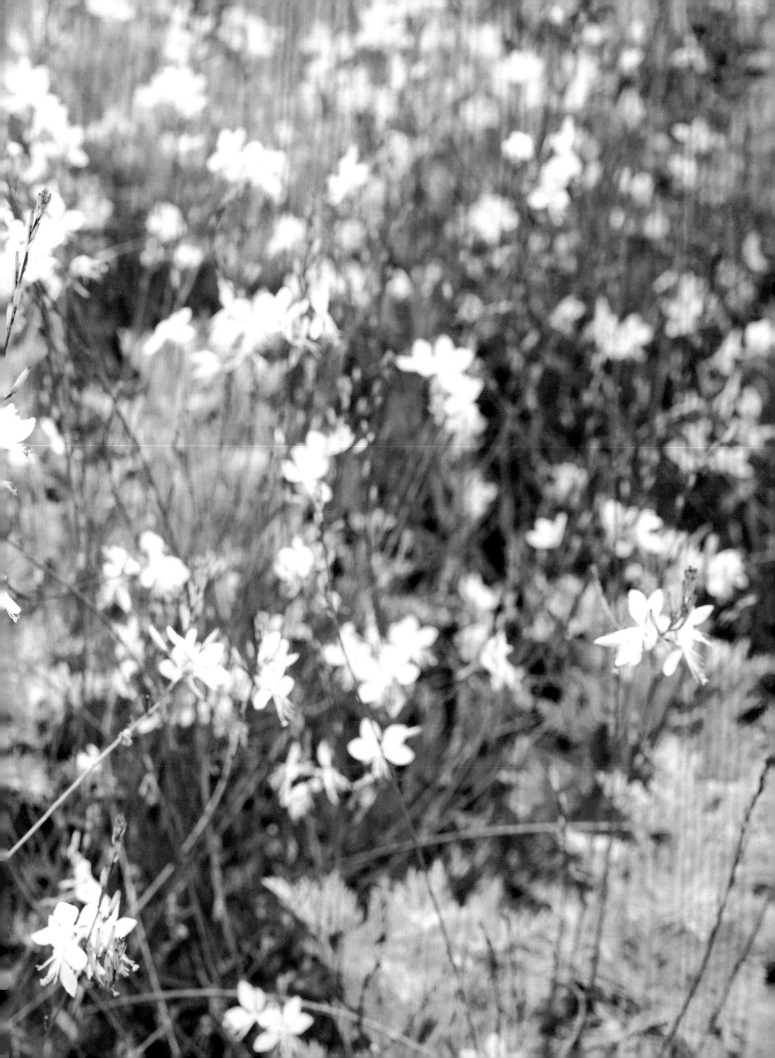

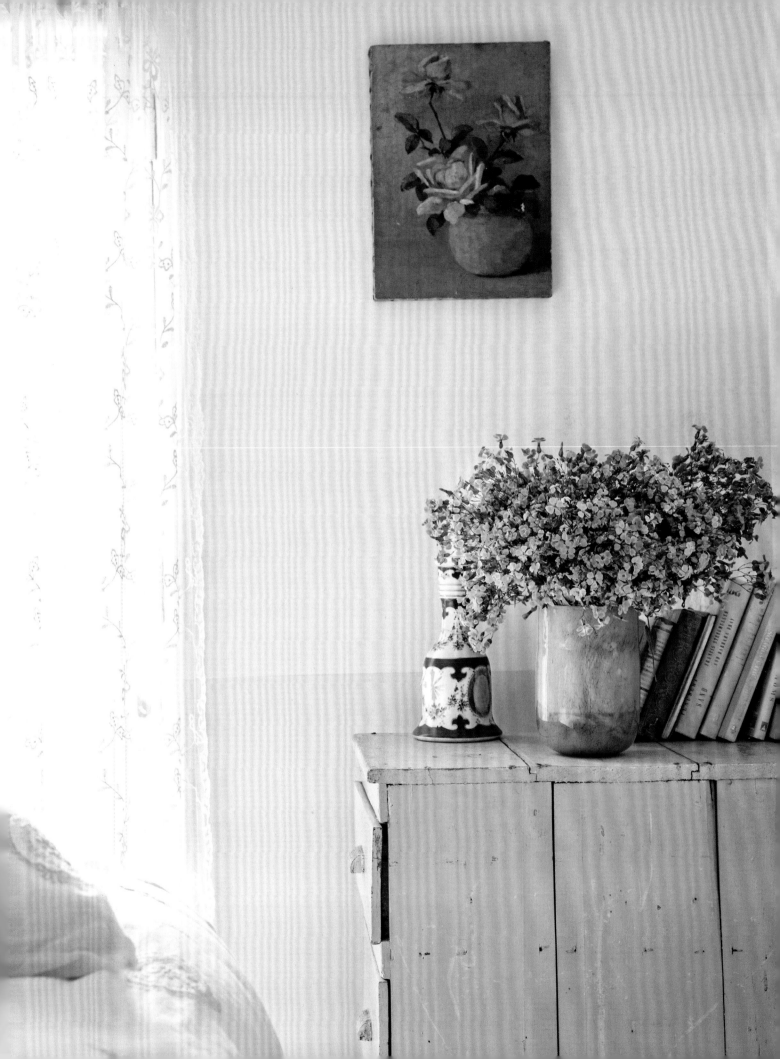

PREVIOUS PAGES In a guest room, it's tricky finding a balance that is cozy and welcoming but not over-cluttered with personal stuff. In my garden suite, there's a treasure of a headdress picked up on travels to India with many floral moments woven in, a lace curtain from my Target line, a primitive pale blue chest of drawers, a floral painting, and a simple vase of an abundance of pink phlox. Quite the happy space for a sleepover.

ABOVE A forever-to-keep piece of mine is a floral, slightly chunky decorative molding on a bedhead. It's beautifully distressed with just a hint of deep turquoise hidden in the folds. **RIGHT** Floral everything contained in my hallway nook: vintage wallpaper, a floral painted chest, a fine Capodimonte bud vase, an oil pastel painting, and an explosion of lilac in a decorated pot. It's the themed palette that stops it from looking chaotic.

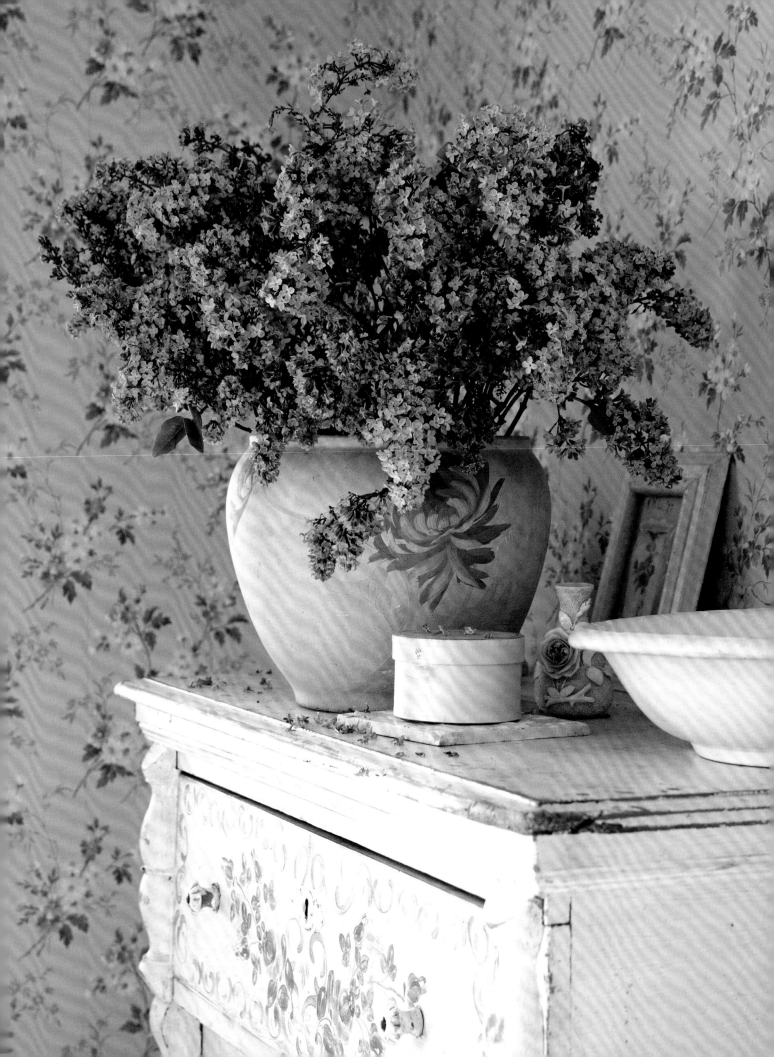

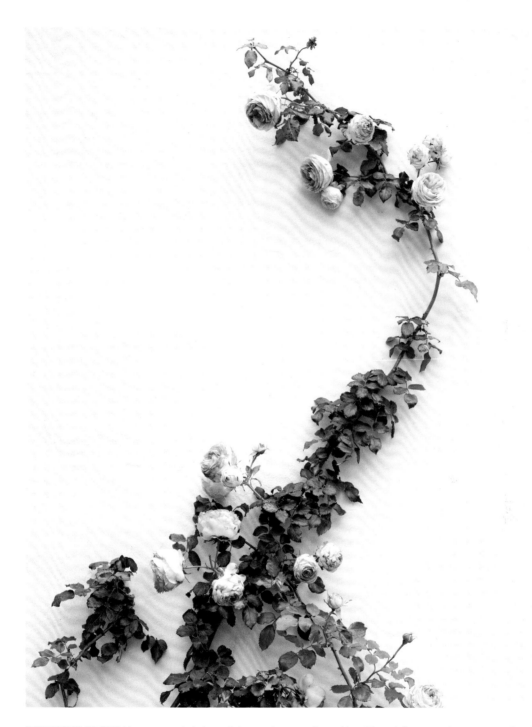

PREVIOUS PAGES My personal pinboard, layered with sketches, messages, ribbons, labels, a photo of my dad, and casually but mindfully placed flowers, both real and fake. The real flowers are pale pink ranunculus, which I love for their characteristics of a small rose that lasts for a long time, fading beautifully, with a few white bachelor's buttons tucked in. Some of my smooshed vintage flowers—as pretty as they are, at times they need a refresh so a simple steaming allows the silk and floppy velvets to pop back to life. **LEFT** Simple but meaningful, a white painted vintage milk bottle, a couple of Yves Piaget roses, and a plain little spoon engraved with a special message. **ABOVE** Eden roses climbing up the wall of the house, a perfectly pretty moment, reminiscent of a traditional English garden. **OVERLEAF** Cuttings of peonies and roses, tools, and my favored white gardening gloves on my florally work station.

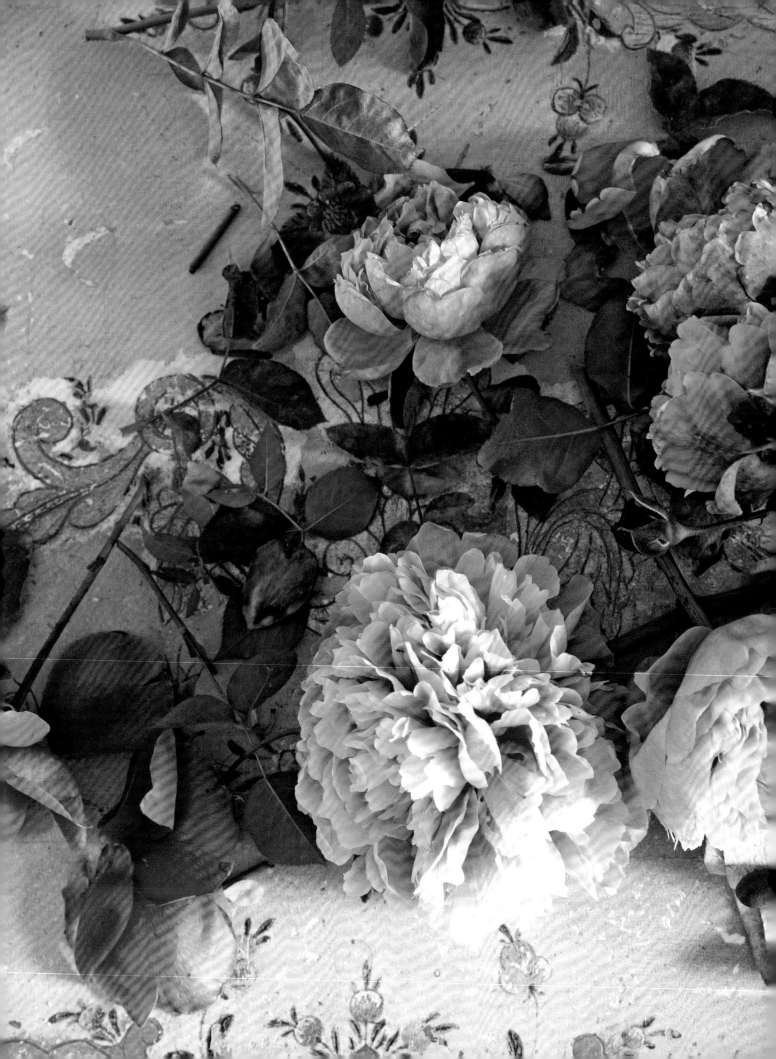

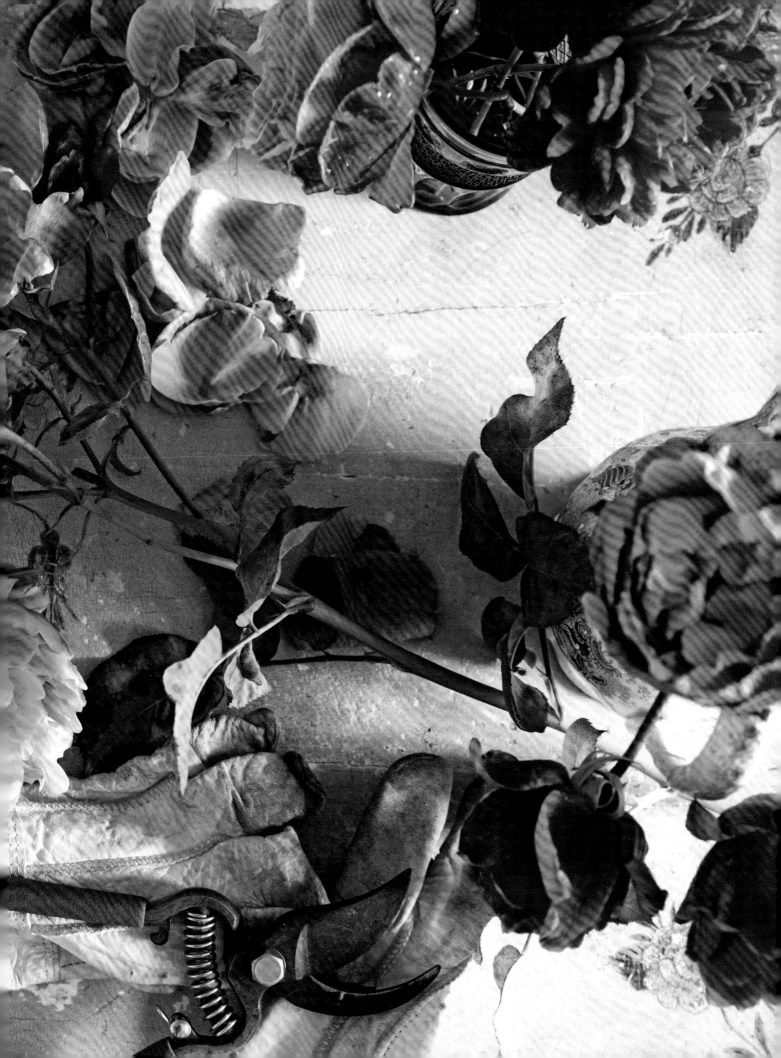

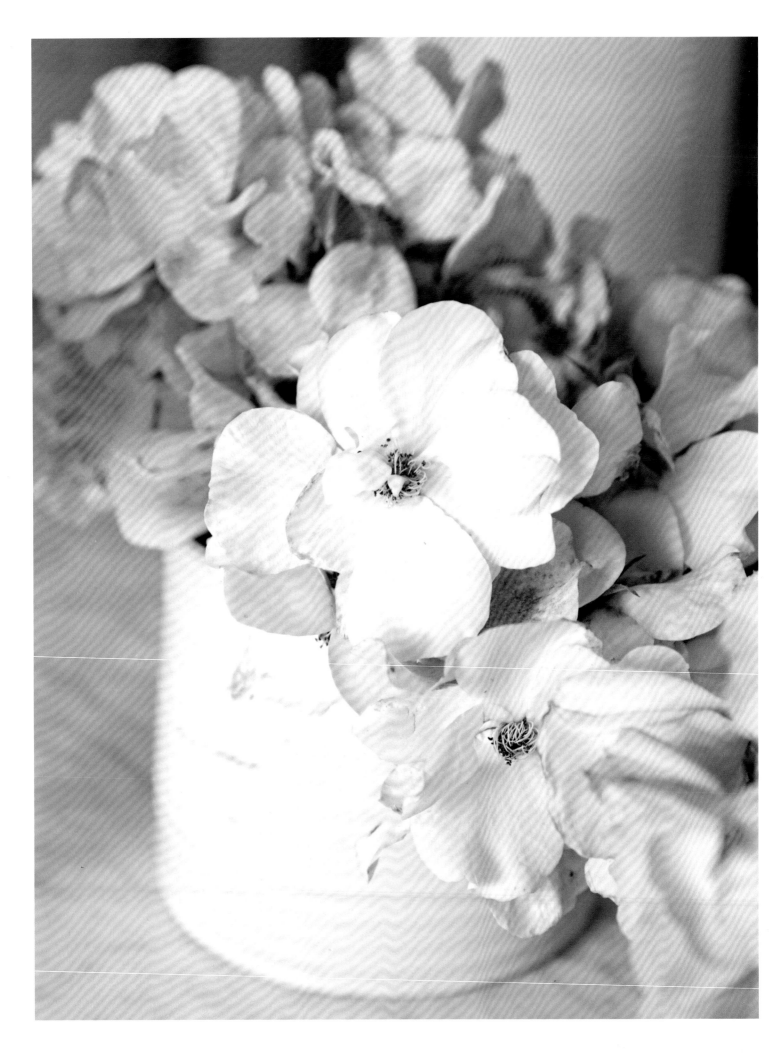

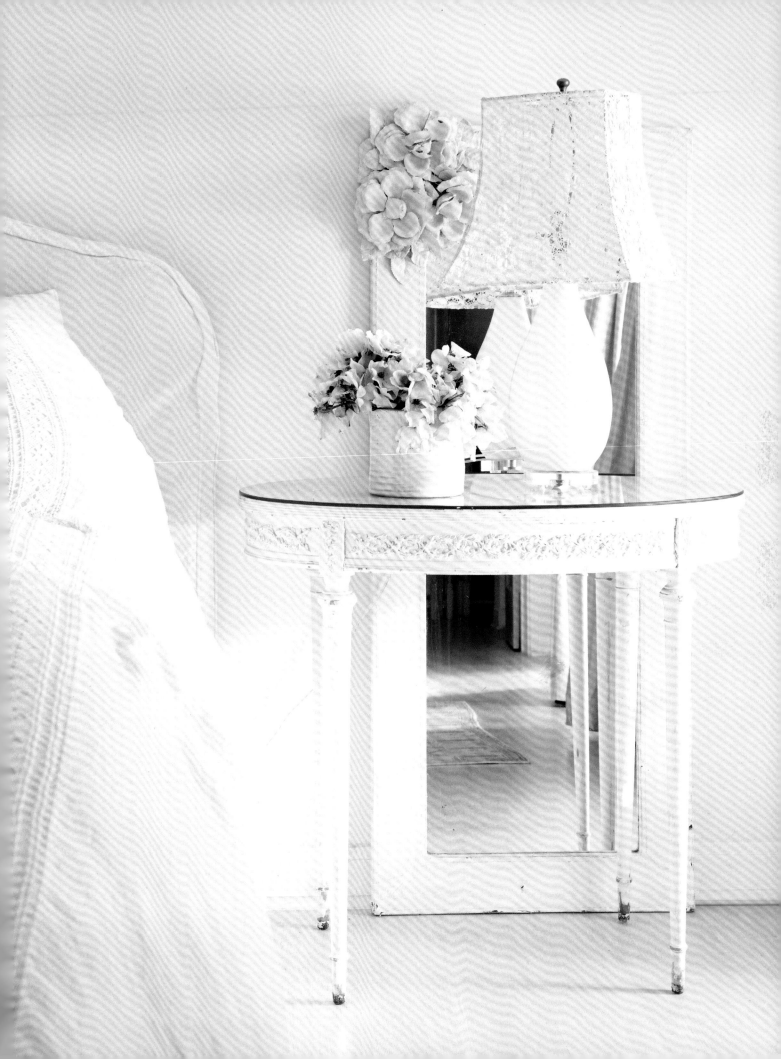

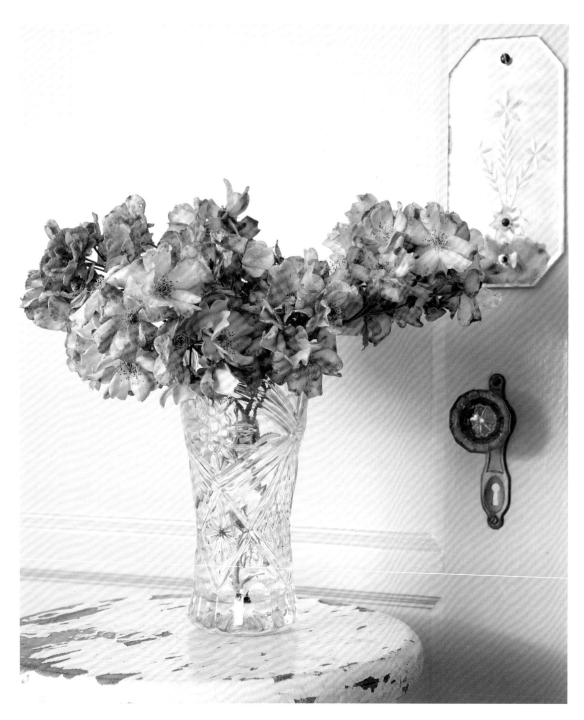

PREVIOUS PAGES My simple bedroom is enhanced with many moments of white on white. I love the vine-like quality of the dogwood flowers in a ripply vase. My linen and crochet lace duvet cover is pretty but minimal. I have a floral lace lampshade on the palest pink glass base, and on the wooden mirror an unusual burst of white leather roses—all quietly flowery. **ABOVE** Fading Francis E. Lester David Austin roses in a cut-crystal vase, that echoes the etching on the glass doorplate. Everything's a bit timeworn (including the flowers) so it doesn't come across as too frilly, but still romantic. **RIGHT** A mass of hydrangeas in a painted pitcher. There's a touch of floral embellishment on the chest of drawers that complements the floral theme of the vintage wallpaper design. I can usually only find a limited numbers of rolls of vintage paper, so I compromise by installing a chair rail and applying the paper only above.

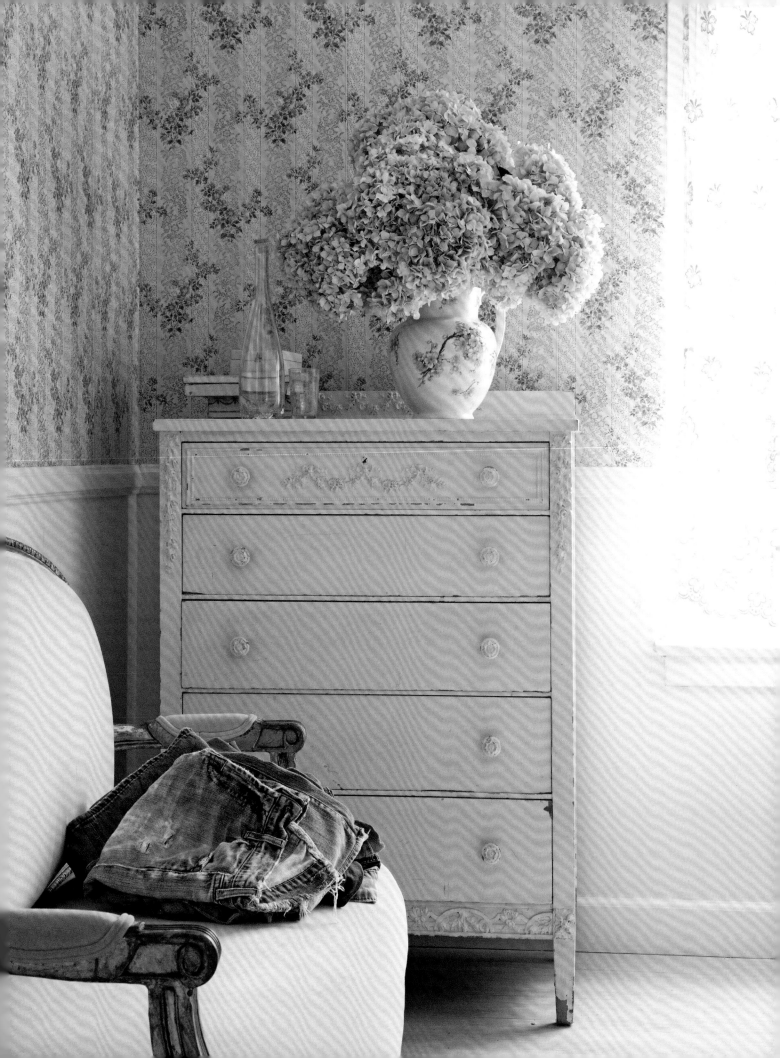

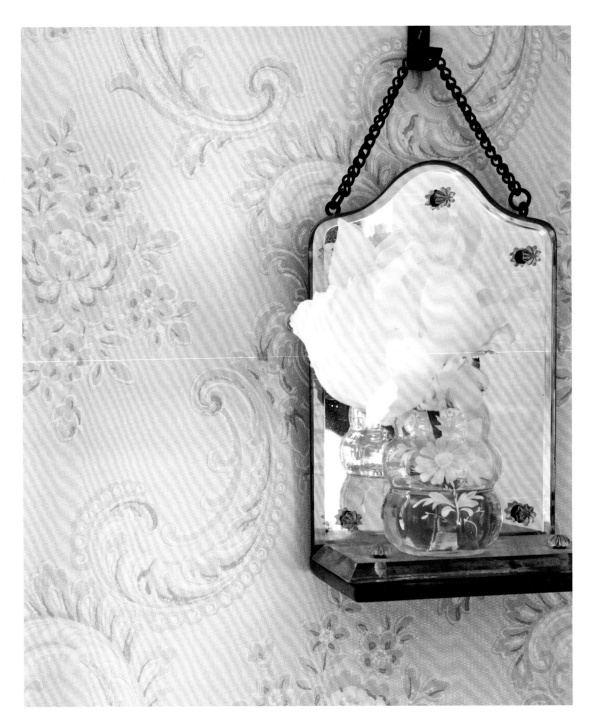

LEFT The bedding is *Rosabelle* from my faded linen collection. It speaks to the lace lampshade and the simple pot of explosive peonies that subtly change color as they age. **ABOVE** My favorite flowery damask vintage wallpaper sets the stage for the little mirrored hanging shelf where an oversized white peony sits in a tiny white painted floral vase. **OVERLEAF** A whimsical vintage hat, worn by me from time to time, against a vintage wallpaper moment. Not all roses are made for cutting due to their fragile petals, but

these cabbagey Yves Piaget roses are as tough as they are pretty. There is a multitude of flowers on flowers, from the primitive carving on the drawer facing to the amateur oil painting and the hodgepodge of vintage jars with floral embellishments. **FOLLOWING PAGES** On the left, a moment in time of my desk strewn with inspiration: the peonies are on their way out, becoming like tissue paper as they fade. And on the right, another view of a favorite painting with homage roses popped into a decorative decanter.

LEFT AND ABOVE A change of venue: my bed and breakfast in Round Top, Texas. The sun beats down daily on Blue Bonnet Barn, one of the eight individual cottages that make up The Prairie. The surrounding garden foliage is sparse—only the hardy wisteria flowers briefly in May, but even heat-exhausted blooms still have plenty to give. **OVERLEAF** Perfectly faded linens blowing in the breeze. **FOLLOWING PAGES** Cornflower Cottage is a mushy, cozy floral delight. The bed linen is *Paradise Floral* from my collection, pretty, cool, and understated. A panel of floral patterned lace flutters at the window.

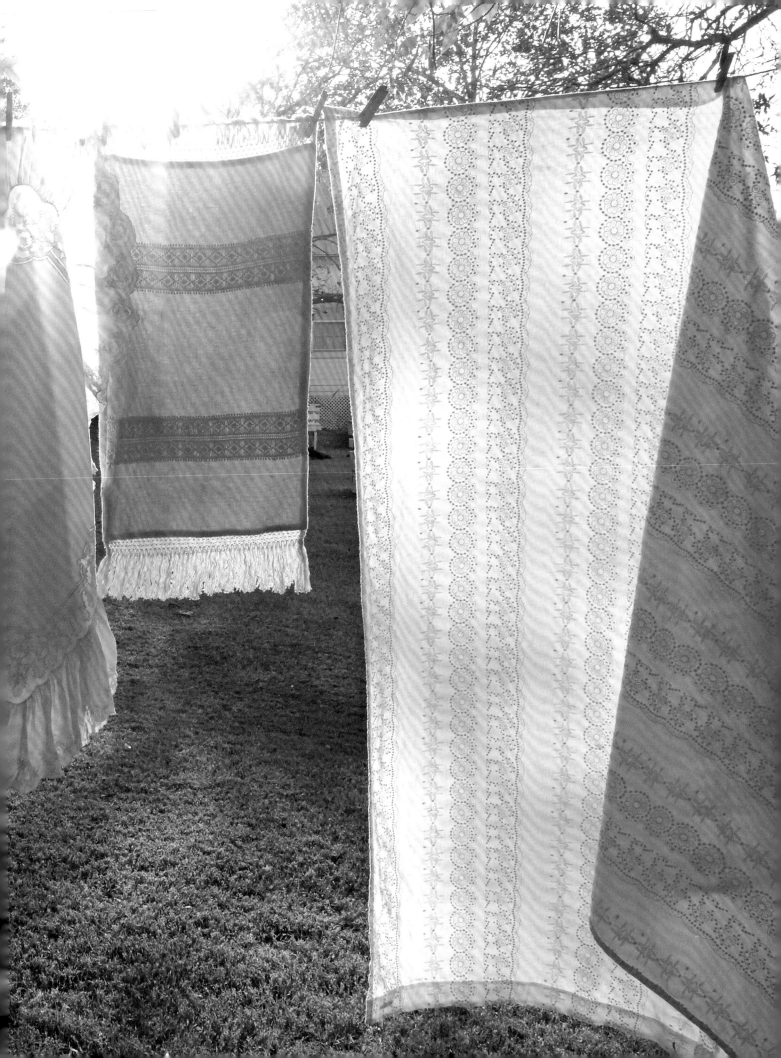

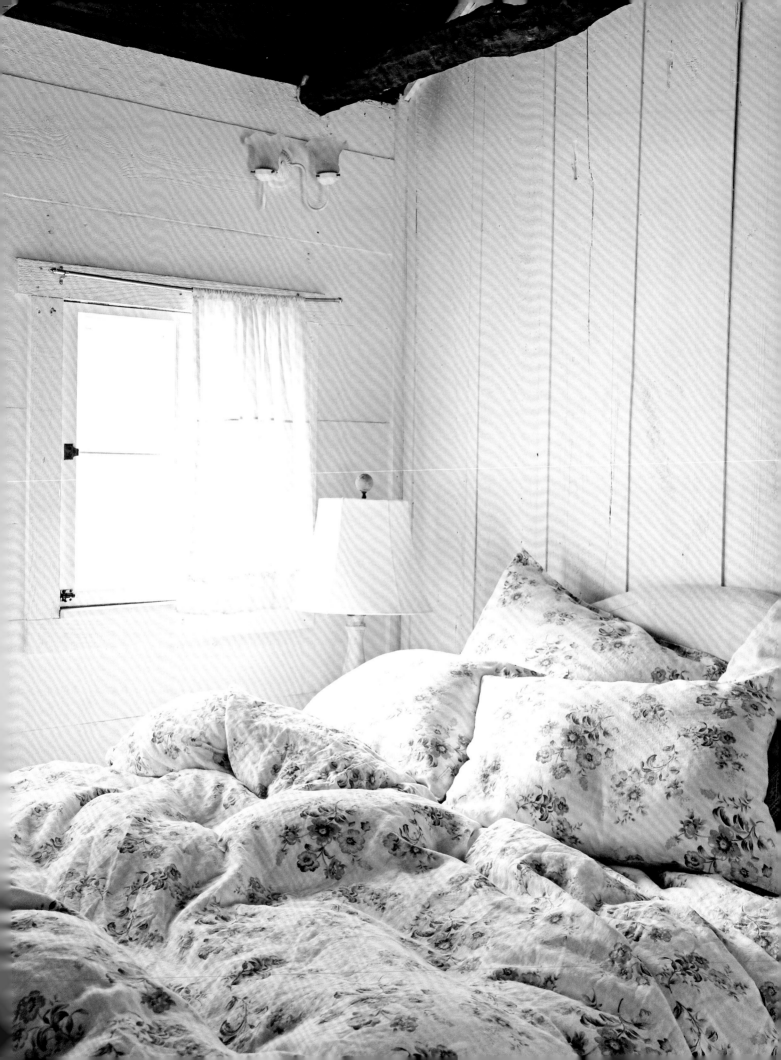

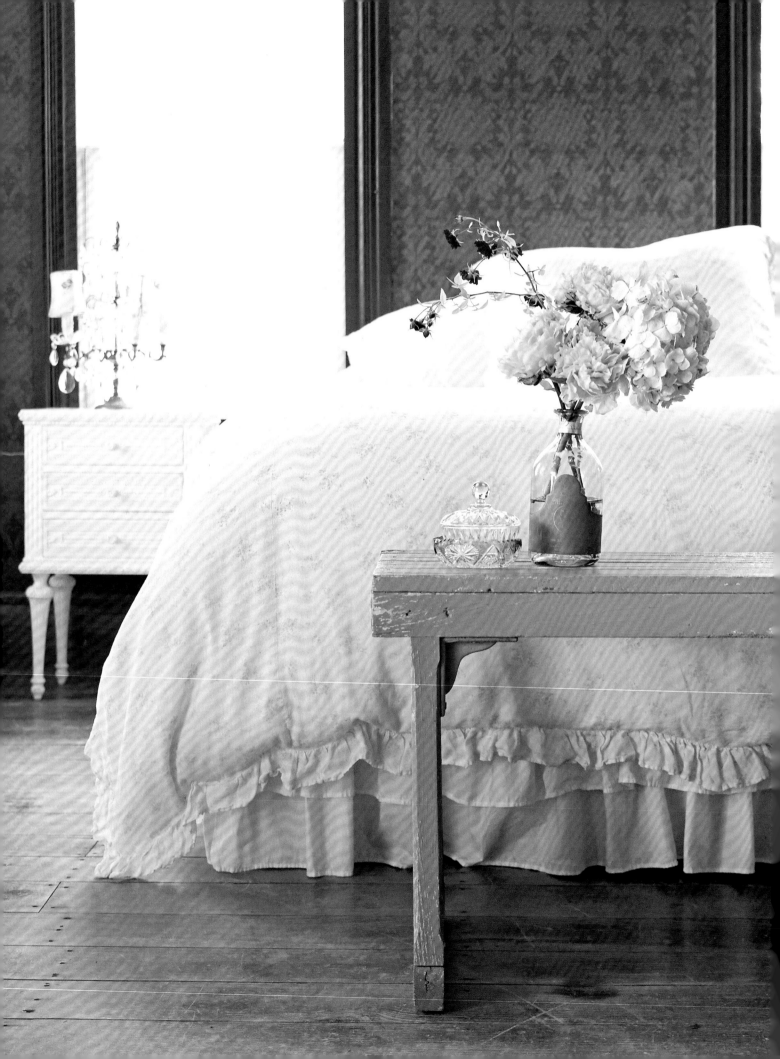

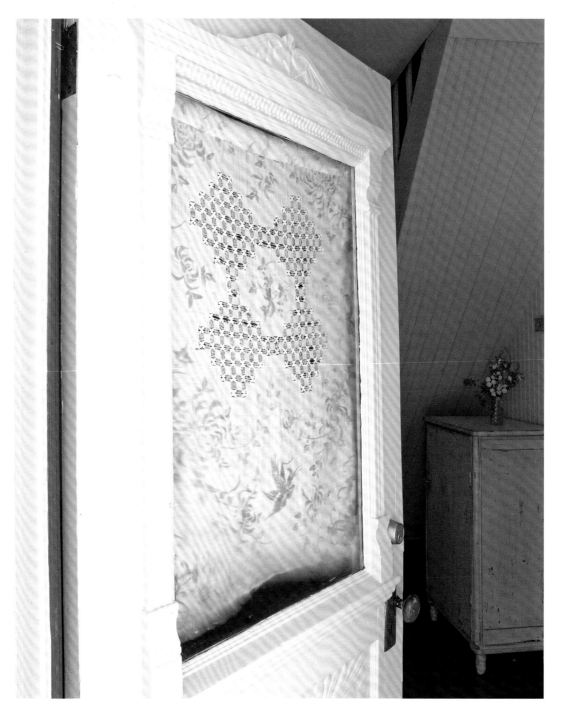

LEFT A feminine bed with a ruffled floral duvet and a vase of hydrangeas from the supermarket, but the room is saved from over-sweetness by the gritty aesthetic of the damask teal wallpaper. **ABOVE** On the door, a salvaged lace tablecloth shades the sun. **OVERLEAF** As rugged as Texas is, there is always room for a rose and romance. Here sits an heirloom quality sofa, upholstered in *Rose Majesty* print—my reinvention of English chintz.

FOLLOWING PAGES I have to rely on blooms carefully selected from the supermarket and an ever-growing, ever-changing collection of fake forever flowers strategically placed indoors and out, using my repertoire of floral-embellished vases and bowls sourced from the legendary flea market right here in Round Top. My signature Prairie barrel of flowers is proudly mostly fake so it can sit outside and withstand the blazing sun and heat.

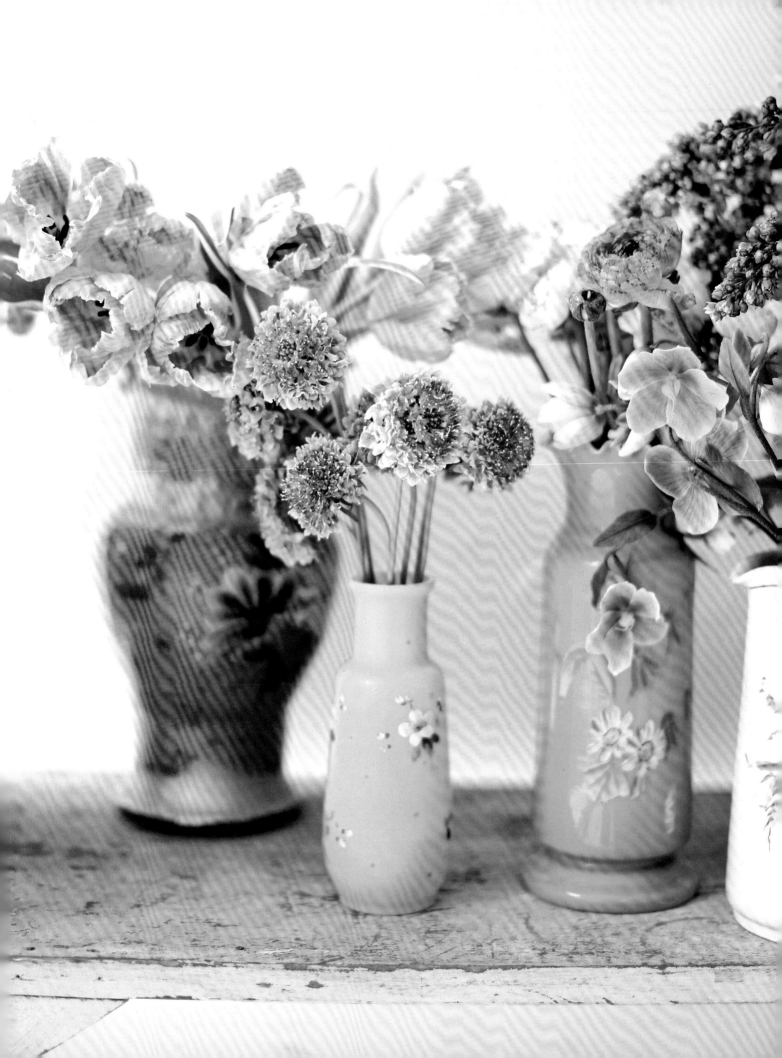

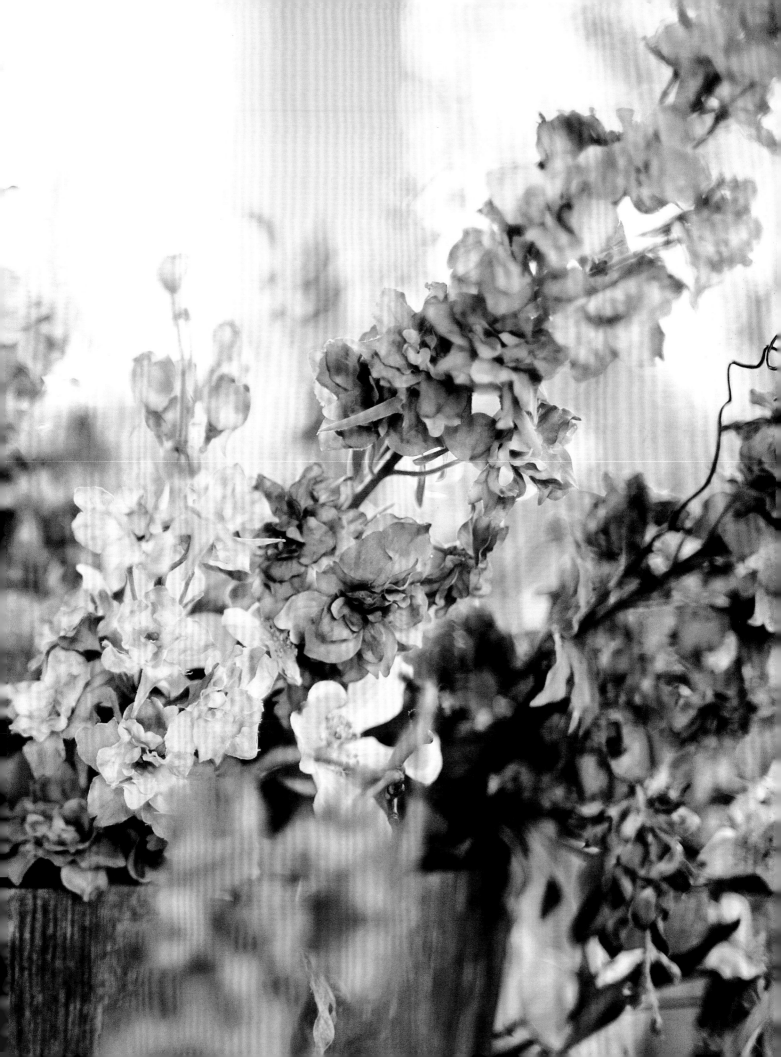

FIORE DESIGNS

For as long as I can remember I have been popping flowers from my garden into an ever-growing collection of lovely and eccentric vases, many gathered over the years at flea markets, but I rely solely on my intuition where floral arranging is concerned as I have no formal floral education. So continuing my floral affair, I wanted to include the art of floral design, and learn something more about it. I chose Fiore Designs, based in Venice, California, created by Jennifer Juhos and Nicole Renna because I saw in their work a soft and natural aesthetic, In their hands, a floral design is a living work of art, a floral landscape created from nature, the design evolving then expiring with the rhythm of the flower's life. They describe their business as a full service floral, event design and styling studio with, as they say, a bit of pixie dust sprinkled throughout. That pixie dust comes from the bond between them. They found a common bond in the artistry of the bouquet, floral storytellers.

I gave them a range of ideas but encouraged them to do what they loved within it. When they arrived at photographer Amy's house with bucket after bucket-load of flowers I was initially a tad concerned because I couldn't really relate to the amount of different shapes and colors, but then I saw Jennifer at work, and learned how a true floral artist works, creating a structure and then layering in accents for depth, and over the course of the photo shoot I developed a whole new appreciation of this aspect of the world of flowers. I tend to use a mass of one, maybe two types of flower, but Fiore's creations contained dozens of bursts of texture and color—that being the difference between an enthusiastic amateur like myself and a true professional.

I watched Jennifer methodically create drama with foam and hidden wires, with the harmonious brush strokes of a true artist. I observed and learned as she assessed various moods and spaces before creating the designs, gifting small spaces with soaring vertical designs, adding full-on feminine frills, and using colors like yellows and dark, dark purples that are far removed from my pale, pretty, pink palette. I learned a lot about myself and my comfort zone in the course of this floral journey.

RIGHT On a zinc table in Amy's shady garden is a breathtaking palette of joyful wild spring blooms, including hyacinths, sweet peas, cornflowers, and tiny Café Latte spray roses in a lovely round concrete pot. There is movement to each stem. I found a metaphor for life on watching Jennifer create this natural but secretly structural display. Because I am not traditionally schooled in much, most of my design work is based on instinct and so the outcome can be unexpected, albeit beautiful. On seeing a studied artist (along with heart and soul) at work, I observed the confidence of knowing creating beauty is a certainty. See page 233 for bouquet breakdown.

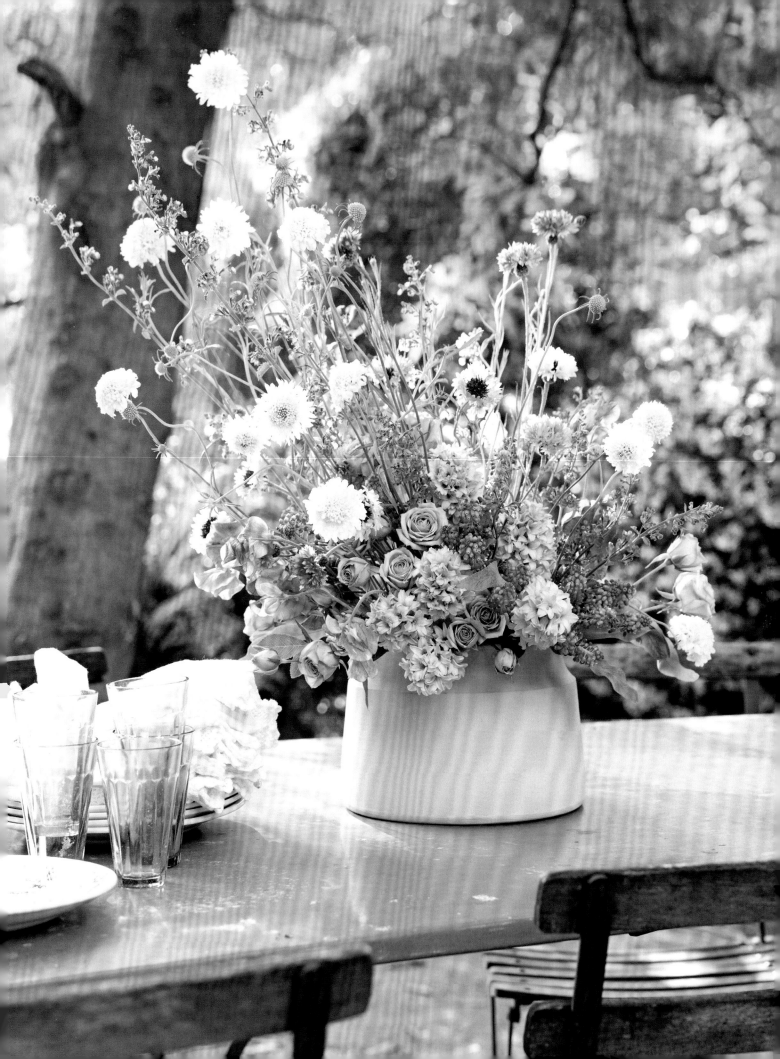

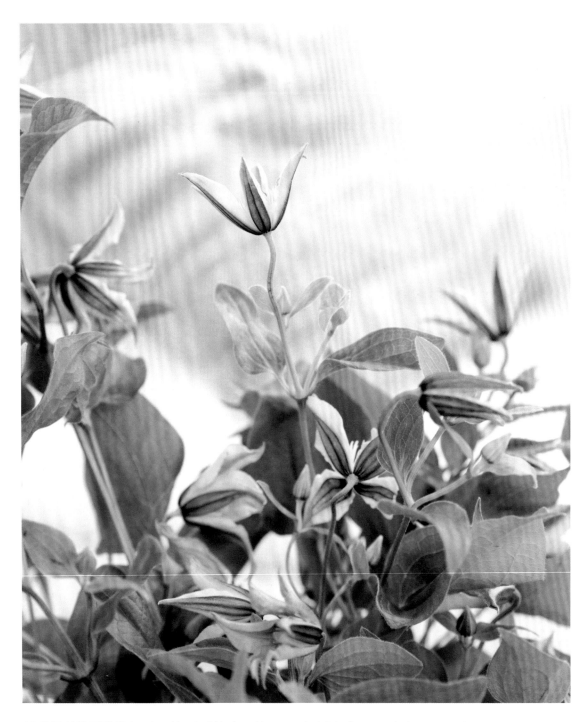

ABOVE AND RIGHT Amy's whimsical kitchen. I love her unique style—a textured distressed cement wall and a scrubbed pine table sit comfortably with a magnificent crystal chandelier and mismatched antique chairs. On the table, in a pair of long wooden troughs, are two complementary displays of garden blooms using peonies, iris, sweet peas, bay leaves, and much else besides—a living work of art. The lovely movement is thanks to an invisible foam and wire supporting structure—I watched in awe as Jennifer of Fiore Designs created it—but the result is still so natural and flowing. See page 233 for bouquet breakdown.

OVERLEAF A weathered stone pot filled with lush pale blooms, profusely feminine. See page 233 for bouquet breakdown. Perched on the bathtub, playing with scale, tall orchids in interesting small pots.

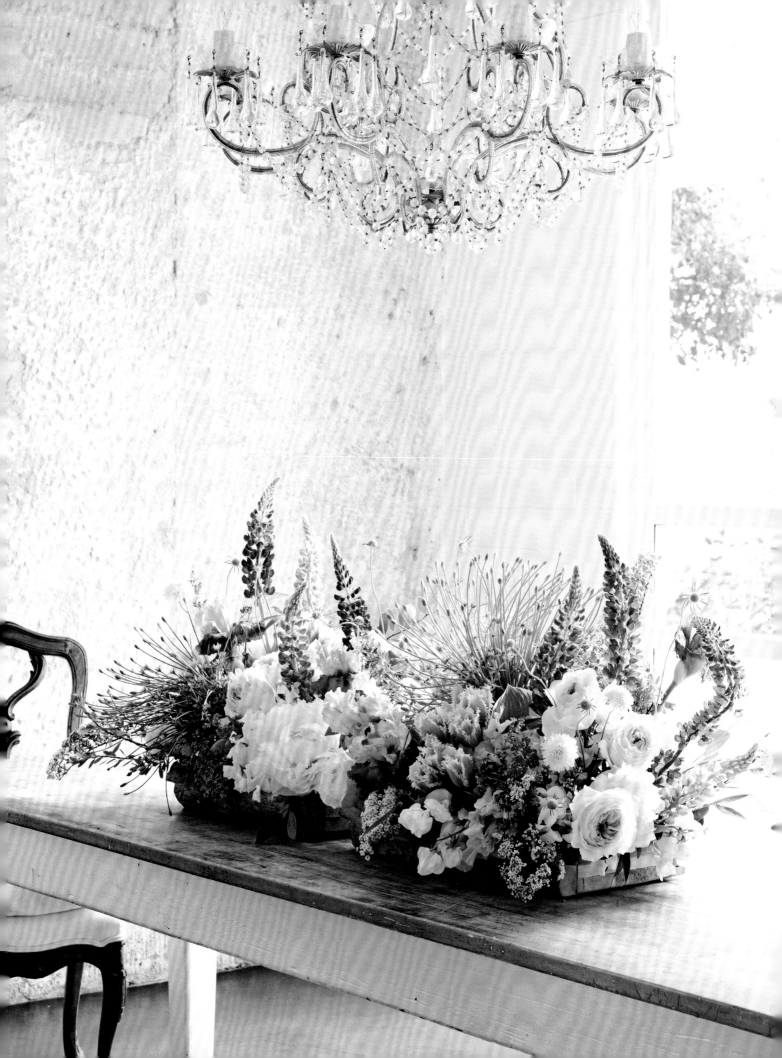

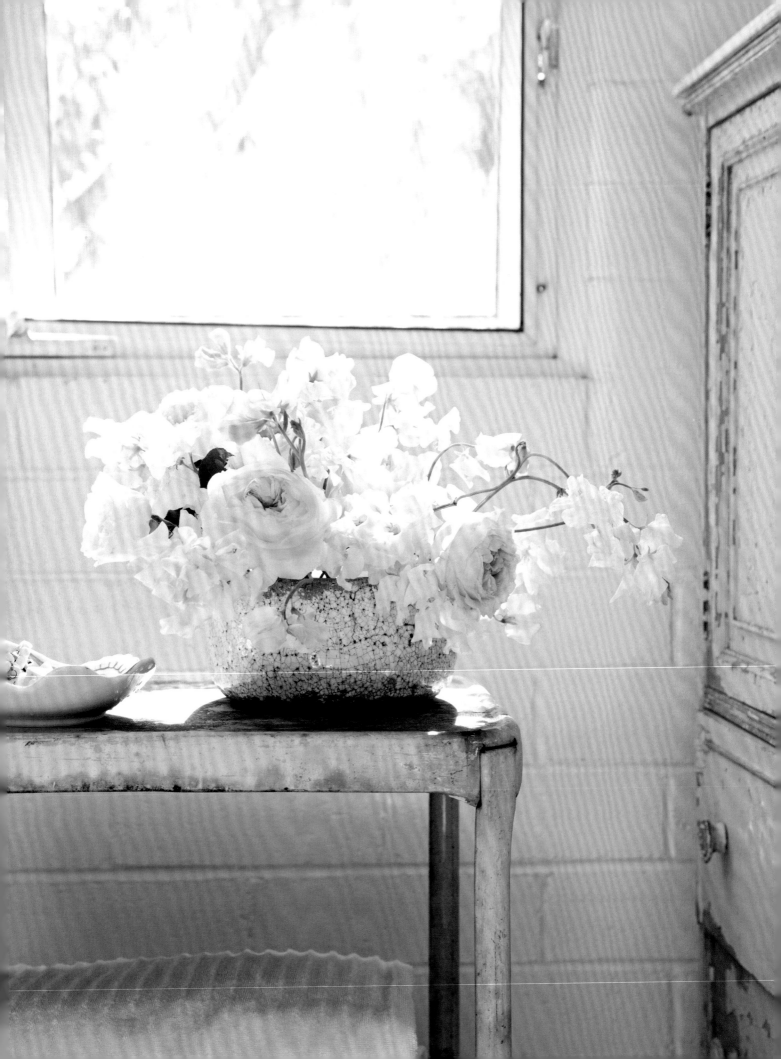

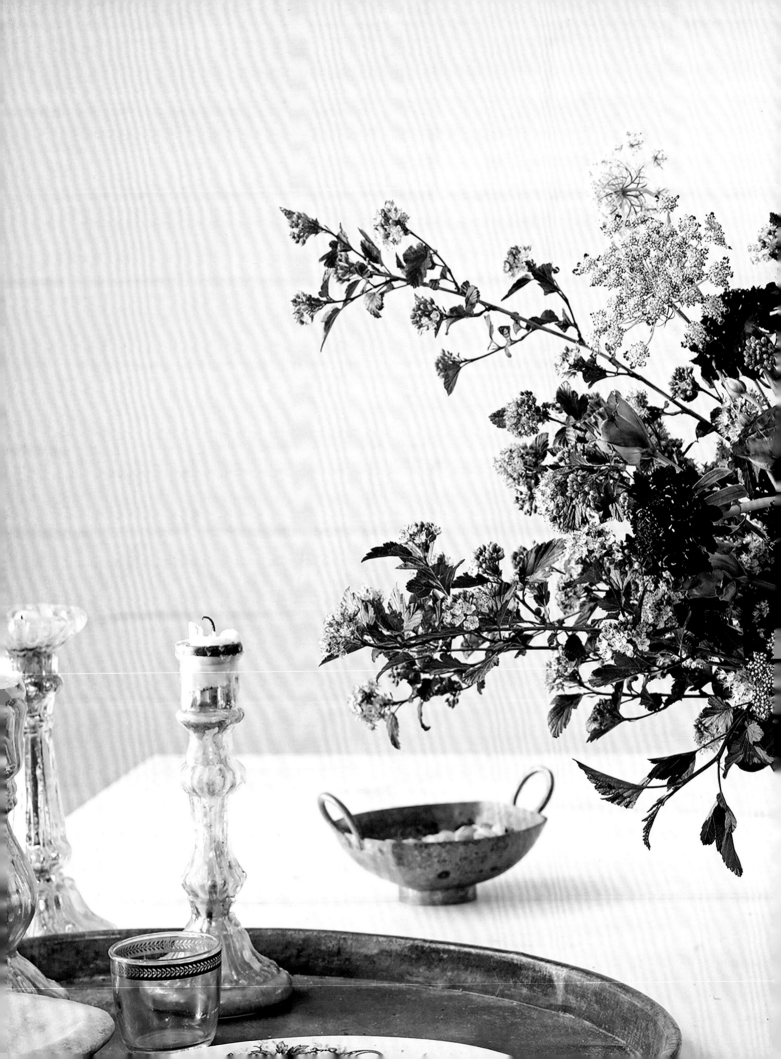

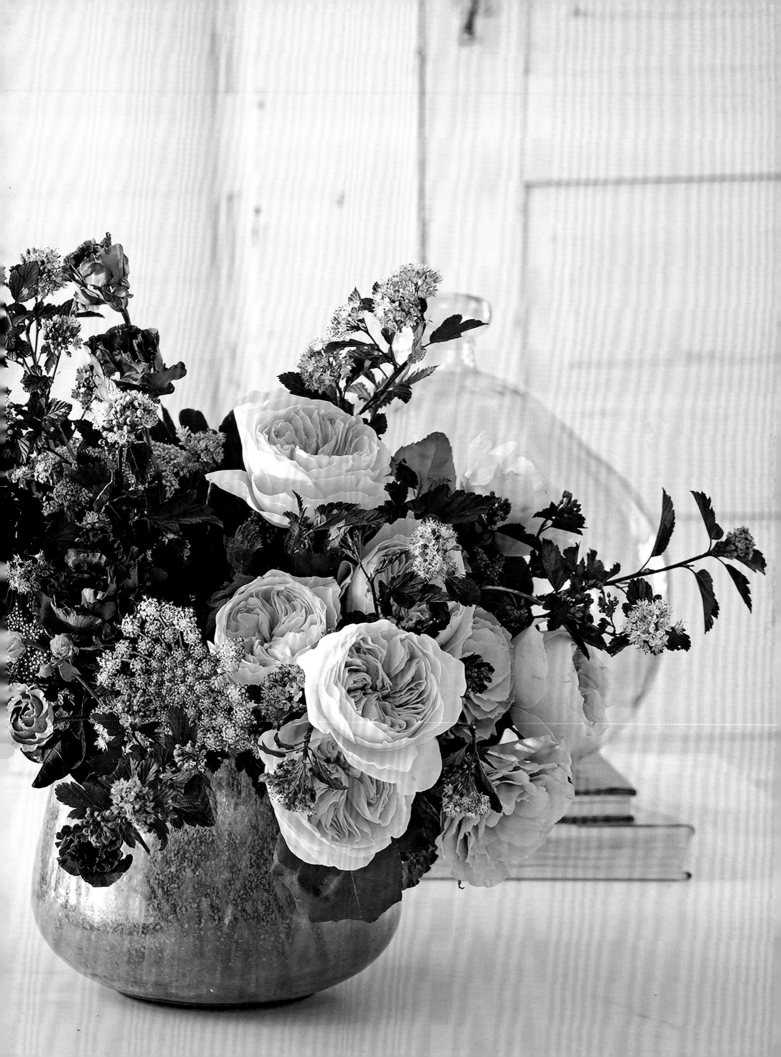

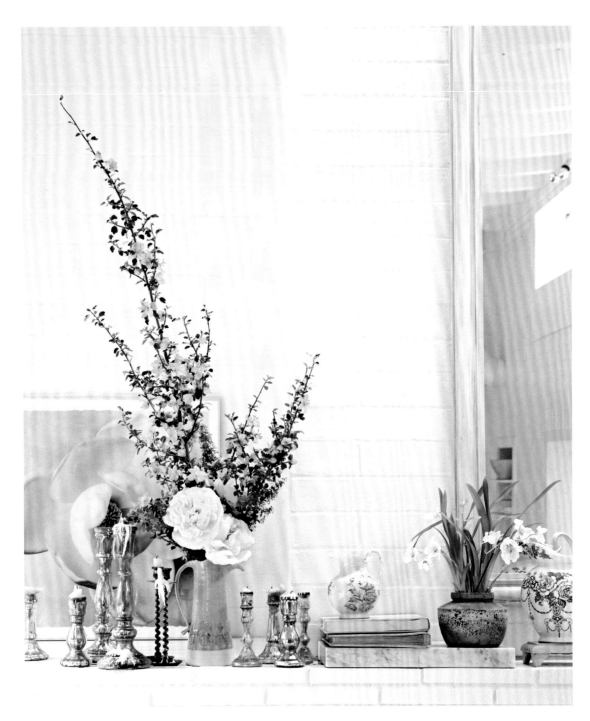

PREVIOUS PAGES Against all odds, perhaps my favorite arrangement. These are flowers and colors, and even a dark iridescent bowl, that I would never normally use, but the sweeping peach garden roses, blending into the umber palette of plums, soft purples, and faded reds is passionately romantic to me. **ABOVE** A striking vertical yellow branch of flannel bush softened by a Lemon Chiffon peony,

and in the pot to the side, a little yellow orchid. Yellow is not one of my colors, but I surrendered and warmed to these. **RIGHT** In an iridescent water pitcher, a burst of purple delphiniums and dahlias. I love the scale of delphiniums and the way they drop their petals quite quickly, making lovely petal piles. See page 233 for bouquet breakdown. **OVERLEAF** Breathtaking leftover petals of the day.

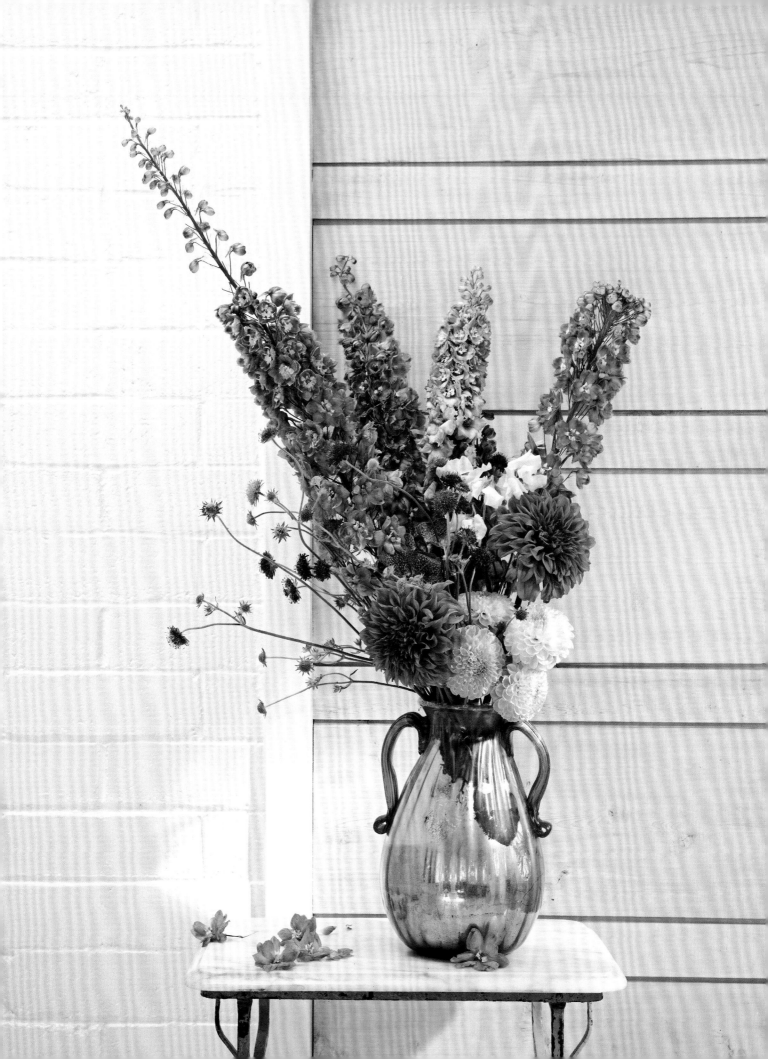

BOUQUET BREAKDOWN

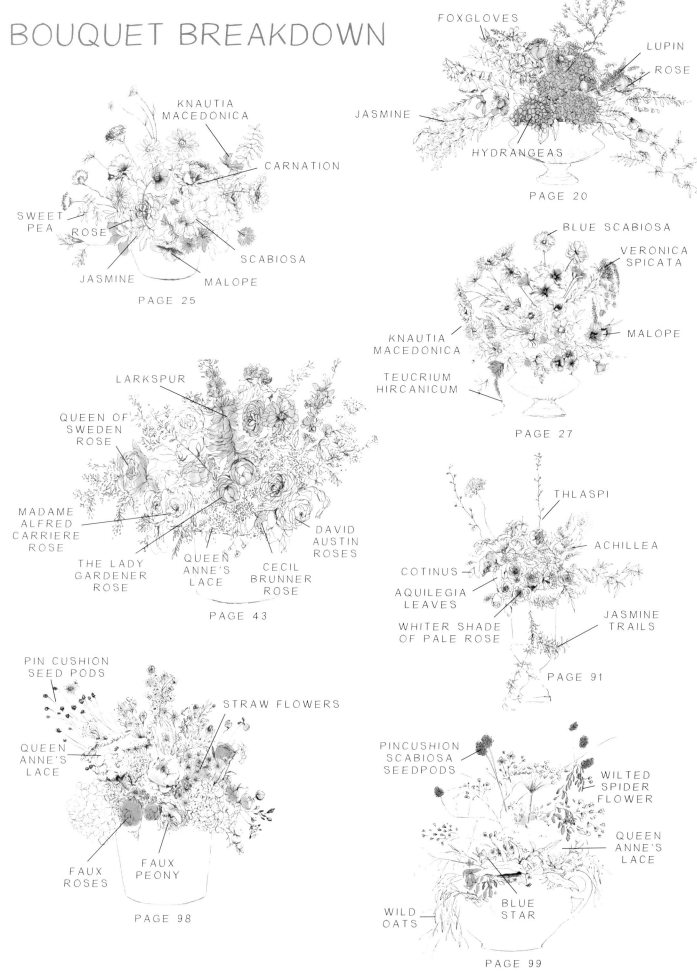

FOXGLOVES

LUPIN

ROSE

JASMINE

HYDRANGEAS

PAGE 20

KNAUTIA MACEDONICA

CARNATION

SWEET PEA

ROSE

SCABIOSA

JASMINE

MALOPE

PAGE 25

BLUE SCABIOSA

VERONICA SPICATA

KNAUTIA MACEDONICA

MALOPE

TEUCRIUM HIRCANICUM

PAGE 27

LARKSPUR

QUEEN OF SWEDEN ROSE

MADAME ALFRED CARRIERE ROSE

THE LADY GARDENER ROSE

QUEEN ANNE'S LACE

CECIL BRUNNER ROSE

DAVID AUSTIN ROSES

PAGE 43

THLASPI

ACHILLEA

COTINUS

AQUILEGIA LEAVES

WHITER SHADE OF PALE ROSE

JASMINE TRAILS

PAGE 91

PIN CUSHION SEED PODS

STRAW FLOWERS

QUEEN ANNE'S LACE

FAUX ROSES

FAUX PEONY

PAGE 98

PINCUSHION SCABIOSA SEEDPODS

WILTED SPIDER FLOWER

QUEEN ANNE'S LACE

WILD OATS

BLUE STAR

PAGE 99

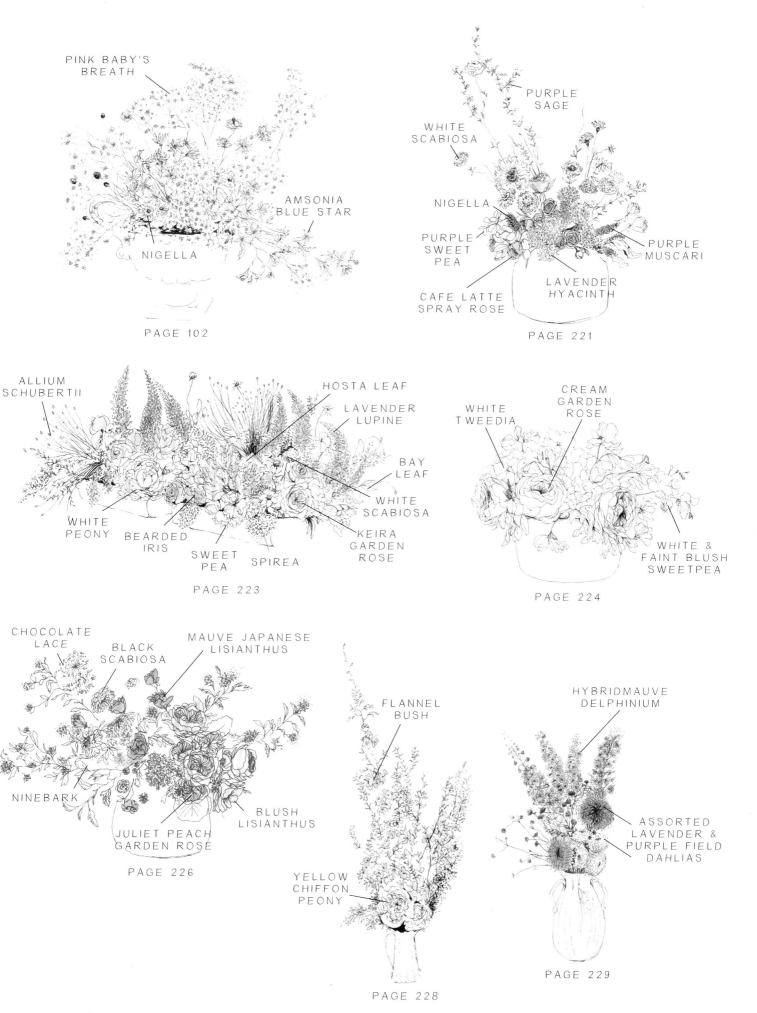

PINK BABY'S
BREATH

NIGELLA

AMSONIA
BLUE STAR

PAGE 102

PURPLE
SAGE

WHITE
SCABIOSA

NIGELLA

PURPLE
SWEET
PEA

CAFE LATTE
SPRAY ROSE

LAVENDER
HYACINTH

PURPLE
MUSCARI

PAGE 221

ALLIUM
SCHUBERTII

HOSTA LEAF

LAVENDER
LUPINE

BAY
LEAF

WHITE
SCABIOSA

KEIRA
GARDEN
ROSE

WHITE
PEONY

BEARDED
IRIS

SWEET
PEA

SPIREA

PAGE 223

WHITE
TWEEDIA

CREAM
GARDEN
ROSE

WHITE &
FAINT BLUSH
SWEETPEA

PAGE 224

CHOCOLATE
LACE

BLACK
SCABIOSA

MAUVE JAPANESE
LISIANTHUS

NINEBARK

JULIET PEACH
GARDEN ROSE

BLUSH
LISIANTHUS

PAGE 226

FLANNEL
BUSH

YELLOW
CHIFFON
PEONY

PAGE 228

HYBRIDMAUVE
DELPHINIUM

ASSORTED
LAVENDER &
PURPLE FIELD
DAHLIAS

PAGE 229

RESOURCES

Rachel Ashwell Shabby Chic Couture

1013 Montana Ave, Santa Monica,
CA 90403
(310) 394 1975
shabbychic.com

facebook.com/rachelashwellshabbychic
facebook.com/officialshabbychic.
instagram.com/rachelashwell
instagram.com/officialshabbychic
pinterest.com/rachelashwell
pinterest.com/rasccouture

The Prairie by Rachel Ashwell
theprairiebyrachelashwell.com

Simply Shabby Chic
target.com

ENGLISH COUNTRYSIDE & A LITTLE BIT OF WALES

Beautiful Babington

babingtonhouse.co.uk
Instagram @sohohouse

Floristry by Toria Britten, Flowers from
 the Plot
flowersfromtheplot.co.uk
Instagram @flowersfromtheplot

Storybook Cottage

Instagram @cowparsley_and_foxgloves
Paint on kitchen cabinets, hallway floor,
 walls: Flake White by Fired Earth
Paint on kitchen floor: Lime White by
 Farrow & Ball
Paint on wall behind Aga: Paris Grey by
 Annie Sloan
Roses: davidaustinroses.co.uk

Roses, Roses & Roses

pearllowe.co.uk
Instagram @pearllowe
Pink and white wallpaper: Nicholas
 Herbert
Orange and white wallpaper: Robert Kime
Blue and white wallpaper: Robert Kime
Bathroom floor tiles: Fired Earth
Kitchen: devolkitchens.co.uk
Paints: Farrow & Ball

A Welsh Treasure

Lucy the Flower Hunter
lucyhunter.co.uk
Instagram @lucytheflowerhunter
Email studio@theflowerhunter.co.uk

Floor tiles
theantiquefloorcompany.com

Annabella Daughtry
Instagram @justbelle
belledaughtry.com

Flea Markets

Ardingly Antiques & Collectors Fairs
West Sussex
iacf.co.uk

The Giant Shepton Flea Market
Somerset
sheptonflea.com

Sunbury Antiques Market
Kempton Park
sunburyantiques.com

Portobello Road
Notting Hill, London

FRENCH FLEURS

Whimsical Beauties

Laurence Amélie
laurence-amelie.com
Instagram @laurence.amelie

Forever Flowers

Atelier Boutique Legeron
20 Rue des Petits Champs, 75002 Paris
ets.legeron@wanadoo.fr
boutique-legeron.com/en/

Floral Crowns by Tanya Boureau
grangedecharme.canalblog.com/
Instagram @grange_de_charme

Trés Jolie

Adriana Anzola
myshabbywhites@gmail.com
etsy.com/shop/Myshabbywhites
Instagram @shabby_whites

Sweet Petite Paris

Ladurée Tea Rooms
75 Avenue des Champs Elysées,
75008 Paris
laduree.com
laduree.fr
Instagram @maisonladuree

Floristry by Amy Kupec Larue, Your
Guide to the Gardens of Paris
33(0) 6 77 23 46 44
amylarue@orange.fr
gardenguideparis.wordpress.com
gardenguideparis@gmail.com
Instagram/Pinterest @gardenguideparis

NORWAY FLORAL DREAMS

Faded Floral Grandeur

Damsgård Museum
bymuseet.no/en/museums/damsgaard-
 country-mansion/
damsgard.hovedgard@bymuseet.no

Atelier Flora
Ovregaten 2A, 5003 Bergen
post@atelierflora.no
atelierflora.no

Toneblomst
Starvhusgt. 3, 5014 Bergen
toneblomst.no
post@toneblomst.no

Violet Cakes
violetcakes.com
Instagram @violetcakeslondon

Poetic Portraits

Jorunn Mulen
jorunn-mulen.com
Instagram @jorunnmulen
Email jmulen@hotmail.com

BLOSSOM & BEAUTIES IN THE USA

My Floral World

Los Angeles Flower Market
originallaflowermarket.com

David Austin Roses
davidaustinroses.com/us

Silk flowers/floral supplies
Moskatels
738 Wall St, Los Angeles, CA 90014
(213) 689 4830

Farrow & Ball wallpaper
us.farrow-ball.com

Bennison Fabrics
bennisonfabrics.com

Artwork

page 172 Kim McCarty
kimmccarty.net

Page 183 Kinley Danger
shabbychic.com

Fiore Designs

fioredesigns.com
Instagram @fioredesigns
Email fioregirls@icloud.com

Flea Markets

Original Round Top Antiques Fair
Round Top, TX
roundtoptexasantiques.com

Brimfield Antique Flea Markets
Brimfield, MA
brimfieldantiquefleamarket.com

INDEX

Page numbers in *italics* refer
to illustrations.

Amélie, Laurence 94, 95, 96-113, *172, 174-5*
The Antique Floor Company 87
Anzolia, Adriana 95, 122-33
Atelier Flora 143

Babington House 14-29
bar areas *20-1*
Baroque *141*
bathrooms
　Babington House *22-3*
　Pearl Lowe's home *64-5*
　storybook cottage *48-9*
bedheads *26*, 188
bedrooms
　Adriana Anzolia's home *124-5*
　Babington House *24-5, 26*
　Cornflower Cottage *211*
　Jorunn Mulen's home *167*
　Pearl Lowe's home *53, 54-5, 56, 66-7*
　The Prairie *211, 212*
　Santa Monica *183, 186-7, 196-201*
　storybook cottage *44-7*
Belle Époque 134, *140*
birdcages *129, 130*
Blue Bonnet Barn 206
bouquet breakdowns 232-3
Boureau, Tanya *105, 107, 120-1*
Britten, Toria 13, 14, *25, 27*
buckets *79, 87, 88, 98, 125*
buddleia *88*

Cabin by the Lake *26-7*
carnations *19, 23, 152*
chairs *94*
Chéret, Jules 134
Cornflower Cottage *211*
cornflowers *36, 38*
curtains *54, 65, 69, 151, 211*
cutting gardens *80-1*, 96

Damsgård Museum 143, 144-59
daybeds *78, 156-7*
decks *113*
delphiniums *229*
deVol Kitchens 68
dining areas
　Babington House *19*
　Damsgård Museum *158-9*
　Pearl Lowe's home *61*
　Santa Monica *171*
　story book cottage *36-7*
dinnerware *178-9, 180-1, 182*
doors *34, 40*, 213
dried flowers *129, 130, 131, 132*

echinacea *89*
entrances
　Babington House *12, 16*
　storybook cottage *40-1*
　Wydene *87*

fake forever flowers 114-21, *127, 177, 190-1,*
　213, *217*
Fiore Designs 220-30
France 94-141
Franceschini, Ubaldo 96, *106*

gardens
　Babington House *15*
　Santa Monica *174-5, 184-5*
　storybook cottage *32-3*
Gyldenkrantz family 144
gypsy caravans *71*

handmade flowers 114-21
headdresses *186*
Herbert, Nicholas 55
hollyhocks *112*
Hunter, Lucy 86
hydrangeas *12, 98, 133, 135, 158-9, 162, 165,*
　167, 199, 212

interior architecture *123, 138-9*

jars *203*
jasmine *145, 152, 161*
jugs *87, 89, 176*
Juhos, Jennifer 220-30

Kime, Robert *56, 62*
kitchens *222-3*
　Adriana Anzolia's home *132-3*
　Damsgård Museum *150-1*
　Jorunn Mulen's home *162*
　Laurence Amélie's home *104-7*
　Pearl Lowe's home *68*
　Santa Monica *178-9*
　storybook cottage *39*
Kupec-Larue, Amy 95, 114, 134, *135, 141*

Ladurée, Maison 134-41
Ladurée Tea Rooms 95
Légeron, Bruno 95, 114-19
lighting
　candelabras *61, 63*
　chandeliers *126, 140, 145, 223*
　wall sconces *18, 82, 92, 127*
living areas
　Laurence Amélie's home *98-9*
　Pearl Lowe's home *62*
　Santa Monica *172*
Lowe, Pearl 52-71

McCarty, Kim *172*
Maison Ladurée 134-41
Maison Légeron 95, 114-19
milk bottles *192*
mirrors *20, 22, 23, 101*
Mulen, Jorunn 143, 160-7

Norway 142-67

offices *60*
orchids *225, 228*

pantries *152-3*
peonies *55, 98, 135, 141, 200-1, 204-5,*
　223, 228
pinboards *190*

pitchers *128*
Playroom *24-5*
pots *147, 224, 225*
potting sheds *74-5*
The Prairie 169, 170, 206-19

ranunculus *190*
Renna, Nicole 220-30
Rococo 143
roses *26, 44, 57, 59, 73, 109, 135, 137, 141,*
　147, 156, 176, 205, 227
　Ballerina *32-3, 34, 49, 76-7*
　cabbage roses *128*
　Café Latte *221*
　Cool Water *162*
　David Austin *36-7, 43, 174-5, 198*
　dogwood rose *70*
　dried roses *129*
　Eden *193*
　Fragrant Memories *31*
　Francis E. Lester *171, 198*
　Joie de Vivre *23*
　Kate *92*
　spray roses *221*
　Sweet Antike *89, 92, 93*
　Yves Piaget *171, 172-3, 178, 192, 203*

sample albums *116-17*
Santa Monica 170-205
Schneider, Gérard 96, *105*
Siddorn, Carol 86
silk flowers *115, 116-17, 118, 126, 149, 177*
sitting areas
　Adriana Anzolia's home *123, 128-9*
　Babington House *27*
　Pearl Lowe's home *57*
　The Prairie *214-15*
　storybook cottage *35, 43*
　Wydene *90-1*
storybook cottage 30-49
strawflowers *130, 131*
studios
　Jorunn Mulen's studio *163, 164-5, 166*
　Laurence Amélie's studio *94, 108, 110-11*

thistles *148*
tissue flowers *119*
Toneblomst 143
trompe l'oeil 158-9

United States of America 168-230
urns *91, 102, 103, 158-9*

vases *100, 150, 168, 172, 189, 196, 198, 201,*
　216-17, 220
Violet Cakes *142, 154, 155*

Wales 86-93
wallpaper *156-7, 212*
　Nicholas Herbert *55*
　Robert Kime *56, 62*
　vintage *154, 179, 189, 199, 201, 202*
window sills *31*
windows *69*
Winnamen, Kinley *182*
wood-burning stoves *146*
wreaths *40*
Wydene 86-93

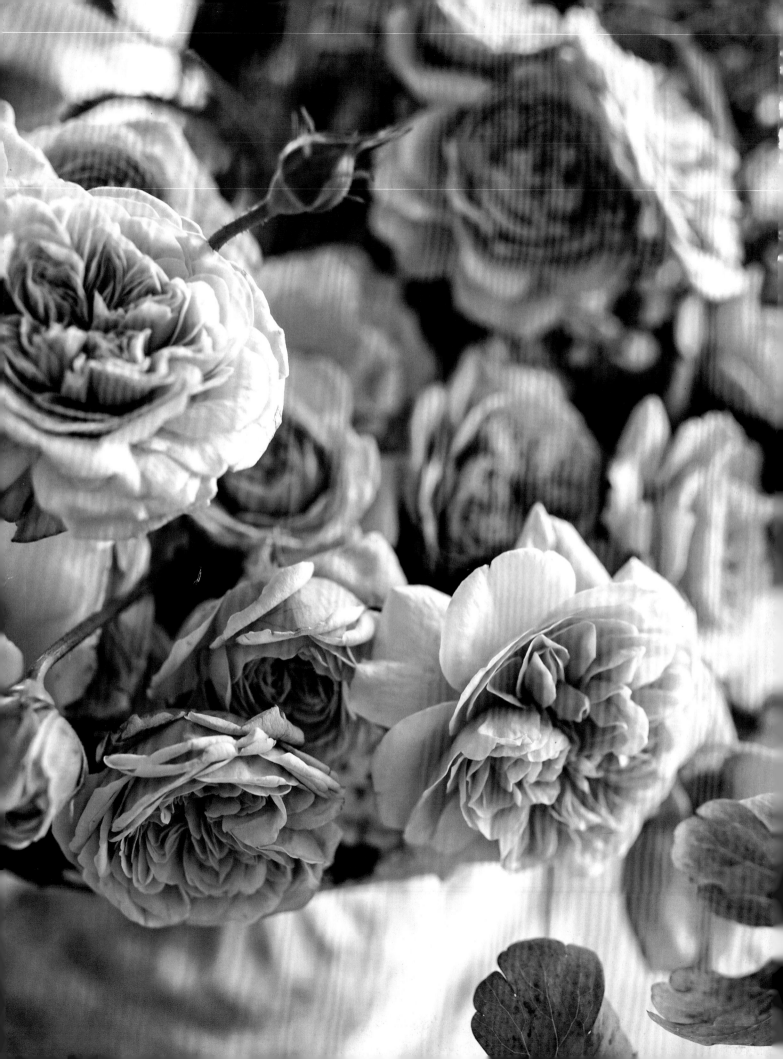